HOPPER

HOP

Also by Tom Folsom

*The Mad Ones: Crazy Joe Gallo
and the Revolution at the Edge
of the Underworld*

*Mr. Untouchable: The Rise, Fall,
and Resurrection of Heroin's Teflon Don*
(with Nicky Barnes)

A JOURNEY
INTO THE
AMERICAN DREAM

PER

Tom Folsom

it books
AN IMPRINT OF HARPERCOLLINS PUBLISHERS

*it*books

HOPPER. Copyright © 2013 by Mad Ones Corp. All rights reserved. Printed in the United States of America. No part of this book may be used or reproduced in any manner whatsoever without written permission except in the case of brief quotations embodied in critical articles and reviews. For information address Harper-Collins Publishers, 10 East 53rd Street, New York, NY 10022.

HarperCollins books may be purchased for educational, business, or sales promotional use. For information please write: Special Markets Department, Harper-Collins Publishers, 10 East 53rd Street, New York, NY 10022.

FIRST EDITION

Designed by Renato Stanisic

Cover stamp illustration by Kevin Bassie/shutterstock.com
Endpaper photograph courtesy of the Everett Collection

Library of Congress Cataloging-in-Publication Data is available upon request.

ISBN 978-0-06-220694-7

13 14 15 16 17 OV/RRD 10 9 8 7 6 5 4 3 2 1

Acknowledgments

Hopper is a rebel biography. The story was out there, the road beckoned, and the people who populated his world were ready to share their memories. The book world tried many times to have Hopper commit his life to the page, but in his improbable, twisted journey into the American dream, his chase for meaning in madness, he could never stay long enough in one place to write it down. It's been a long, strange road, one that brings to mind Hollywood's famous line "We're not in Kansas anymore." For Hopper it was always about the ride.

In a time of tell-all celebrity accounts, which make tabloids like the *National Enquirer* look like pop art, I knew I had to go deeper to tell a story Hopper would have wanted for himself. Dennis was a picaresque character who packed the literary punch of a

modern-day Don Quixote. As *Rebel Without a Cause* screenwriter Stewart Stern put it, "Like Jimmy Dean, Dennis was one of these incredible visitors." Stern always believed a movie should have been made about the boy from Kansas who dreamed of going to where the movies were made.

In his lifetime, Dennis wore many hats and spun many myths— be forewarned that the terrain is treacherous, but only the most interesting roads have been taken.

Hollywood and the people in Hopper's life want his story told. As producer Danny Selznick, son of the legendary David O. Selznick, said, "I knew that someone needed to do his story." Fascinated by the sheer breadth of his adventure, I didn't ask anyone's permission. I simply embarked on the journey.

I want to thank those who were generous with their time and helped to navigate through each stage of Hopper's life. They were willing to veer off the well-trodden path and pave the way to more interviews and connections. Thank you to friends and family, rebels and riders, lovers and foes alike. In particular, Peter Fonda, Dean Stockwell, David Lynch, Robert Walker Jr., Stewart Stern, Don Murray, Boyd Elder, Paul Lewis, Todd Colombo, Michael Gruskoff, Tomas Milian, Danny Selznick, Rol Murrow, Larry Schiller, Toni Basil, Karen Black, Les Blank, Peter Pilafian, Henry Jaglom, Philippe Mora, Frederick Forrest, Mary Ellen Mark, Stefani Kong Uhler, Don Gordon, Linda Manz, Robert Duvall, Dennis Fanning, Ice-T, Robert Solo, Haskell Wexler, Harry Dean Stanton, David Anspaugh, Alex Cox, Gary Ebbins, and John Lurie. Thank you James Rosenquist, Irving Blum, Larry Bell, Chuck Arnoldi, Doug Christmas, Laddie John Dill, Kenny Scharf, and all of Hopper's art world buddies. Also Peter Coyote, Taylor Mead, Rick Klein, and Arty Kopecky for leading me further into the sixties and the commune scene. Lost years in Taos were regained thanks to Ron Cooper, Lisa Law, Peter Mackaness, Paul Martinez, Desiree Romero, and Bill Whaley. Dodge City came to

life once more with Ruth Baker, Leonard Fowler, and Don Steele. Thank you also Victoria Duffy, Katherine LaNasa, Bill Dyer, Peter Alexander, Peter Biskind, Robert Dean, Jallo Faber, Douglas Kirkland, Christopher Knight, Kat Kramer, Kat's mother, Randy Ostrow, Jamie Sheridan, Michael Knight and the Wurlitzer Foundation in Taos, Cherie Burns, Doug Coffin at the World Headquarters in New Mexico, Kevin Cannon, R. C. Israel, Ouray Meyers, Julia Bortz Pyatt, Lynn Robinson, Don Michael Sampson, Sakti Rinek, Jack Smith, the D. H. Lawrence Ranch, Stephen Bender, Jorge Hinojosa, Logan Sparks, Mark Seliger, and Dave Weiner.

Thank you to Jim Fitzgerald, Hopper's longtime literary agent who has been trying to do this book for decades, my agent Zoë Pagnamenta, her assistant Sarah Levitt, and the team at Harper-Collins: Carrie Thornton, Cal Morgan, Brittany Hamblin, Kevin Callahan, Gregory Henry, Michael Barrs, and Renato Stanisic. I want to express my deepest gratitude to my friends and family, and my wife, Lily.

For Dean

**He's a walkin' contradiction,
partly truth and partly fiction.**

—"The Pilgrim: Chapter 33," Kris Kristofferson

Contents

1

The sun hung like a flaming sword above the high desert of Taos. In the hours to come, it would paint the folds of the craggy Sangre de Cristo Mountains blood red, setting them afire in the name of the Redeemer. Now it dropped unforgivingly over this dry and dusty land in northern New Mexico, beating down on the scraggly burial ground about to crack open in the heat. No breeze stirred the batches of plastic flowers sprouting up from the rocks piled in heaps on the graves. The stones weighed down the multitude. Impatient for the apocalypse, and thirsty for a drop, the restless souls prepared for the arrival of another.

Then, to the furious roar of a host of engines, screaming as if stoked by hellfire, out from the valley of death shot a customized Harley-Davidson, blazing chrome with red flames flickering on the orange teardrop gas tank. The angry buzzing wasp flew straight for the blinding light.

Dennis Hopper smiled as the wind flapped the fringes of his buckskin jacket. Dressed in filthy breeches with a floppy cowboy hat looped around his neck, he dug in his well-worn boots and spiraled up like a cyclone. No earthly force could shake him from his steed, hot between his legs. He'd hung on to a speeding train

going from Dodge City to Hollywood as a boy, only to race faster than the speed of light up a washboard dirt road to the heights of Monument Valley. After a brief detour to sniff it all in under the frilly, upraised skirt of New Orleans, that Mardi Gras queen, he was back in the saddle, hungrily devouring blacktop at 108 miles an hour, going flat out on a wide-open red-tinted stretch of highway. This time he'd make it for sure.

Riding higher and higher, Hopper tore through the cosmos fast and loud, the deafening boom of his chopper ripping the fabric of space and time. He followed the glittering stars winking at him in the firmament. Guiding him was James Dean, still burning bright, and in his own orbit, a twinkling Andy Warhol. There was supergiant John Wayne, a massive star even brighter than a giant, despite being very cool. Out yonder flashed Elvis, trailed by the distant glimmer of boy-genius Orson Welles. Hopper gave it some gas.

He was getting closer now, for ahead in the distance loomed a snowcapped bluish mountain as big as his imagination. A hairpin turn on a treacherous rocky path—littered with the ancient ruins of a forgotten civilization—revealed a hidden plateau, damp and lush and glowing viridescent in the hallucinatory light that when filtered through the thin alpine air illuminated everything in Technicolor. An endless field of beaming yellow flowers lit the last stretch.

Like a lost city of the Incas, a fake Wild West town emerged in the mountain mist. Fake cowboys roamed freely here in their tengallon hats. Strapped with shiny six-guns loaded with blanks, they jangled past the facades of a fake telegraph office, a fake gunsmith, a fake Longhorn Saloon. A fake steeple rose over the centuries-old Spanish plaza that was guarded by the golden statue of a conquistador standing square in the dust, waiting for wild dogs to piss on him in the moonlight. In scrawled chalk lettering, the weathered sign of the fake white church quoted the Gnostic Gospel:

Show Me the Stones the Builders Have Rejected for They Are the Cornerstones

Outlaws and misfits were welcome.

Planting his boots in this strange, fantastical world of his own creation, the road-weary traveler took it all in. At last he'd reached his peculiar American Dream, tailor-made to fit his nervy frame.

"Oh man," cried Hopper. "It's all *real*." And it was only just the beginning.

PART 1

The Yellow Brick Rubber Road

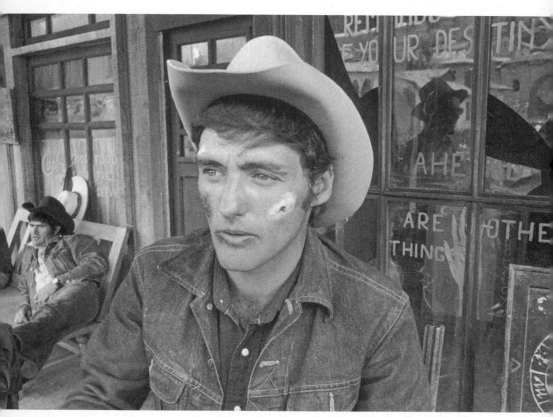

Jimmy's Place portrait taken by Cecil Beaton on the set of
The Last Movie, *Peru, 1970*

KANSAS

Dennis Hopper lit up a cigarette in the rich Peruvian night. Clean-cut and wiry with more than a hint of disrepute, this handsome gentleman wore a Stetson hat as he barreled down the far side of the acid-green Andes, deftly maneuvering the plummeting hairpin turns in his muddy red Ford pickup truck. Emblazoned on the side was his personal slogan: KANSAS—HOLLYWOOD, CALIF. BROKEN BONES BUT RARIN' TO GO! Sitting shotgun, a journalist from *Life* was hungry for the inside scoop for a major cover story about what this wild-eyed actor—suddenly known around the globe as the chopper-riding, hell-raising LSD freak behind the phenomenally successful *Easy Rider*—was doing in a remote corner of the world, coked up like a maniac and surrounded by a pack of psychedelic cowboys who considered him a genius, or some sort of messiah.

At the beatific age of thirty-three, Hopper had built on the mountain—as if to ring in the new decade of the seventies—a curious world of which only he seemed to know the true meaning. It lay fourteen thousand feet above sea level in the ancient village of Chincheros, which was populated by native Quechua Indians who had little clue as to what was going on in his head. Centuries

before, they'd been overrun by conquistadors. Now came Hopper, transforming their village practically overnight into a Wild West frontier town. He had herds of horses and saddles hauled up the mountain. He flew in burly men to be dressed in a variety of cowboy getups. He dragged B Western movie sets up the mountain path, including a sort of spiritualist temple called Jimmy's Place with the saying REMINDS YOU OF YOUR DESTINY painted on the window. So what the devil did it mean?

The journalist held on for dear life as Hopper launched into his story, a strange and twisted tale full of superhero highs and decadent lows. It all began rather innocently in Dodge City, Kansas, just around the time the Dust Bowl was settling down. Back in its rip-roaring heyday, dime-store books around the globe branded Dodge City, "the Wickedest City in America," the end of the trail for herds of cowboys ready to raise hell after bringing longhorn cattle from Texas—and trouble to boot. It took the quickest guns in the West to keep the peace, including the legendary heroes of the gunfight at the O.K. Corral in Tombstone, Arizona—Wyatt Earp and his tubercular sidekick, Doc Holliday.

What the law didn't chase off, the dust certainly did by the time Hopper's tale began.

On a bright Saturday morning in April 1939, the old cowtown proudly dragged out its boots and did its best to look its wildest worst. The junior chamber of commerce had issued a bulletin stating "Keep Your Whiskers" and offered a two-hundred-dollar prize for the best beard, one that harkened back to those woolly days of old Dodge. Everybody came out for the big day, including the Hopper family. Barely three years old, Dennis watched in amazement the shaggy wild men draped in buffalo skins, looming over dapper dudes in handlebar mustaches. They all took their places like extras outside the railway station alongside a cast of tens of thousands from across the country, desperate for a bit of color after years of suffering under the sun-blotted blackness of the dust storms. The seconds

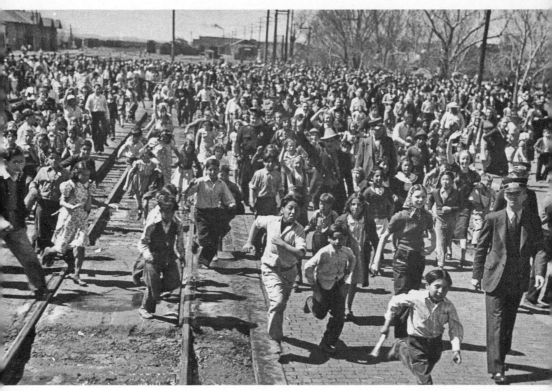

Dodge City *premiere, Kansas, 1939*

ticked toward the arrival of the actors. The town would ever afterward remember the premiere of *Dodge City* the movie as the biggest thing to happen to Dodge, shadowing even its storied past.

Shortly after ten o'clock, thirty barnstormers from the Wichita Aeronautic Society ripped through the skies. The band struck up "Oh! Susanna" as the steel-blue Warner Bros. Special chugged in on the tracks of the Santa Fe Railroad. Out from the extravagant seventeen-car train, which included eight luxury Pullmans, stepped a curiosity cabinet of Hollywood's most wanted, like Humphrey Bogart, and some unwanted, like the exotic Lya Lys, who sucked the alabaster toe of a Venus statue in the surrealist film masterpiece *L'Age d'Or*. The punch-drunk former light heavyweight champion of the world, "Slapsie Maxie" Rosenbloom, stumbled out of the baggage

car gussied up to look like the Lady Gay Saloon, the infamous watering hole of the "bibulous Babylon of the Western frontier," as Dodge City was known before it turned dry as a bone. A collection of B-movie sharpshooters burst forth into the light, Hoot Gibson and Buck Jones in his white ten-gallon hat. Buck's trusty horse, Silver, pranced out of the animal car. Murmurs passed between mother and grandmother. Would he really come all the way from California to see them?

At last, the star with the slick, pencil-thin mustache appeared on the platform to the roar of his fans.

"I remember Errol Flynn came to Dodge City," said Hopper, telling a story he would repeat to friends and journalists throughout his life. "That was big time."

Starring in Hopper's earliest memory, the swashbuckling Hollywood libertine flashed a blazing smile to the throngs of young girls flushed with excitement, waving like crazy from the sidelines clamoring for his attention, and held back only by the efforts of six companies of National Guardsmen. One day when Dennis was all grown up, he, too, might roll through town in a fringed buckskin jacket, high on his steed.

Straddling a white horse strapped with a $25,000 hand-tooled black-and-silver saddle commissioned by the Santa Fe Railroad, Errol Flynn led the parade, trailed by a procession of covered wagons, twenty-five corn-fed children on Shetland ponies, unicyclists in derby hats, and dignitaries—including three governors, Franklin D. Roosevelt Jr., and the newly crowned cowgirl queen, Miss Mary Jean Frankenberger, a freshman at Dodge City's junior college. Miss Mary had her white boots on.

West of Chicago

THERE WAS NO LAW!
West of Dodge City
THERE WAS NO GOD!

At the Dodge Theater, the town's ornate movie palace lit up by marquee lightbulbs, *Dodge City* depicted the coming of the Santa Fe Railroad to the frontier outpost, setting the stage for hordes of bad guys just itching to be shot down by Errol Flynn playing the lone cowboy. All night at the Dodge, grinding out shows till dawn, the trailblazing hero rode into the sunset again and again with his girl on shotgun, rosy Olivia de Havilland. By sundown, having triumphantly resurrected the long-lost glory days of Dodge, the real Errol Flynn chugged out of the station with the key to the city in hand; going with him were Hoot and Buck, and even trusty Silver, riding off in the animal car.

"And anyway, they came there," said Hopper of those movie cowboys, offering a hint as to why he turned out the way he did. "That probably had a lot to do with me eventually wanting to be an actor, I think."

Not a single cowboy could be found roaming the lone dusty streets come Monday morning as life resumed in Dodge City, pop. 9,000—just yesterday brimming with ten-gallon hats, now emptied out like an abandoned movie set. Brandishing his silver cap pistols, little Dennis played shoot-'em-up against the older boy who lived across the street from his grandpa Hopper. One of them had to be Indian; one of them had to be cowboy. Looking back to his trike-riding hell-raiser playmate with a pint-size straw hat, Leonard Fowler remembered, "Dennis wanted to be cowboy most of the time."

/ / /

"Like, when I was little, I lived on a farm near Dodge City, Kansas," continued Hopper in his peculiar high-pitched twang, roaring down the mountain and jumping ahead in his tale for the *Life* journalist. "Wheat fields all around, as far as you could see. No neighbors, no other kids. Just a train that came through once a day."

A farm-raised runt, he would lie in a ditch at his grandparents' as the wind rustled and the Kansas sky loomed before him. By his side was his trusty dog with a spot around his eye. The tracks of the Santa Fe Railroad split the weathered farmhouse from the wheat fields spreading west as far as he could see. Chugging furiously, the train roared past, leaving nothing else for Dennis to do but pick himself out of the ditch and poke around the dirt with a stick. Filling his lonely world with collections of butterflies and stamps from faraway places—"Occasionally I cleaned out the chicken house. I watched, more than anything else"—he spent most of his hours wondering where the train came from and went. Where had the train taken all those cowboys?

The confusing question had yet to be answered as Nellie tucked her grandson into bed. Lightning bugs faded away in a Mason jar as off in the distance, storms flashed like blue veins on a giant's temple.

Dennis had come to live at the egg ranch shortly before his sixth birthday, after World War II blew in like a mean sou'wester and swept his father away from Dodge. With his mother busy "at the pool," the family would say without much further comment, Nellie took him in. Fixing lunch in a white clapboard farmhouse like Auntie Em's in *The Wizard of Oz*, she kept an eye out as Dennis roamed the alfalfa patch on a Shetland pony given to him by his grandpa. Lonnie even brought him home a sheepdog from the Clutter family, doomed to be brutally murdered by drifters, as depicted in Truman Capote's *In Cold Blood*. Hard at work in his bib overalls on a wheat field out in Garden City, some sixty miles away, Lonnie left Nellie to raise Dennis and his baby brother, David, along with tending to the coop. The family thought it was too much for the old woman, but Nellie came from rugged stock.

Long ago, one Mattie Mac Masters McInteer bumped along in a covered wagon to Kansas. Reading her Bible every Sunday, she prayed her daughter might witness more than hardship. She even

named her after the famous globe-trotting newspaper girl, Nellie Bly, who beat the record set in Jules Verne's *Around the World in Eighty Days*. Little Nellie Bly McInteer didn't see alligators in Port Said or lush tennis courts in Hong Kong, but she did grow up to see the grasshopper plague. And the jackrabbit invasion that forced the townspeople to go on roundups—pounding out the rampant bunny problem with clubs so as not to waste bullets. And the Black Blizzard of '35 when the apocalyptic face of Jesus Christ appeared in a dust cloud over the baseball diamond like the Second Coming.

Yes, Nellie managed to see a few things through twenty-mile-an-hour winds that sucked dust from the rutted fields and pummeled the egg ranch. It seemed the sun might never shine again, but when it finally did, the dull gray light revealed a weathered old farmhouse with no color at all.

Then one May day in 1936, screaming in the distance, the Super Chief roared past, splashing its brilliant warbonnet colors of red and yellow onto the egg ranch. Tearing through the Southwest touching speeds of 108 miles an hour, going faster than any train before, the brand-new transcontinental flyer continued its inaugural journey to the Pacific. This Train of the Stars, as the honchos at the Santa Fe Railroad dubbed it, catered to Hollywood big shots ready to discover the next big thing. The egg ranch was just another blip on their juggernaut journey, but one day those big shots would be staring at Dennis, who knew nothing of what went on inside their luxurious sleeper cars named Taos and nothing of their dirty dealings on the Navajo rugs with those aspiring Errol Flynns. But the boy was destined for greatness. Nothing could keep him from lying in the ditch with his dog, waiting for the train. Nellie was so poor she had to make his shirts out of gingham chicken-feed sacks, but she gathered eggs from the coop so they'd have money to go to the movies.

///

In singing-cowboy Saturday matinees at the Dodge Theater, Gene Autry yodeled to the delight of the grannies, making them swoon. Against the backdrop murals of powder-blue sky and fake cacti, Autry shot it out with six-guns for the motherless little dogie hooting in the balcony with a sack of chocolates from Duckwalls, the five-and-dime. Opening on *The Singing Vagabond*, *Guns and Guitars*, and *Public Cowboy No. 1*, the red-velvet curtain swooshed close on the promise of unending adventure with the hero riding off on Champion, his horse, followed by his pardner, Frog, with the floppy hat. Entranced by the light that projected the movies, piercing the dust and darkness, Dennis had the strangest thought a boy ever had—and it led him to the heights of fame, and the most debauched states.

"I was about five," said Hopper to the journalist as he careened down a precarious stretch of Peruvian track. "My grandmother put some eggs in her apron and we walked five miles to town and she sold the eggs and took me to my first movie. And right away it hit me. The places I was seeing on the screen were the places the train came from and went to. The world on the screen was the real world, and I felt as if my heart would explode I wanted so much to be a part of it."

Holding on for dear life, the journalist took note. It was hard to pin down what all this madness on the mountain actually meant to Hopper, but it seemed to be the ultimate incarnation of his lifelong pursuit of the American Dream. It wasn't the Horatio Alger up-by-the-bootstraps variety they tried to teach him at stinkin' Lincoln Elementary. It was something far more fantastic he'd been chasing like the ragged tail of a shooting star, ever since he was a little boy on a twelve-acre egg ranch across from the railroad tracks. He'd go far and wide to find it even if it took him to the farthest reaches of the Peruvian Andes.

Unveiled to America on the cover of *Life* in 1970, Dennis Hopper smiled in a black cowboy hat, wearing a bolo tie and a

shit-eating grin, holding a football in the crook of his arm and twirling a dandelion. The ensuing pages told of a raving madman riding around his private, drug-crazed world in darkest Peru, a world that included "whipping parties" and one inexplicable instance of a woman chained to a porch post Joan of Arc fashion with fire crackling at her feet. The whole tale seemed completely too insane for readers to zero in on a single nostalgic childhood detail. But one Ruth Baker, still in Dodge City long after her famous second cousin flew the coop, was quick to point out the crack.

"Well, Nellie sold eggs," clarified cousin Ruth. "But the story about her bringing them in an apron to walk to Dodge, that's not true. That wasn't Aunt Nellie. She'd do lots of things but she'd never bring eggs in an apron to Dodge. That's quite a walk."

Perhaps Dennis had appropriated for himself the opening scene from *The Wizard of Oz* when, after the three roars of MGM's Leo the Lion, Auntie Em fills her apron with eggs in a sepia-toned Kansas. At some point it ceased to matter whether it was a real memory or a movie memory. Hopper probably couldn't tell the difference anymore as he looked back with a head full of visions paid for by golden eggs.

Aiming the weapon of choice of his favorite cowboy, Red Ryder as played by Wild Bill Elliott—"He didn't sing and dress in all that glittery stuff," said Hopper, "he was just a cowboy"—the little dude fired BBs at the black-clad desperadoes lurking in the wheat fields. Lying in wait for the train and staring above those fields, Dennis no longer saw the blank screen of a Kansas sky. Instead he projected a panorama of Technicolor mountains—the kind they put in *King of Dodge City* or *Vigilantes of Dodge City*, which really are nowhere to be found in the town's flat reality. He desperately wanted go to this fantastical land of the movies, bursting with singing cowboys beckoning him to adventure, but unlike the twister to Oz, the Super Chief left him in the ditch with his dog on its way to his American Dream.

THE POOL

The summer the *Dodge City* premiere blew into town, Dennis's mother was itching for a change. Marjorie began to teach swimming to the local kids, and per an exclusive contract with the city was promoted to pool manager, a move the *Dodge City Daily Globe* reviewed as "popularly received by patrons of the pool." Riding shotgun, her husband Jay Hopper worked at Busley's, the local grocery, collecting nickels for ice-cold Coca-Cola in the cooler, the sign instructing, "Serve Yourself. Please Pay the Clerk." Stacking jumbo cans pasted with bold labels for Tendersweet Sweet Corn, Hand-packed Tomatoes, and Bar-B-Q Prunes, Jay proved himself a valuable addition to the Busley Bros., just as his father, J.C., was a well-oiled cog for Western Light and Telephone.

As Dodge's meterman, making his rounds on the small-town grid, old J.C. would never think about going off in his pickup truck until his job was done. The Good Samaritan made it home every night for dinner with his wife, a noble grand of the Rebekah Lodge, who led the local ladies in the path of righteous women from the Bible. Bertie Bell found it a blessing that their son had inherited J.C.'s mild, even temperament, Jay's one flourish being a taste for loud neckties.

The girls of Dodge City Senior High thought Jay was a jewel of a guy, handsome behind the counter in his spotless white grocery apron, dark and stormy in his *Sou'Wester* yearbook portrait. In less charitable moments, the girls wondered how Marjorie Mae Davis ever landed him in the first place.

"I would say perfect," said one of Jay's admirers, pondering the mystery. "He was a perfect man. Why would he marry her? She wasn't real pretty. She was just an ordinary person."

The girls were just jealous. A cheerleader on student council, staff on the school newspaper the *Dodger*, and a performer in the minstrel show providing blackface entertainment for lily-white Dodge, the fiery farm girl screeched in from the egg ranch and sucked the class of '35 for all it was worth. A history buff with an interest in heritage that eventually led to her becoming president of her genealogical society, Marjorie was bred to blaze trails like one of her great-grandmothers, the very sister of Daniel Boone. If only she hadn't married the summer after graduation and immediately gotten pregnant.

Lying flat on her back in the maternity ward of St. Anthony's, Marjorie considered Virginia's favorite son with his leonine white beard and immaculate gray uniform. She just *felt* somehow that Robert E. Lee was related to her newborn. Perhaps the Confederate general's spirit would lead her little bundle, Dennis Lee Hopper, to rebel against the dull tyranny of his father.

/ / /

"With our country engaged in war," declared the U.S. Postmaster General, "it is imperative that prompt, efficient, uninterrupted postal service be maintained."

Receiving orders to report to Kansas City, Missouri, for two years of duty as a subrailway postal clerk, Jay was off to deliver mail for his country. Riding back and forth along the same flat stretch of

track between Newton, Kansas, and La Junta, Colorado, he sorted the letters on the westbound No. 7, and about 150 miles into his day whizzed past his in-laws' farm where young Dennis looked out for the train while his mother ran the pool.

Luxuriating in the town's glamorous leading lady role, Dennis's mommy gave a critically acclaimed performance. Dark from baking out in the sun all day in a dazzling one-piece that accentuated her swim-toned, honey-brown thighs and a glistening set of butterfly shoulders, Marjorie put on the best show in Dodge. Exhausted by the time she closed up for the evening, she slept in town while Jay slept in Newton, their Dennis safely tucked away at her parents'.

After riding the rails for a year, Jay was able to squeeze in a midroute quickie, getting off at Dodge to spend three hours a day with his wife, barely enough time to get her pregnant again. Depending on how Marjorie looked at it on a particular afternoon, her lot was better than that of the girls with husbands off in Europe, battling Nazis with submachine guns instead of flaccid mail sacks.

/ / /

Keeping a cool watch from behind dark sunglasses, Marjorie starred in her fifth season as Dodge City's pool mistress. Turning twenty-eight at the pool, she got ever closer to that day when she'd appear formless and gray in the mirror like her mother, whom the family treated like a saint for taking care of the boys, frustrating Marjorie so much that she screamed, "I don't want to hear it!" Another day, Marjorie told Nellie, her own mother, "Go to your room!" It was a nightmare.

The family gossiped about Marjorie's endless summer, a sticky morass stretching over five long years. What reason could Marjorie

possibly have for abandoning her two boys while she played at the pool? It was terrible how she let her mother take her kids along with all the laundry, all the cooking.

"Nellie raised those boys," Nellie's brother would say. "Marjorie would rather be in the swimming pool than messing with her little kids."

Boiling in the heat that once brought Bleeding Kansas to the point of slave revolts and killing sprees, the pool mistress watched from her white wooden perch, embalmed from her high school days with her taut brown body and the burn of Daniel Boone's blood in her veins.

Back in winter, Jay had called long-distance from Miami to wish the family Merry Christmas and inform them that he was off to fight in the Asiatic theater of operations. He'd enlisted for the army at Fort Leavenworth and looked handsome in his uniform.

Marjorie was all alone now, and Dodge was just so hot in the summer, the only escape was going to the movies or jumping into the pool.

The kids she once coaxed to climb the rungs of the high dive and plunge into manhood were now emerging from behind the shower wall. Old enough to go beat each other up at the drive-in hamburger joint after football games, then hop into gas-guzzling deathtraps and race blind drunk—a pack of hell-raising delinquents.

Dennis was looking more and more like his father from *The Sou'Wester*, staring back at her with his slicked-back hair and chiseled-face, leading-man looks. He almost seemed lost to Marjorie, loving Nellie like his mother, but what could she possibly do to make him love his real mommy again as he had when he was a baby? Marjorie knew something that might make a difference. Sometimes in bloody Kansas, the only thing to do was sweat and rot or do something crazy. She told her Dennis that his father had been killed in the war.

The True Travels, Adventures & Observations of Wild Man DENNIS HOPPER & His Encounter with the Pool Mistress

Ready to prove himself worthy of the war-ravaged widow in an act of bravery witnessed by practically the whole town, the little cowboy climbed the rungs of the ladder up to the high dive, walking the plank until his toes were curled around its springy edge. Practically naked in his swim trunks as the harsh glint of reality reflected off the water, he sniffed in chlorine and the collective nerve of his classmates at stinkin' Lincoln Elementary—of men who had taken the plunge and boys too weak to jump.

The corn-fed jocks who liked to pound on each other stared up at the scaredy-cat kid clogging the pipeline to cannonball glory. Marjorie called from below. She told Dennis if he wasn't going to be a big boy and jump, he'd just have to stay there all day until she shut down.

So began the showdown in Dodge City between the little chickie and the pool mistress—like the time Wild Bill Elliott duked it out with the knife fighter in *Cheyenne Wildcat*. It lasted till Marjorie finally closed up, leaving her hysterical Dennis to climb down the rungs of the ladder at sundown.

[The cameo was completely wrong for the picture. Cut to Christmas 1945. Like the ghost Dennis had read about in *Hamlet*, Dennis's father suddenly reappeared in Dodge City.] Jay wasn't back from the dead but rather Manchuria, where the postman had been serving as a medic in the OSS, America's clandestine spy organization. The curtain closed on this chapter of Dennis's life, and he would never understand exactly why his mother had told him his father was dead.

CALIFORNIA

The latest in a line of prospectors and fortune seekers drawn to California, American dreamers came back from the war and flocked to the land of extravagant idiocy, where Walt Disney slapped mouse ears and a happy ending on everything. Dreamers needed their mail delivered, too, and the Hoppers followed, with Jay reporting for duty as the new postman of La Mesa, outside of San Diego. Dennis would finally get to go where the train went.

He was around twelve or thirteen (some three years after losing and oddly regaining a father), and along the way noticed the Rockies weren't anywhere near as grand as the enormous blue-violet movie mountains looming in his head. And weren't bandits supposed to jump aboard as the family blazed through the painted land of Arizona? There wasn't even a Comanche chasing in hot pursuit. When the Hoppers finally did make it to the frontier's end, Buck Jones didn't greet them in a ten-gallon hat. No Wild West Parade either, just a concrete freeway zooming toward a blue version of the golden ocean that stretched beyond the egg ranch.

"Wow, what a bring-down," Hopper would say of his long-awaited moment. "The Pacific was the horizon line—in my wheat field."

Cowboys didn't ride past his new home in Lemon Grove with the citrus groves paved over to make way for the dreamers, where the new pool mistress of El Cajon screamed at the new postman of La Mesa. Miserable in his reality, Dennis ran away from home. Seeing as his milk money was barely enough to hightail it to Tijuana, he wouldn't have gotten far in his escape had it not been for the good fortune of finding the Old Globe Theatre in San Diego's Balboa Park.

"Hark ye gentles, hark ye all, time has come for curtain call!" Dennis cried as he ran up the aisle, clanging the bell to start the show.

In this authentic replica of the Elizabethan playhouse, lying among eucalyptus trees and peacocks strutting in the bamboo brake, Dennis found himself dressed in the rags of a Victorian beggar boy in the Globe's 1949 holiday pageant, *A Christmas Carol*. Playing a ragamuffin asking for alms, shoved offstage by the magistrate as the play opened, he settled in backstage, finding a home in the little world of actors in greasepaint. Dazzled, he waited patiently backstage until, on cue, he ran out and snatched a turkey from a redeemed Scrooge. Hearts melted; those beaming, blue-haired grannies would've shit in their hats if they knew what the kid was really thinking. He simply *hated* his dear mother, the scheming liar sitting among them in the audience. Up there onstage, Hopper swore he would show her. He was going to outdo her. He was going to be an *actor*.

/ / /

A voracious student of his craft, teenage Dennis cast away his prescribed English class reading at Helix High, made up of "About 5% Brains, About 36% Dolls, About 31% Guys, About 18% Screwheads, About 10% Deadheads," according to the *Tartan* yearbook. Diving into a tome of his own choosing, *Minutes of the Last Meeting*,

he pored over this boozy account of a cadre of Hollywood bohemians who boldly drank their way into oblivion in the service of art. Here in the pages lived the finest Shakespearean actor in Southern California, John Barrymore, who drank in life until his liver turned black.

Boldly sucking in a drag of his cigarette, the great Hopper thrust himself onto the world's stage.

In pomaded hair and a too-big gray suit, he played the oily villain in the drama club production of *Charley's Aunt* but, preferring serious fare to such hammy Victorian-era farce, also wrestled down *The Hairy Ape.* He howled in speech club as Eugene O'Neill's filthy brute who haunts decent society. While the deadheads and screwheads squeaked out soliloquies from *The Glass Menagerie* for the upcoming National Forensic League high school dramatic declamation contest, Hopper ambitiously took on the toughest role of them all, the indecisive Hamlet.

At fifteen he was a master of the hambone acting style then at its apex with Sir Laurence Olivier donning a fleshy nose, dandy's wig, and villainous eyebrows as wretched King Richard III. Or Orson Welles, masked in blackface for his film version of *Othello.* Enraptured by his hammy heroes—the great rival fakes of their age—Hopper was on the path to greasepaint glory, but the stars intervened and changed his course.

In one fateful week, Hopper sat glued to a death match playing in theaters across America. In *A Place in the Sun*, delicate Montgomery Clift did his haunting shuffle to the electric chair and, in spite of the sets and makeup and all other things that screamed fake in the movies, somehow managed to be *real.* In the other corner, brawny Marlon Brando slouched in a sombrero and thick mustache as Mexico's Tiger on a White Horse, Emiliano Zapata, the revolutionary martyr of *Viva Zapata!*

To be or not to be? Would Hopper continue on the path toward the grandiloquent Shakespeareans, last of a fast-dying breed? Or

would he dive into dark, unexplored territory? Daring him to leap into the unknown was Kipling's checklist of manhood, "If," ingrained in his brain from his declamation contests.

IF YOU CAN MAKE ONE HEAP OF ALL YOUR WINNINGS
AND RISK IT ON ONE TURN OF PITCH-AND-TOSS,
AND LOSE, AND START AGAIN AT YOUR BEGINNINGS
AND NEVER BREATHE A WORD ABOUT YOUR LOSS

"There was something real happening," said Hopper. "I didn't really know what it was but I knew it was fantastic and marvelous and that I had to find that thing."

That summer, sixteen-year-old Hopper took off to apprentice at the Pasadena Playhouse. Kicking off its season of star-spangled Americana, *Valley Forge*, "a tale of living suffering," was drenched in the sort of misery all the rage with serious theatergoers. Onstage, wearing a powder-white wig, burly Canadian actor Raymond Burr faced the horrors of that awful winter as General George Washington. Hopper was so thrilled, he forgot about his own grinding poverty, a harrowing condition shared with his sprightly pal from the Helix drama club. Bill Dyer scooped flavor after flavor in a nearby ice-cream parlor, while Dennis flipped burgers at the Playhouse Café. The two were so desperate, they broke into Bill's aunt's home in Pasadena, busting the lock on the flimsy back door and bursting in to raid her fridge.

"My God," said Bill. "We're breaking and entering, we're so hungry!"

Excited to hit the skids and hot to reach the brooding dramatic lows of his new heroes, Hopper skulked into the Pasadena Playhouse Laboratory Theatre, showcasing unknown plays and lesser-known actors. He shone in his role as the juvenile lead in *Doomsday*.

Set in a bomb-ridden, war-torn Poland suffering under a crazed dictator named Hitlin, an amalgam of Hitler and Stalin, this dirge of horrors ended with the merciful drop of the curtain. Exiting to scattered applause and emerging into the light of balmy Pasadena, Hopper slunk back to the screwheads.

"High school was hell," said Hopper, yet he was always smiling in the pages of his *Tartan*.

/ / /

The La Jolla Playhouse was the dream of a group of Hollywood actors who brought the split-level farmhouse tradition of rustic New England summer stock to the earthly paradise of the ritzy seaside. The Pacific's flat blue horizon looked a lot more interesting with starlets lounging wistfully in bathing suits, learning their lines on the rocks against dramatically crashing waves. Managing the Playhouse was jet-setting *Life* photographer John Swope, who had just shot the magazine's cover of Brando in a toga.

At the rosy stucco Valencia Hotel, the Pink Lady of La Jolla, seventeen-year-old Dennis couldn't keep his eyes off Swope's wife, a sweltering older brunette lounging poolside in her movie-star sunglasses. To the world she was everymother, from the honorable poverty-stricken woman of *A Tree Grows in Brooklyn* to the homely maid stuck in *The Enchanted Cottage*. To Hopper she would always be Sally Bowles, the flighty American who lavishly sleeps her way across Europe in *I Am a Camera*, the snapshot of Weimar hedonism opening the Playhouse season.

Dennis fell into "worshipful passion" for this lovely movie star Dorothy McGuire, doing all the things as his Sally Bowles that Dodge City missed out on. Wide-eyed and hormonally raging, he hung on to the curtain pulley as if it would hoist him to the moon. All the while fluttering onstage in a billowy skirt and a tight black strappy top accentuating her terrific shoulders, something

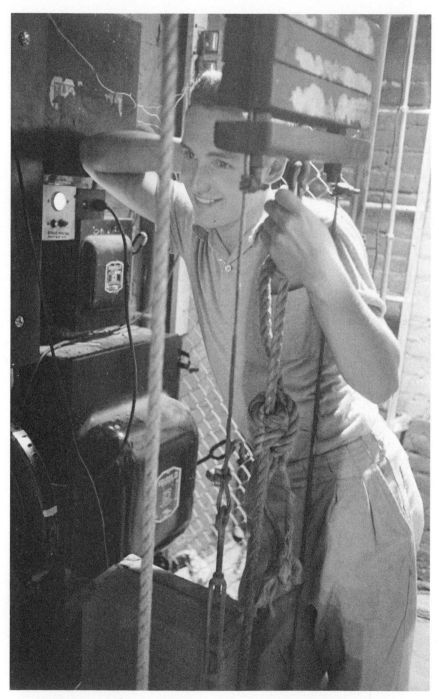

Apprenticing at La Jolla Playhouse, age seventeen, 1953

like those of his mother—though somehow Dorothy looked *better*, without the pinched face—she didn't scold but instead offered sexy unconditional love to the struggling young artist in an intoxicating blend that was part mother, part—

Hopper was so starry-eyed that he missed his cue to bring the curtain down. Banned from pulling it for the rest of the season, he cleaned the dressing rooms of visiting stars like a stable boy.

"What a glamorous job that was," said Hopper. "I'm very serious. It was a glamorous job. Seriously it was. I mean, there were all these movie stars; I'd never seen a movie star before in my life. I was actually cleaning their toilets!"

And not just any toilet but Olivia de Havilland's toilet! She rode into the La Jolla Playhouse to star in the season finale, *The Dazzling Hour*. Dennis's bathroom fantasy had come true, the fantastic women of his youth converging in one breezy dream summer.

Returning to Helix to star in his senior play, *Harvey*, he shone as the man whose only friend is a six-foot imaginary rabbit. Hopper was voted most likely to succeed, class of '54. He performed all summer at the San Diego National Shakespeare Festival and, donning his doublet as Lorenzo in *The Merchant of Venice* at the Old Globe, projected the ballad of his undying love to the brunette maiden beaming at him from the audience. He had invited Dorothy to come to the show and she came!

"Fair ladies," spoke Hopper in tights, "you drop manna in the way of starved people."

Soon to play the kindly frontier marm in *Old Yeller*, Dorothy offered her discovery some oh-so-arousing words of encouragement after the performance. Better yet, her husband promised a letter of recommendation to a big-shot TV casting director. Along with his two-hundred-dollar Old Globe scholarship, Dennis had everything he needed to get the hell out of Lemon Grove for good.

"When you run out of your two hundred dollars," huffed Marjorie, "call us and we'll come get you."

HOLLYWOOD

Clanking alongside a glittery streak of hot rods cruising Sunset Strip, eighteen-year-old Hopper checked his pockets when he and his pal from drama club, Bill Dyer, decided to pool money for a hamburger. Two cents. That's all he had. Rolling down the window, Dennis threw out the last pennies from his two-hundred-dollar scholarship and burst out laughing. What else could he do? Struggling to make it as a lounge singer, Bill had just enough gas in his beat-up Chevy to drive his roommate through the gates of Hal Roach Studios, known as "The Lot of Fun" from its days of cranking out Laurel and Hardy films.

It had taken Hopper some time to finally connect with the bigshot casting director within, a tough bird named Ruth Burch. She sized up new meat with the professional eye of a butcher and got a whiff of the overeager odor of success. This kid looked like a real pretty boy. A little guy, not much taller than five feet eight. But he had those blue eyes—crazy, yet sweet. And that big bobble head (the stars always had big heads), only what was with the *grandiosity*? Did the kid think he was Laurence Olivier?

Telling Hopper he was too cocky for his own good, the tough bird sent him to the trenches, doling him out a bit part on *Cavalcade*

for America. Celebrating the true grit historical backbone of the nation, its upcoming episode, "A Medal for Miss Walker," told the tale of a hospitalized Civil War veteran who falls in love with his nurse. Playing a dying amputee with three limbs and ten lines, Hopper landed a cattle call reading for a hot new NBC series, *Medic*, staged in real clinics and real operating rooms. Its newspaperman creator went to extreme lengths, with no effort spared to make his show feel real. He wore a hearing aid for half a day before his show on deafness. He spent time in an iron lung to get "inside" his polio story. He filmed six different births to capture the perfect shot of the cutting of an umbilical cord. He went a little overboard with his episode about a C-section, "The Glorious Red Gallagher," which the network found too graphic and unfit for family viewing.

Still, everyone agreed the upcoming "Boy in the Storm" episode required an actor committed to *Medic*'s unflinching brand of rusty-nail realism. Fakery had gotten Hopper to this point, with his dramatic Shakespearean flourishes and perfect diction that floored the competition in his declamation contests. But in the face of some thirty-five other desperate hunks of meat clamoring to get the role, he would have to cast aside any whiff of fakery and plummet headfirst into the dirty depths of realism. Fortune smiled, for who better than Vincent Price to help him become *real*? Starring in *House of Wax*, the man jumped out at screaming teens in red-and-blue stereoscopic specs, right before their eyes, making them feel part of the writhing, living drama just as the blaring trailer promised.

The door creaked open to a lush Spanish villa outside of Beverly Hills, guarded by a five-and-a-half-foot stone Huastecan sun god wearing a cobra crown. Within lay Hopper's host, in the flesh among succulents and oversized tropical potted plants. The prop boy at La Jolla Playhouse, one of the only friends Hopper had in town, had made the introduction. Hopper had certainly come to the right place.

The Real, the True Miracle of Third Dimension!

In his earlier days, the oddly handsome Vincent Price had frequented that *Minutes of the Last Meeting* salon of boozy Hollywood bohemians who so inspired Hopper. Price desperately hoped to play one of the great Shakespearean leads but also longed to deliver a performance so *real* he could actually touch his audience. One day when *House of Wax* was playing in Times Square, he snuck into the theater, quiet as he could, mind you. In the row ahead of him, two teenage girls shuddered as they watched his mad sculptor in grotesquely alive 3-D. When the lights came on after the bone-chilling ending, Vincent Price peeked his head between the girls and asked, in his politely devilish tone, "Did you *like* it?" He made the girls scream.

Something weird was happening in the Price home, apart from the fact that Vincent Price was living there. It wasn't the giant totem pole sticking out of the backyard like an erection, tongues protruding from the animal figures stacked one on top of another. It was a five-by-six-foot painting obliterating the living room wall, an abstract canvas by American artist Richard Diebenkorn. It sucked Hopper in like a whirlpool.

Was it a California landscape of hills and swimming pools? Or was it a sunset? It seemed to change colors and moods according to the time of day and Hopper's own state.

"I'd been painting abstractly," said Hopper, who'd been dabbling ever since his mother gave him a set of watercolors back when he was a boy. "But I'd never really thought that anybody really painted abstractly until I saw these things."

Taking Hopper under his wing, Price taught him all about the burgeoning abstract expressionist movement. Sick of snobs who thought all great art came from Europe, Price was a fierce champion of this truly American revolution that exploded the psyche like jazz. He liked Jackson Pollock, a New York tough guy who

came from rugged western stock. A rebel, he broke away from his mentor, the cantankerous muralist Thomas Hart Benton, who loathed the formless drippings of his ex-protégé. Hopper was pretty disturbed, too.

The splattered drip-drops in the eleven-by-fourteen-inch Pollock on Price's wall were Brando on a canvas, jumping off the screen, vital, completely spontaneous. Inspired, Dennis dashed off a huge abstract of his own, diving into the void toward some greater unseen reality, leaving it to dry on the driveway. Price's son backed over it on his way to the market.

/ / /

"Whatever's wrong with me, it's really not like being *crazy*, is it?" asked the boy in the storm.

When Hopper stepped out of his Medic read, he told his agent, the legendary Bob Raison, "You know, I got this job." Hopper just knew he'd risen above the herd.

"You had a good experience reading," said Raison, tempering expectations. "I wanted you to get a good experience *reading*. You didn't get this job."

"They said my seizures were the best they'd seen," said Hopper. "Indistinguishable from the real thing."

Broadcast to America in black and white on a Monday night at 9:00 PM in January 1955, "Boy in the Storm" starred teenage Hopper in a hospital bathrobe, wrenching hearts as he twittered about in slippers, hopeful as a baby bird that someone would take him home despite his illness. In a flash, he dropped to the hospital floor and jerked about in an epileptic seizure, foaming at the mouth in a television tour de force. The boy in the storm took off into the stratosphere, a whirlwind that dropped him directly into the nexus of the sixties' Technicolor universe, which was completely unbelievable and yet somehow real.

THE SYSTEM

Cut to the year 1969, the jukebox blasting "Age of Aquarius" by the 5th Dimension. Across the globe, hippies, seekers, outlaws, and misfits are hanging on every word of thirty-three-year-old Dennis Hopper, the revolutionary director who upended the Hollywood studio system. His attendance is requested at a nuclear physics conference meeting on a mountaintop in Sweden for the purpose of "projecting a new society." A prophet of the age, wild-eyed with greasy hair flowing from under his felt cowboy hat, he offers followers and reporters, "Light is my obsession. I feel it as an elemental source of power, like a kind of cosmic coal. It makes things grow; it makes things die. It can turn into anything—a plant, an idea. Movies are made of light. Just think of the power of light to transform itself into everything we are and can imagine!"

The *New York Times* got the exclusive of his earliest clash with the industry, the epic tale of how a young rebel stuck it to the man, *man*, the most feared force in Hollywood.

"I was going to be either a matador, a race-car driver, or a boxer," began Hopper. "In Spain, if you're broke and lousy in school, you become a matador. In Italy, you race cars. Here, you box, or act.

I boxed and got beat up, so acting was the only thing left." He explained how the morning after playing the epileptic orphan on *Medic*, five major studios gave him contract offers. "Columbia called first and I was brought into Harry Cohn's huge office." That's Harry Cohn—the tyrannical Columbia Pictures studio boss, better known as *King* Cohn.

Hopper was dressed up in a suit and tie; there were no Navajo talismans dangling around his neck yet. He had waited in the reception office, a sweatbox set up so that a desperate person might have to wait three days before admittance, the beastly Cohn secretly peeking in to examine his prey.

In the lucky position of being courted for a contract, Hopper was buzzed right through the soundproof portal—discolored from years of sweaty palms.

"And I walk, *swish, swish*—you know, sweating, man."

He shuffled down the length of plush carpet toward an enormous desk raised slightly above floor level like a stage. Cohn had ripped off the design from Il Duce, whose picture had once hung on the wall, the fascist dictator being the subject of Columbia's 1933 documentary *Mussolini Speaks!* Oppressed by his surroundings, Hopper took in the hundred or so Oscars glinting in an arc behind the movie mogul's desk. ("Like a rainbow," said Hopper. "I had never seen an Oscar before. I was nervous as hell.") Sitting down, he picked a crack in the ceiling to stare at as Cohn laid on his fleshy charm.

"I've seen your TV show, kid. You got it; you're a *natural*, like Monty Clift! What else have you done?"

"Shakespeare."

Cohn couldn't believe it. "*Max!* Send the kid to school for six months. Take all the Shakespeare out of him. I can't *stand* Shakespeare."

"At that point," explained Hopper, wrapping up his oft-told tale,

"I said to Harry Cohn, 'Go fuck yourself.' Whereupon I was barred from Columbia. I didn't go back there for fifteen years, until they agreed to release *Easy Rider*. Freaky."

After telling Cohn where to stick it—the same Cohn who used his Mafia connections to threaten Sammy Davis Jr. with the loss of his only seeing eye if he didn't quit looking at one of Cohn's blond movie stars—Hopper should have been blackballed from Hollywood for the rest of his life. If he was lucky.

But it just so happened that Warner Bros. needed a baby-faced hell-raising type for its upcoming juvenile delinquent picture, *Rebel Without a Cause*. The studio scooped him up for $200 a week for twenty-six weeks. Unlike Warner matinee idol Tab Hunter (formerly Arthur Kelm), Dennis Hopper had the good fortune to remain himself, providing the perfect angle for his first big ink. Biting the hook, Hollywood gossip maven Hedda Hopper typed NO RELATION as the headline of her item: "Hear Dennis Hopper has been signed to a long-term contract by Warner Bros."

With a name in place, the studio machine was ready to crank out a new star on the assembly line. Eager to shine him up like a lucky penny, the publicity folks shot stills capitalizing on the wholesome look of their newest contract player. They posed him waking up bright-eyed and bushy-tailed at five o'clock in the morning, making his bed and stuffing a pillow into a fresh white case, drinking a thick-as-Elmer's glass of milk from his fridge, responsibly writing out checks for the bills on his kitchen table. Cornball images perfectly complemented Hopper's upcoming *Rebel* role, making it all the more frightening that any sweet American boy could be swept up in the scourge of delinquency. Still, he couldn't look like a total sissy, so the studio's top flack, an expert forger of backstories on incoming talent, dished up a ripe coming-of-age factoid about fourteen-year-old Hopper helping with the harvesting on his grandparents' wheat farm. The kid not only tilled America's soil but, after getting pounded by a tough customer in the Golden

Gloves welterweight finals, landed a broken nose, two busted ribs, and a three-week stay in the hospital.

"Dennis Hopper might have been trading leather in the boxing ring today instead of trading lines in the acting profession," went the item Warner Bros. sent out for immediate release, "but for a ferocious young man bent on beating in Hopper's head."

Now that the flacks had roughed the kid up with a little Tinseltown sprinkling of grit, the only thing left was to hook him up with a love interest.

REBEL

Starlet after starlet, including buxom Jayne Mansfield, hoped to play the girlfriend of the brooding loner who hates his apron-wearing father for submitting to his domineering mother. Rain poured down on the Warner Bros. backlot as the girls cozied up to Hopper for their *Rebel* screen tests. All night long he embodied the star-making role of the lost boy who only wants somebody to tell him the truth. Who else could even come close to nailing the part of the troubled teenage hero? Hopper thought he was the best actor in the world, "pound for pound," but nobody seemed to recognize it.

By the time the cinematographer finished tinkering with CinemaScope, famously dismissed as only good for shooting snakes and funerals, the next big thing felt like a wet, unhappy animal.

After his soggy ordeal on the backlot, Dennis returned home to his apartment on Doheny Drive and slept off the experience. The next day his roommate, trusty Bill Dyer, handed him the phone.

"It's Natalie Wood!"

The child star? Why was *Natalie Wood* calling? Wasn't she in *Miracle on 34th Street*—the little girl who sits on the lap of the Macy's Santa Claus?

"I tested with you last night," said Natalie. "Do you remember? It was raining."

"Oh, yeah, yeah."

"I'd like to fuck you, but I don't do anything. I just lay there."

At breakneck speed, Hopper varoomed his new red Austin Healey convertible, courtesy of his new contract, toward the spired Chateau Marmont on Sunset Strip. His first bona fide Hollywood starlet lay in Bungalow 2, the one by the pool, continuing her ongoing audition with the director of *Rebel*, Nicholas Ray, a silverhaired, chain-smoking auteur cursed with a romantic nature and a taste for vice. Doing all she could to be perceived as *wild* by the aging director, sixteen-year-old Natalie hoped to shed that awful sugary nutmeg-wafting residue of child stardom.

Picking up the nubile starlet and wheeling her up winding Mulholland Drive, Hopper parked on a secluded lover's lane in the Hollywood Hills and started to go down on her.

"Oh, you can't do that."

"Why?"

"Because Nick just fucked me."

Overlooking the twinkling panorama of Hollywood, Hopper reached the big time, an event duly sent out for immediate release by the studio flack.

"Hopper, Warner Bros. contract player who makes his film debut in *Rebel Without a Cause*, is dating Natalie Wood, pretty filmland starlet. Natalie, incidentally, has tested for a role in the James Dean starrer which rolls shortly."

It was true. Hopper wasn't the star. He was playing the bit part of a hoodlum named Goon. Hopper had only been a stand-in that rainy night for the *real* star, twenty-four-year-old James Dean, who had been off in New York prowling rainy Times Square, hunched in an overcoat and puffing a cigarette dangling from his Cupid's-bow lips. Dean's pose was inspired by a photo of existential philosopher Albert Camus, grimacing on the back of one of his paperbacks,

which were so chic to carry in a back pocket. The resulting pictures went into Dean's upcoming *Life* profile, "Moody New Star," paving the way for his breakout film, *East of Eden*.

Rumors floated around that Dean actually slept in his dressing room during *Eden*'s filming, locked inside the studio gates at night by director Elia Kazan, who wanted his star focused and free from the distraction of zooming around town on a shell-blue Triumph motorcycle. Nobody was allowed to disturb Dean. It was said he kept a loaded Colt .45 by his side as he slept.

Hopper liked to tell the story of how Kazan finally unleashed his hellcat to the cast and crew who were lined up outside the soundstage. "You're gonna meet a boy and he's gonna be strange to you and he's gonna be different," said Hopper impersonating Kazan. "But no matter what you see, or what you think of him, when you see him on the screen, he's gonna be pure gold. I want you to meet James Dean." Kazan opened the soundstage door to unveil his freak secret weapon, like 3-D, so real on-screen he grabbed you. Dean came out and screamed, "Fuck you! Fuck you! Fuck you! Fuck you! Fuck you!"

One day, feeling stiff in a tie, Hopper met Dean at the commissary where the studio players—cowboys and Indians alike—ate lunch in their costumes. "I didn't believe it. Here was this grubby guy in tennis sneakers, an old turtleneck, and glasses," said Hopper. "We were introduced, and he didn't even turn around; he didn't say hello. That's how he was, man. Honest. If he didn't feel like talking to you, he just didn't."

Trailing Dean like a shadow, Hopper became a regular at Googie's, the zippy populuxe-style coffee shop to the stars on Sunset Strip. Googly eyes from the double *O*s of its electric green-blue sign looked down on jittery actors emoting over diner coffee and Stanislavsky while trying not to ogle the self-obsessed farm boy who poured in endless sugars. Gazing longingly at each spoonful as it dissolved, Dean held court over the back booth as king of

the "night watch" crowd. This bizarre cast of characters included a spectacled toady rumored to have gotten his nose done to look more like Dean, and Vampira, a goth television hostess who rode around Tinseltown in a hearse or an old Packard convertible, chauffeured as she held aloft a black umbrella to blot out the sun. Such strange customers were attracted to Dean. Vampira took note of the night Hopper secretly followed Dean all around his regular spots, peeking into restaurant windows, looking for him.

"Oh, for God's sake, Dennis!" Vampira told him. "Don't be so San Diego!"

Hopper was coming into his own, without feeling the need to copy anybody. After all, he was Natalie Wood's leading man, drinking black coffee in his very own booth. Despite her intimate rehearsals in Bungalow 2, however, Nicholas Ray hadn't yet told Natalie whether she had gotten the part. And why cryingly not?! Couldn't she play Dean's girl? Hadn't she already acted beside him on the live television show *I'm a Fool*, playing the nice girl to his wandering drifter?

"I know you," Dean had told her. "You're a *child actor*."

It was *horrible*! Would she ever lose her Christmasy glow? Jangled up on Googie's coffee, a nervous wreck, Natalie ordered Hopper to take her to the Villa Capri. Dean had just started lurking around this Rat Pack hangout but ate in the kitchen, a new kind of cool that Sinatra and the boys didn't exactly get. They'd send the kid over a glass of milk and a comb, give him the rub.

"Fine man, fine boy," said proprietor Patsy D'Amore. "Dressed with overalls, like men who dig ditches."

By nightfall, Natalie was practically sobbing on the checkered tablecloth about how Ray still hadn't called to say she'd gotten the part. She just *wasn't* enough of a bad girl to play a delinquent. Or *was* she?

A randy Hopper took her up twisty Mulholland Drive through the Santa Monica Mountains, haunted by the ghosts of

thrill-seeking teens who had turned the dangerous road into a makeshift drag strip, inspiring the harrowing "chickie run" scene in the *Rebel* screenplay. Hopper drank half a bottle of whiskey and handed it over. Natalie puked. It started to rain. Now they were really bad, living the nightmarish drama as they wheeled down a treacherously slick stretch of killer road. Turning a hairpin corner, Hopper plowed his red convertible head-on into an oncoming car, throwing Natalie onto the street. Neighbors ran out with blankets, and the ambulance roared toward her.

"It's all my fault," groaned Hopper. "I shouldn't have brought that bottle."

At the emergency room, Nicholas Ray pushed his Goon up against the white wall and slapped him. "Shut up," said Ray. "And straighten up."

Looking at Ray's bad, bad Lolita scratched up in a hospital bed, the doctor called her a goddamn juvenile delinquent.

"Do you hear what he called me, Nick?" screamed Natalie. "He called me a goddamn juvenile delinquent! *Now* do I get the part?"

Hopper was amazed. Lying in the street in the rain, Natalie hadn't been calling for her mother but instead rattled off the digits of the Chateau Marmont, repeating, "Nick Ray . . . the number is," conscious enough to know she was in the throes of a breakout performance that needed to be seen at once.

Stunned at this totally neurotic, completely savvy freak wunderkind on her way to megastardom—practically daring him to one-up her—Hopper prepared to shed any trace of the fresh-faced goody-goody voted most likely to succeed.

On the first day of shooting, Ray sent a dozen roses to Natalie's dressing room. Just like Goon, a *real* delinquent, Hopper freaked out and called Natalie all sorts of nasty names for whoring around with Nick.

"All the guys just wanna screw me," said Natalie of her silver fox. "He just wants to make love to me."

Just as the director was about to shoot the planetarium scene at the Griffith Observatory, Hopper ran off to get a hot dog, holding up production and costing the studio plenty. Ray tried to fire him on the spot, but the brat was under contract, so he cut his lines. Hopper moped while Dean moved like a jungle cat in the fight scene, flashing about like a matador, the switchblade quick in his hand against Buzz, the bully gang leader. Dean insisted on using real blades, so real blood ran down his neck after Buzz accidentally stabbed him behind the ear.

"Cut!" yelled Ray, ready to call in the studio medics. Dean lost it and, by Hopper's account, threatened to murder his director.

"Don't you ever say fucking 'cut!' man. I'm the only one who says 'cut' here! If I get that *close*, I want it on film. I don't want you cutting it!"

Frozen in the taillights of Dean's raw talent, but refusing to be silenced into obscurity, the boy in the storm had no choice but to bump up his offscreen role as the passionate lover fighting to win back Natalie. Hopper got so into his role that he pulled aside one of his fellow *Rebel* delinquents, Steffi, who was the daughter of Hollywood columnist Sidney Skolsky. Hopper detailed how he'd gone out with a gun one night for a showdown with Nick at the Chateau Marmont. His attempt to end the twisted ménage à trois by blowing away the dirty rat only fed into an item the studio was sending out to Steffi's father: "Hopper registers with the impact of a young Cagney." But nobody seemed to pay much notice to Hopper now that his lines had been cut. He was practically an extra, forcing the studio to spread its bullshit thinner by the day.

DEAN

Wheeling a pea-green two-tone Custom Deluxe 20 Chevy pickup truck across a dusty stretch of Taos, New Mexico, a weather-beaten Hopper slammed on his brakes. He was pushing forty. It was sometime in the middle of the seventies.

Screeching to a stop, he hopped out and planted his boots in the dirt. Decked out in his cowboy hat, a faded denim jacket, and a big goddamn belt buckle and bolo tie, he faced the camera for a James Dean documentary, to climax in a rousing Dean montage to the tune of "James Dean" by the Eagles. By now, he had the tale down of that fateful night at the chickie run scene.

"Look, I really wanna be a great actor, too," Hopper told Dean. "I want to know what you're doing. I wanna know what your *secret* is."

Hopper had always been fascinated with Dean, ever since a cold, wet early morning at the end of a long, brutal day of shooting. Lying in the street before a green-eyed windup monkey, Dean watched the toy clank its cymbals until it wound down, then lovingly covered it up with a piece of discarded newspaper for a blanket. Curling up beside his only friend in the world, Jimmy went to sleep. It would be the opening shot of *Rebel Without a Cause*.

"I have a script in my hand that says this guy's in the gutter,

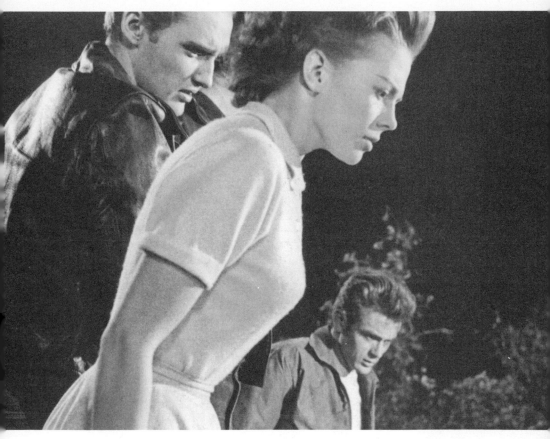

Dennis, Natalie, and Dean, Rebel Without a Cause, *1955*

drunk," explained Hopper. "Well, first of all, the guy is in the street playing with a toy monkey? And doing baby things—trying to curl up . . . Where did that *come* from? It came from genius; that's where it came from. That was all him. Nobody directed him to do that. James Dean directed James Dean."

Everything came to a head in the hills of Calabasas, on a thousand acres with pepper trees and thoroughbred horses owned by movie mogul Harry Warner. Called to the Warner Ranch for the chickie run, all the delinquents cheered on two gas-guzzlers in a suicide race toward a rocky bluff with the inky waters below. First who jumped was a chicken.

Blazing paths in a red windbreaker, Dean somersaulted out of the black '49 Merc in a death-defying feline leap much too real for Hopper after a long shoot of watching genius unfurl. He realized he didn't know anything!

Going after Dean, Hopper threw him right up against that iconic Merc and asked for his secret.

"So, he asked me, very quietly, why I acted," said Hopper. "And I told him what a nightmare my home life had been, everybody neurotic because they weren't doing what they wanted to do and yelling at me when I wanted to be creative, because creative people ended up in bars—which I later found out to be true."

"How can I do it?" asked Hopper. "Do I have to go to Strasberg? Do I have to go to New York?"

Dean had been schooled at the fabled Actors Studio under diminutive acting coach Lee Strasberg, keeper of the Method, the mysterious acting alchemy that spun performances into Oscar gold. But Dean was too much himself to be anybody's disciple. Guided by his own method, he eked out a bohemian existence in his beatnik pad in Manhattan with bull horns mounted on the wall, bringing him back to the roots of his animal instinct, a reminder to strip away the bark of civilization.

Strasberg taught many dangerous things, like emotional memory.

"You are too sensitive," Dean warned, telling Hopper never to go there. "He'll *destroy* you."

Was that what had sent Dean howling and writhing on the floor when he tried to win the love of his brothel madam mother in the gut-wrenching scene in *East of Eden*? Jesus.

Maybe Jimmy was right. Hopper shouldn't play with that sort of thing.

"Jimmy and I found we'd had the same experience at home," said Hopper. He felt just like Jimmy, a lonely farm boy who needed an escape.

"Let me help you a little," said Dean. Every once in a while, when Hopper didn't even know he was watching, Jimmy would mumble, "Why don't you try the scene this way?" And Jimmy was always right.

"There'll never be anybody like Jimmy again, man," said Hopper. "It was, in a strange way, a closer friendship than most people have, but it wasn't the kind of thing where he said, 'Let's go out and tear up the town.' Sometimes we'd have dinner. Also we were into peyote and grass before anybody else."

In those days, he and Dean would sit around and cook peyote on a stovetop, like a can of Campbell's Soup, or smoke pot in the Warner Bros. dressing room with brown paper bags over their heads so the stink wouldn't get out. They looked like small-time bank robbers, but so long as they were stoned? Guaranteed easy access to the moment, so precious for actors.

Then suddenly Jimmy was gone, leaving Hopper alone to watch the curtain open to vibrant Technicolor, Dean grinning before the green-eyed monkey. Leaping out of the speeding Merc '49 before it dove into the water, Dean seemed so *alive* that he seemed to exist somewhere beyond the screen. Hopper could hardly believe he was dead, killed in his silver Porsche 550 Spyder a month before *Rebel* hit theaters.

/ / /

The amputee girl from across the hall knocked on Hopper's door. Jimmy used to visit her, inspired by her body like a Greek ruin. Standing on her one leg at the threshold, she told Hopper's roommate it was horrible; there had been an accident. Was Dennis in the Porsche with Jimmy? Bill got really paranoid.

A strange thing happened when Dennis came home that night from Googie's. Dennis told Bill, "Jimmy's in this room with us now."

Sitting inert on a shelf was that weird toy monkey, cymbals ceremoniously extended, but silent. Hopper had saved it from the set.

"Jesus, that monkey," said *Rebel* screenwriter Stewart Stern, visiting Hopper's apartment not long after Dean's death. They were just back from their impromptu road trip to Tijuana to see the bullfights. Hauling ass from the border, Hopper had driven his red Austin-Healey at breakneck speeds. He claimed to be an aficionado of the bullfights, but instead of hanging out at Caesar's, the hotel where the matadors stayed, they'd stayed at a dump and hit the lap dancing joints packed with sailors from San Diego.

"Well, you know," said Dennis, staring at his friend with a weird glint in his eye. "Jimmy comes to see me still. He does."

One day when he'd been taking a nap, an incessant, tinny clanking woke him up. Looking across the room, he saw it jumping up and down on his shelf, crashing its little cymbals.

"All of a sudden the monkey came to life," said Hopper. And sometimes when he was shaving, he got the feeling he was being watched. "I look and there's Jimmy, right on the other side of the window."

Around the world, all sorts of strange stories were popping up about Dean. In an Indonesian mountain city, Javanese teens smoked cigarettes and strutted the streets in rolled-up jeans and *Rebel*-red jackets. Deep in the heart of Arkansas, college students built a fire by a river, sculpted an Academy Award out of mud, flung earth at each other in a bacchanal and chanted, "Jimmy, give us a sign." A dog howled in the distance. Fans sent eight thousand letters a month addressed to James Dean in care of Warner Bros. Dean's ghost even beat out the very alive Rock Hudson in a *Photoplay* poll casting votes for America's number one star. *Jimmy Dean Returns!*, an account "written" from the dead by Dean via his dime-store salesgirl lover, sold five hundred thousand copies. He'd been communicating to her through automatic writing. Suffering another

one of these ridiculous stories at the end of an exhausting road trip, Stern had his fill.

"Dennis, you're out of your mind."

Not long after, he invited Hopper for a barbecue at his home in Benedict Canyon. The hamburgers sizzled while something tapped away inside.

Tat-tat-tat-tat-tat-tat-tat-tat.

"That's the—"

"No, Dennis, the monkey isn't here."

"Well, it's Jimmy."

Stepping inside, they saw on Stern's top shelf a little wooden Buddha from Thailand, bouncing up and down.

Tat-tat-tat-tat-tat-tat-tat-tat.

"It's Jimmy," said Hopper. "I'm getting out of here."

Hopper flew out the door, leaving Stern to deal with Dean.

"Sit down," said something powerful. "Leave yourself alone, but pick up the pen."

So, Stern began to write—rather, *Jimmy* began to write—but the only word Stern could decipher was "wood." Natalie Wood perhaps? Whatever it meant, it was definitely spooky, leading him to conclude that if anybody were to have contact with the dead, it would be Dennis.

THE DEATH CURSE

Within weeks of the silver Spyder crash on September 30, 1955, *Variety* pegged Dennis Hopper as the next James Dean. Of course the next James Dean would *never* call himself the next James Dean. The trick to winning what Warner matinee idol Tab Hunter acidly called the "James Dean Replacement Sweepstakes" was to completely deny being a contender. Stating on the record that he refused to give any interviews about Dean, Hopper did *not* permit photographers to snap pictures of a treasured painting given to him by his departed friend.

Otherwise he'd be as shameless as his slick pal Nick Adams, a fellow *Rebel* delinquent who'd taken to showing up to parties in a candy-red windbreaker. For *Life*'s feature "Delirium Over Dead Star," the notorious Hollywood opportunist posed with a cigarette by his kitschy shrine of Dean memorabilia, including Dean's hat and a poem Dean had penned about a lonely boy.

Hopper let it be known—he wanted no part in such gloss. Coolly playing his cards, he pleaded to *Young Movie Lovers* magazine, "Please, don't call me another Jimmy Dean."

Practically every young actor was being thrust into the sweepstakes, like a guy Hopper saw pulling up to a popular Hollywood

restaurant in a Porsche, just like Dean's. He even kind of looked like Dean. Weird. And his name *was* Dean!

You Picked Dean Stockwell
to Play Jimmy Dean!
But Would It Ruin Him
or Make Him a Star?

So asked the pages of *Movie Life*, a cheap fanzine that made this grown-up child star cringe. Dean Stockwell preferred to hang out with his subterranean art crowd and make cosmic collages and strange underground movies like *For Crazy Horse*, *Pas de Trois*, and *Moonstone*, screened out in the wilds of Topanga Canyon.

But a dark horse roaring in from Tupelo had no reservations about going after James Dean gold. Dropping to his knees before Nicholas Ray, the stranger with the slicked-back black hair commenced to recite Dean's lines from "Rebel Without a Pebble," as he adoringly called his favorite film. He'd seen it over and over in the theaters and was desperate to star in the upcoming *James Dean Story*, not realizing it was going to be a documentary, or knowing what a documentary was anyway.

"I'd sure like to take a crack at it," said Elvis Presley. "I think I could do it easy."

Hunting down Hopper so he could hear all about Jimmy Dean, Elvis confided how worried he was because the script of a B Western he was about to star in instructed him to smack around his lovely costar. He told Dennis, "Man, I never hit a woman before."

Realizing the confusion, Hopper sat down the sloe-eyed cowboy for a chat. He broke it to him gently that the movies—like Santa Claus or the Easter bunny—weren't real. Dennis ought to know, having just filmed *Gunfight at the O.K. Corral*. Playing the troubled rustler Billy Clanton, he'd clutched his chest and dropped off the balcony for the final scene. Crashing onto one of the old-time

cameras at Fly's Photographic Studio, he was a portrait of wasted youth. Then he picked himself up, brushed himself off, and walked off the Paramount backlot with fake saguaro cacti and a mountain made of a big hump of gray asbestos. See, he wasn't really dead. He'd merely shot it out with *fake* bullets against a *fake* Wyatt Earp at a *fake* O.K. Corral.

Elvis felt duped. "He believed that movie fights were real, and that movie bullets were real," Hopper recalled. "And when I explained that they weren't, he got very pissed off at me! And Elvis was twenty-one years old at the time!"

/ / /

"I've made a study of poor Jimmy Dean," said Elvis. "I've made a study of myself, and I know why girls, at least the young 'uns, go for us. We're sullen; we're broodin'; we're something of a menace. I don't understand it exactly, but that's what the girls like in men. I don't know anything about Hollywood, but I know you can't be sexy if you smile. You can't be a rebel if you grin."

He'd taken in as much as he could of his dead idol—gobbling up a hunka Hopper and a hunka burnin' Natalie Wood, who dug her claws into his back as he rode around on his brand-new Harley-Davidson motorcycle. Nick Adams chugged a quarter mile behind on Elvis's old one.

By then, Elvis figured he knew so much about Dean that he had this rebel thing licked. With total conviction, he sang to his girl in his B Western, *Love Me Tender*, beaten only by *Giant* at the box office. Elvis didn't even need to writhe on the floor. He simply refused to smile.

Chewed up and spit out by this slick hillbilly who loved his mama, Hopper sat in an all-night seedy diner with fellow sweepstakes losers Nick and Natalie like a trio of kids airbrushed into the famous *Nighthawks* painting by the other Hopper. They prepared

to get to work on their extensive study of real-life lonely outsiders—real coffee drinkers, real pie eaters.

Like Nancy Drew and the Hardy Boys prowling skid row, the impressionable gang gawked curbside as the LAPD tossed real derelicts into a paddy wagon. Sharpening senses, becoming real artists hip to the underbelly, they took the world as their stage.

"Fuck Errol Flynn!" cried Hopper, swinging from a length of rope and landing on the porch of Nick Adams's home in sleepy Laurel Canyon. Another evening he wrapped himself in Nick's bearskin rug and paraded through the neighborhood with a movie poster featuring Dorothy McGuire wearing a bonnet. The mad act landed notice in *Variety*, bolstering Dennis's wacky, irreverent persona.

Meanwhile, Hopper and Natalie were becoming a steamy item. Posing in fishnet stockings on a cabaret stool for *Look*'s "Natalie Wood: Teenage Tiger," she offered tabloids an inside peek at the "Real Life Rebellion of a Teenage 'Man-Buster.'"

"We got in a relationship where we were going out to parties together and we would score for each other," explained Hopper. "We had great fun procuring for each other. We weren't blind to the fact that we could see other people, but we were having sex all through our relationship."

Natalie upped the stakes of her blossoming wild-child image by arranging an illicit rendezvous with a married movie star who slipped her a pill, then whipped and savagely raped her. Roaring over to Hopper's apartment in her Thunderbird, Natalie burst in and caught Hopper in the midst of painting one of his abstracts.

"Lay down," she demanded, grabbing Hopper's bullwhip. "Let me whip *you*."

Hopper had become something of an expert at the Western art of whip cracking, hoping it would give him a little something extra to further his career. Getting whipped was even better.

"It was almost that we were naive to the point that if people

did drugs and alcohol and were nymphomaniacs," figured Hopper, "then that must be the way to creativity, and creativity's where we wanna be. We wanna be the best."

One night at Nick's rustic cabin in La Cañada, Hopper set the scene of a boozy salon where madness and genius thrived. Natalie starred as bombshell Jean Harlow, luxuriating in the bubbly decadence of Hollywood's golden era.

"OK, Natalie," directed Hopper. "We're ready for the orgy."

Natalie disrobed. Stepping naked into a tub filled with champagne, she screamed when the bubbles fizzed up into her nether regions. ("Set her on fucking *fire*," said Hopper.) The next scene featured Natalie in the emergency room, back to those doctors who once cast her as a delinquent.

/ / /

First Dean died. Then Hopper's sidekick Nick was found dead in his apartment in 1968, having overdosed on pills. Perhaps even murdered.

Having OD'd on his porcelain throne at Graceland in 1977, Elvis was dead, all bloated up on his rebel image. Hopper cried when he heard the news over the telephone.

Lastly, in 1981, over the course of a stormy night of sambuca with her fellow actors, husband Robert Wagner and Christopher Walken, Natalie fell off her yacht and drowned, to forever star in an enticing unsolved Hollywood mystery set off Catalina Island.

So the winner of the James Dean Replacement Sweepstakes by default was Hopper. Inquiring *Weekly World News* readers wanted to know: Would Hopper be the next victim of the diabolical *Rebel* curse? The intrepid tabloid asked him to comment on their story "Dreadful Death Curse of Cult Movie."

How did they even manage to track him down? He wasn't exactly readily available at the time. His skin was pale and slimy. Even

in newsprint, he looked wet, drenched in a psychotic's perspiration. His bugged-out eyes were wide as the mysterious fanged Bat Boy, a regular on the cover of this Martian-infested supermarket rag.

"It's very strange the way they all died," admitted Hopper, then at the height of his coke-addled paranoia. "I only know I'm a survivor. I won't let it get to me."

GIANT

The imaginary line was the lesson Hopper took from the set of *Giant*, the Warner Bros. epic shot on the heels of *Rebel* in the summer of 1955. The studio machine spared no expense on what promised to be a *Gone with the Wind* for the Lone Star State. The whole town of Marfa, pop. 3,500, sweltered in the heat as Elizabeth Taylor chugged in on the Texas and Pacific Railway to the dirt-dry whistle-stop. They'd all come out to see her, finer than four thousand head of the finest Texas cattle brought in for the big roundup scene. Not to mention Clear View Snuffy, the National Brangus bull champion imported from Oklahoma to play King Tut, pride of the Benedict ranch. Cordoned off from the set with a huge wooden derrick atop a well filled with real oil imported from California, ready to gush on cue, a crowd of thousands shuffled about in cowboy boots, wiped sweat off with worn handkerchiefs, all to catch a glimpse of Liz—"jack-off material," said one onlooker. Powdered and puffed and cleavaged, she was the biggest movie star James Dean had ever worked with, and he couldn't help but be nervous, so he did what came naturally. Sauntering over to the good people standing around to see this tale of oil and greed, he whipped out his dick and peed.

Riding shotgun back to town after wrapping for the day, Hopper said, "Jimmy, I've really seen you do a lot of strange things, but today, really, that takes it, babe. I mean what was that, what was *that* all about?'"

"Working with Elizabeth Taylor," said Dean. "Really nervous, first time I have a scene with her, I can't even speak. So I had to take a pee, and I thought, 'Well, it's not workin' in this sequence for me,' so, uh, I figured if I could go and pee in front of those four thousand people I could get back there and I could do anything on film."

Hopper had his own Liz hang-ups—he'd hug his pillow at night and pretend it was her—but somehow it didn't befit his role as the young upright son of a cattle baron, Jordan Benedict III, to expose himself like Jimmy. But he didn't want to get all frozen up like one of those lit-up Marfa jackrabbits he and Jimmy shot with .22s, hypnotizing 'em in the headlights of the pickup truck.

"Well, you know," advised Jimmy, "if you're smoking a cigarette, don't *act* smoking the cigarette. Just smoke the cigarette when you feel like it."

Dean had plenty of tricks up his sleeve. To embody his character, Jett Rink, the young wildcatter who had aged into a bitter drunk by the time of the climactic banquet, Dean didn't actually drink himself into a stupor when the script called for him to be raging drunk. He just spun around and around until he was disoriented, then staggered ahead, making him appear soused as he stepped into the scene and tried to regain his balance.

Suddenly it came together for Hopper. The trick was to just *be*. When his time came to smoke the cigarette before Liz, playing his mother, Hopper smoked it. Not smoke it all contemplative like Rock Hudson, the big hunk of beefcake playing his father, but how Jimmy smoked it.

"And that's great acting," said Hopper. "Because then it isn't *acting* at all."

That night, Dennis ate with Dean at the Villa Capri. The Rat

Pack had finally accepted Jimmy into the fold. At last showing up in a suit and tie, not his overalls, Dean clowned around with Sammy Davis Jr. like they were old pals. Jimmy was growing up. The kid had a big future ahead of him.

"I saw what you did today," said Dean. "I wish Edmund Kean could have seen you. And John Barrymore. Because today you were great."

Dennis started tearing up, the tears brimming.

"It's very sweet," said Dean. "You're showing appreciation for what I'm saying, but when you really become a fucking actor you'll have to leave the room to cry. *Then* you'll be there."

/ / /

A year after Jimmy died, Hopper strutted down the red carpet in his black tie for the star-studded Texas-sized *Giant* premiere. He pushed his way into the dazzlingly lit Roxy Theatre in New York.

"You are a very, very fine actor," said the television hostess, wrapped in a mink stole and glittering diamond tiara.

"Thank you very much," said Hopper, holding her white-gloved hand for a little too long.

Wielding a microphone like a scepter for the telecast event, she told him how great he was with Natalie Wood the night before on *The Kaiser Aluminum Hour.* Yes. That was the episode where Hopper played a carnival barker who keeps Natalie, a hoochie-coochie dancer, in his evil clutches. Hopper hoped those days were winding to a close. He'd snubbed Natalie as his date tonight for the sophisticated Southern belle of the Actors Studio, elegant Joanne Woodward with chic new Joan of Arc bangs, soon to flex her mastery of the craft by playing multiple personalities in *The Three Faces of Eve.*

"Is this your wife?" asked the hostess.

"No, no, it's not my *wife!*" giggled Hopper, like it was the most ridiculous thing he'd ever heard.

Bubbling with boyish charm that night, he tried to wiggle his way into Joanne's apartment. Why was Joanne suddenly pushing him down a flight of stairs? Alas, the naive lad paled in comparison to the suave lady-killer awaiting a secret rendezvous on the other side of her door, her Actors Studio classmate with the blazing blue eyes.

That guy? *Newman*? How *boring*. Hopper took him out one time to see Miles Davis and he didn't even get it.

"What is this *music*?" asked Newman.

What a square. Of course Paul Newman didn't dig jazz: the music of the Method according to Dean, a raw scorching expression where every note hung in the air as real as real could get. And still Newman managed to land the coveted role of hardscrabble boxer Rocky Graziano in *Somebody Up There Likes Me*, the one to have been played by Dean. But Hopper was the one ready for stardom! He was the one who shone in the firmament against Rock and Liz!

Hopper's reputation in Hollywood was getting weird—Dean worship had left him quirky and neurotic, a nervous persona his peer Anthony Perkins (to play the mama's boy in *Psycho*) already had down. What was the studio going to do with him? Gussied up in white satin pantaloons and a jerkin with gold-tasseled epaulettes, Hopper was the spitting image of the Little Corporal, Napoleon Bonaparte. A Warner flack pointed out how he'd even bought a poodle named Josephine and was giving all of his friends bottles of Napoleon brandy for Christmas. Introduced in voiceover by Vincent Price, who played the Devil, Hopper got about three minutes of screen time before the wacky historical romp moved on to the Marx Brothers. Harpo played Sir Isaac Newton.

What else could Hopper do? Why not farm him out for a whopping $6,000 to horse breeder and cattle connoisseur Cornelius Vanderbilt Whitney?

The filthy-rich scion had a notion to make a whole series of

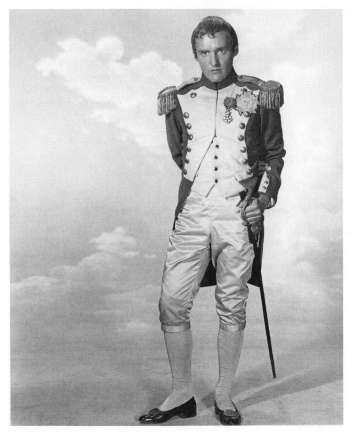

Napoleon, *1957*

films about America. Whitney's landmark production *The Searchers* was expertly crafted by director John Ford with his alter ego in the saddle. Once again the Ford/Wayne combination was sure to be a winner! Only this time around, instead of Pappy and the Duke, it was the sons of the Johns—the Pats, Pat Ford producing and the wooden Pat Wayne starring. Stuck in a retread of their fathers' Westerns, Hopper did what he could in his less-than-stellar role of a twitchy Mexican killer.

Moseying about Western Street, the main drag on the Warner Bros. Wild West backlot, Hopper played the high-strung Utah Kid in an episode of *Cheyenne*. After enough time passed for the

television audience to forget his face, he returned as a spastic train robber ready to jump out of his skin. His crazed look reminded ol' Cheyenne Bodie of something he'd seen only once before—in the eyes of William Bonney, better known as Billy the Kid.

"I'd rather face Bonney anytime," said Cheyenne. "This boy's a *rattlesnake*."

How much longer would Hopper have to stand around and have such cow shit lines slung on him?

Figuring he was a real pepper pot, the studio slapped on an evil cowboy getup—black boots, black hat, black leather vest—and sent him back to Western Street to play a Billy the Kid cameo in "Brannigan's Boots," the pilot episode of *Sugarfoot*. Bested by the hapless happy-go-lucky sheriff "Sugarfoot" Brewster, Hopper stole out of town on his horse.

Meanwhile, back at the Warner Ranch, Paul Newman rocketed to stardom as Billy the Kid in *The Left Handed Gun*, an edgy version of the outlaw legend, which recast Billy as a brooding juvie from the back alleys of New York.

At a party at the home of Stewart Stern, the *Rebel* screenwriter becoming known around town as "the guy who writes for Newman," Hopper considered Warner Bros.' new golden boy, about to ride into the sunset with his beautiful Academy Award–winning bride, digging Oscar gold in *The Three Faces of Eve*.

What the hell sort of racket was this Actors Studio these two had broken into?

Hopper began to spew forth a barrage of nonsensical beat-inspired poetry, leaving Joanne no choice but to whack him on the head with Stern's antique bed warmer, loosening the copper pan from the wooden handle. Perhaps a screw, too.

"I'm a better actor than you are, Newman!" screamed Hopper. "And I'm better than *she* is!"

Cool Hand Newman dealt an unflappable six-gun line. "Dennis, get well soon."

BLACKBALL

It felt like a biblical curse. Hopper was off to the California desert to play another goddamn twitchy bad guy in another B Western, Henry Hathaway's *From Hell to Texas* by Twentieth Century Fox. Couldn't Warner Bros. loan him out for something *grander*, as golden as MGM's 1941 Western spectacular *Billy the Kid*? So big that studio chief Louis B. Mayer had dramatic clouds and mesas painted on top of the film shot on location in Monument Valley, the ancient totemic sandstone buttes of mammoth proportions not quite monumental enough for Hollywood.

Hot and dusty on a Texas prairie staged in the Sierra Nevada, Hopper's son of a vengeful cattleman tried to get the jump on the gun-handy hero played by Don Murray, who retaliated with a spectacular one-handed diving rifle shot. Rodd Redwing, a Chickasaw Indian who worked in the movies, taught Don to *never* shoot at the head—the cardboard wad blank could easily take out an eye.

"Cut!" yelled Henry Hathaway, the last of the great hard-ass directors. "Don, you're pointing the rifle at the *woods*!"

"I was pointing at the body."

"Okay! Take two! Ahhrgh! Yeah, you were pointing at the *woods*!"

As the sun beat down on Lone Pine, California, Hopper got ready to suffer Hathaway's whip like Dean had under George Stevens, *Giant*'s immovable freight train of a director whom budding star Warren Beatty nicknamed the Super Chief.

"I may be working in a factory," Jimmy told the Super Chief, believing his mechanized approach to acting was killing him. "But I'm not a machine. Do you realize I'm doing emotional memories? That I'm working with my senses—my sight, hearing, smell—"

POW!

"Cut! Ahhrgh! Don! I told you you're pointing at—"

"No, Henry, I'm pointing at—"

Hopper sauntered over, shot right between the eyes with a cardboard wad. Real blood trickled down his nose into his mouth. If only the bullets had been real, too.

By the time Hopper moseyed onto his set, Hathaway had directed so many of these oaters and horse operas, he could practically direct this one while taking a shit in the outhouse. He knew the Western inside out, classic tales of good and evil, white man/redskin, simple as Cain and Abel. He'd directed Gary Cooper in *The Virginian*, for chrissakes. Coop never asked about motivations—"Well, why would *my* character do *that*?" But this runty son-of-a-bitch contract player from Warner Bros. was bunging up the works, asking all sorts of damn fool questions that didn't belong in a Western.

"Please don't give me line readings," insisted Hopper, pushing against Hathaway's habit of feeding him every line—the way *he* wanted it.

"I'm a *Method actor*," said Hopper. "I work with my ears, my sight, my head, and my smell."

Hathaway finally snapped. He'd been around since the dawn of time, when dinosaurs roamed Hollywood. He was a young upstart

assistant director on *Ben-Hur*. The 1925 one. They didn't have goddamn sound, let alone worry about *smell*.

Cutting off Hopper, he stopped production to see if anyone could understand the goddamn kid mumbling lines into the floorboards—*Aaaaayeeeeuh, hey man, aahduuh*—like some Jimmy Dean. Hathaway asked his entire cast and crew, "Can *you* understand Jimmy? Can *you* understand Jimmy?"

Someone piped up and said he couldn't understand a single goddamn word the kid said the entire picture.

Hathaway turned to Hopper. "You hear *that*, Jimmy?"

Hopper told Hathaway where he could stick his picture and walked off the set.

Hathaway didn't know what to make of it. Hopper ignored him, ignored direction, argued with him, swore at him, called him a fucking *idiot*.

Dumbfounded, Hathaway turned to the crack shot hero of his picture.

"I just don't know what to do with this kid. I've never seen anything like this before."

Don had. One of the things that drove him crazy about these Actors Studio types was how they'd smoke a cigarette, making the whole scene about the stupid cigarette.

"I don't know how to deal with him, Don."

So the good guy agreed to a man-to-man chat with the bad guy, perhaps not so bad, just a little confused.

"You're not looking at what a Western *is*," Don told Hopper. "The classic Western is a morality tale. Things are pretty black and white. Having all these discussions about psychology?"

Out here in the desert, Hopper told him all about Jimmy on the set of *Giant*, of all Jimmy had to go through to get into the character of Jett Rink.

In Marfa, Jimmy would hang around the locals in his ten-gallon hat, learning rope tricks until he could throw a lasso as sure as a

turn of the earth. All that effort—only to face off against the Super Chief, who sucked the last drop out of him like an oil derrick. The makeup artist sprinkled gray in Jimmy's hair for the banquet scene, but those bags under his eyes? They weren't acting.

Jimmy still couldn't get through to the Super Chief. He wanted to take a drink from his own flask for the scene, knowing his character was too proud to drink from the table of rich folks who looked down on him. The Super Chief wouldn't let him. Only later, when Jimmy was dead, did the director concede that Dean knew Jett Rink better than he did.

"Jimmy wanted to direct too, man," said Hopper. "He wouldn't take anything from the studios, wouldn't let them rust his machinery. That's why he was almost fired during *Giant*. He was his own *man*, man."

Don tried to break through—"Use what Kazan said, 'Take a disadvantage and make it an advantage'"—employing a bit of the ol' psychology by telling Hopper, "Henry, your director, is like your father, and you're *fighting* with the father. Use your frustration in the movie. Make it work *for* you."

Heading back to set, Don hoped he'd done something good for the classic Western, maybe even taught the bad guy a trick or two. He thought Hopper had taken the lesson to heart because afterward Hopper reined himself in, became better behaved, and they were able to get through the shoot on time and within budget. Moseying back to civilization, Hopper awaited his fate from Warner Bros., which was being scribbled on a scrap of paper in the studio's bowels by a number cruncher tallying up revenue from loaning him out for the year: $8,200 from Twentieth Century Fox, $6,000 from C. V. Whitney, and so on. The bottom line? "Dennis cost us $250.00 for the year," wrote the number cruncher. Their lucky penny had come up short. Formal release papers followed, hurling Dennis Hopper into the outer darkness beyond the studio gates.

/ / /

"You've spoken of Dean's description of an imaginary line, and it's one of the most *profound* thoughts I've ever—"

Speaking four decades later in an alternate universe, the dean emeritus of the Actors Studio welcomed his guest to the show. Tonight's special episode of *Inside the Actors Studio* featured distinguished Studio alumnus Dennis Hopper, pushing sixty, with all of his hair shaved off for his latest role as the villain with the evil eye patch and leather codpiece in *Waterworld*, the postapocalyptic summer blockbuster.

"You appeared in a picture called *From Hell to Texas*," spoke the erudite James Lipton. "And here's Henry Hathaway, directing you in an entirely *different* way. You were young and *juicy* and rebellious. What happened on *that* set?"

"He gave me line readings," said Hopper. "Told me when to pick up the cup, put down the cup, when to get on the horse, off the horse, when to hold the reins, when to put the reins down, when to take a drag off the cigarette, how to say my name, and where to sit on the set."

A collective groan arose from an audience filled with aspiring Method actors to whom this prescribed paint-by-numbers style of direction was barbaric.

"I walked off the picture three times. So anyway, finally, the last day of the film—"

The audience could visualize it in their heads like sense memory, this tale of good versus evil . . .

From Hell to Texas . . .
Take Two!

Sick and tired of the rebellious actor's continuing defiance of his authoritarian direction, the villainous Hathaway escorted

twenty-one-year-old Hopper into a room on Twentieth Century Fox's lot filled with fresh canisters of film.

"You know what these are? I have enough film in those cans to work for a month. We don't have to go to lunch or dinner, or anything. We're just going to sit here until *you* do this scene *exactly* as I tell you. We'll send out for lunch, send out for dinner; we're here. Sleeping bags will be brought in."

So went Hopper's version of the showdown between the sadist director and the great actor (lasting three days).

"You want to see Hathaway and Hopper freaking out?" said executives calling each other from the major studios. "Come on over."

Warner Bros. studio boss Jack Warner finally reached his contract player on the horn. "What the fuck is going on? Do what fucking Hathaway says and get back over here!"

His entire studio career was on the line, and still Hopper would not do the scene the way Hathaway wanted it. Finally, on the eighty-sixth take, emotionally bankrupt after three hellish days, Hopper cracked. Exhausted, crying, broken as a kicked mule, he fixed himself up and, holding his nose, did the scene just as Hathaway wanted.

When it was all over, the director pulled him aside and sneered.

"Kid, there's one thing I can *promise* you. You'll *never* work in this town again."

Enraptured by this classic tale of the showdown with the bad guy, the Actors Studio audience sat in awe of the good guy—blackballed by the Hollywood studio system, forced to come to New York for his one shot at the notoriously competitive Actors Studio. Only three spots were available to a throng of fifteen thousand aspirants—not just amateurs, but seasoned professionals clamored to be accepted.

How to distinguish himself? As the line went from John Ford's classic about forging the Western myth: "Print the legend."

THE METHOD

Los Angeles is a city without principles. Mine were falling. So I left. What I mean is, movies are an art, or can be, but out there they make shoestrings. There's no time for creating except around a swimming pool. So I came here and began studying with Lee Strasberg at the Actors Studio. I never studied before. It's great working only from inspiration, but one day it's not there. An actor has to learn his craft. I always wanted to come here, but with Warner's I couldn't. Out there you need permission to go to the bathroom."

Closing his remarks on a New York City talk show in 1959, a year freed from the studio's shackles, twenty-two-year-old Hopper had full liberty to go downtown to the Village and drink up with the abstract expressionists who lurked at Cedar Tavern, a dark-paneled hive of tortured artists haunted by its own Dean: Jackson Pollock, killed in a car accident not long after Jimmy. Plastered and driven by existential guilt over a recent sale of a painting while his friends were still broke, one artist threw fifty-dollar bills into the air, screaming, "I'm sorry! I'm sorry!"

Alas, money could ruin the purity of art. Hopper knew it too well with an offer from MGM dangling before him, threatening

to destroy his image of himself as the suffering blackballed artist. Luring him away from the sanctuary of the hallowed Actors Studio, the bitch dog of Hollywood nipped at his heels. In need of some cash, Hopper slapped a bumper sticker on his Plymouth, THE ONLY ISM FOR ME IS ABSTRACT EXPRESSIONISM, and hit the road for the shoestring factory.

The Actors Studio had taught Hopper simple sense memory exercises that allowed one to experience sensations from the past while performing. Looking up from his crinkled newspaper, Strasberg would fire his Svengali gaze and instruct students to wipe the slate clean by shaking off all tensions. Then they were to ask: What was I wearing? What was I touching? Can I see anything?

On the set of *Key Witness*, MGM's low-budget thriller, Hopper played a switchblade killer, Cowboy, who wreaks havoc throughout East LA on his Harley-Davidson V-Twin Knucklehead. In addition to movie motorcycle lessons, he practiced his craft on a Vespa, racing Steve McQueen along the dirt firebreaks from Coldwater Canyon to the Pacific.

"We had so many wrecks my Vespa looked like a crushed beer can with wheels," bragged Hopper, acquiring the fashionable Italian scooter after getting his wheels taken away for too many speeding tickets.

The techniques of the Method were at his fingertips for his big love scene with a clingy sex fiend, perky in her bullet bra under a tight turtleneck. Action! She ran her fingers through Cowboy's hair. Cowboy reared back and smacked her. He'd just come back from a "bop," a battle, and no sharp fancy nails were gonna get stuck in his slick hair when he was all shook up.

In a flash, Cowboy split, screeching off in his Chrysler with the fins, going so fast out of his bad boy garage headquarters— "Muggles, open the door!"—the fat man who played the LAPD detective had to leap out of the way to keep from becoming roadkill.

"You have to keep your touch, smell, taste, sight, and hearing

really acute," Hopper explained of his method. "Which makes you totally bananas."

The proof was on film. Hopper definitely swung, bossing around his kooky hophead henchmen, but he wasn't anywhere near the mother of all Strasberg's exercises. Having seen actor after actor taken off the Studio stage in a straitjacket once they suddenly hit their *emotional* memory, Hopper finally dug what Jimmy meant. It *could* destroy him. Crash and burn. The thing was so dangerous it took *years* to build up to, years cut short by scurrying back to Hollywood.

Dragging himself out of bed at ten o'clock in the morning to dip into the stark tracts of Nietzsche poolside, Hopper took a final stab at keeping the pulse of Manhattan alive by trudging through modern absurdist plays in the California sun. He covered canvases in thick black oil paint, but it was no use, the sunlight kept shining in.

"Man, I felt like a fly killing myself on a window," said Hopper.

His only escape was to submerge himself in LA's underground art scene at the Ferus Gallery, harkening to *ferus humanus*, the wild man. Introduced to an underground art world of strangers like Wallace Berman, a shaggy Topanga Canyon mystic who kept an American flag decal on his back door—SUPPORT THE AMERICAN REVOLUTION—Hopper's worlds converged.

Landing his first leading role in *Night Tide*, a no-name, microbudget horror film directed by occult enthusiast Curtis Harrington and shot for $50,000 cash on the fringes of weird LA, Hopper played a sailor who falls for a sideshow mermaid on their first date in her nautical-themed apartment atop the Santa Monica Pier carousel. After a hearty mackerel breakfast under draped nets and hanging starfish, it should've been smooth sailing had it not been for Marjorie Cameron.

With her flaming red hair and sorceress looks, Hopper was convinced that Marjorie was an out-and-out witch. The Ferus artist was notorious for her drawing of a wicked beast humping a woman with

a forked tongue. She once attempted to embody the Whore of Babylon in a magick ritual to summon up some sick Frankenstein aberration called a *homunculus moonchild*. Then one day, just like that, Marjorie's rocket scientist husband, Jack Parsons, blew up in their garage. This was all in real life.

In *Night Tide*, no less weird, Marjorie played a siren who lures Hopper's love into the depths of the ocean. Letting out a moan as he rocked in his flippers in a rowboat, Hopper tried to comfort himself over the loss of his mermaid.

/ / /

Hopper had longed to sink his jowls into some real theater, ever since he'd been slated for *The Diary of Anne Frank*, which Warner Bros. refused to let him do because the timing interfered with publicity shots for *Giant*. Now he would have his Broadway debut as Hammond Maxwell.

All artistry was dammed upon entering the gothic gates of Falconhurst, an antebellum plantation dripping with magnolias and fortified by the pure stock of the ruddy Mandingo tribe. The gimp-legged son of a rheumy slave breeder, Hammond had no idea his blushing bride was really a New Orleans bed wench. At the Lyceum Theater, Hopper as Hammond scorned his wife, whose formidable talents in the bedchamber belied her repeated claims of virginity. Plum crazy and drunk on corn liquor, Blanche relinquished her taffeta, pulled the bullwhip from the drawer and deftly beat the baby out of Hammond's pregnant slave lover.

Vogue cover girl Brooke Hayward played the wicked whiptrix, and Hopper would never forget the time her whip accidentally caught the leg of the actress playing the slave, flaying her ankle. On the third day of rehearsal, he told Brooke he'd marry her. *Mandingo* tanked, but Hopper scored a hit.

The couple married in a small ceremony in New York in August

1961, a scattering of the bride's family in attendance to welcome Hopper into their Hollywood dynasty. Brooke's super-agent/producer father, Leland Hayward, hated the freaky homunculus. Joining the celebration was Brooke's childhood friend Jane, practically her sister with the Haywards and Fondas intertwined in business, marriage, and tragedy.

Jane Fonda invited the newlyweds back to her apartment for an impromptu reception attended by her younger brother, Peter, who tried to figure out the guy who had just married into the family saga. Hearing Hopper's story about someone back on the farm in Kansas who used to cut the heads off chickens, Peter thought he painted a very graphic picture of life in rural America. Why Hopper was going on about bloody chickens running about spurting blood just after his wedding, Peter couldn't fathom, but the chickens would be brought up on more than one occasion.

Peter was intrigued. He could see some incredible excitement in Hopper's aura.

THE MAD PAD

The great Bel Air fire of '61 roared up the canyon like a tsunami of flame, destroying the Hoppers' new home as well as six hundred poems (fifteen thousand, as Hopper's telling progressed) and three hundred paintings he'd created over the years. He tried to start painting again but just couldn't bring himself to do it, so he hammered his paintbrush onto the canvas and threw it into a corner.

Dark times awaited him at super-producer David O. Selznick's two-story Spanish colonial residence, shady enough for the reclusive Garbo to feel comfortable when hiding out there in the twenties. In the study hung the oil painting prop of Selznick International Pictures' *Portrait of Jennie*, starring the fiery beauty Jennifer Jones. David O.'s wife and leading lady was waiting in vain for another interesting project to come her way.

"That's not good enough," David O. would tell Jennifer as scripts arrived at the door. "You haven't worked for a while so when you do again, you're gonna have to make a *big* entrance."

Every night he dictated memos into the wee hours. The Kent cigarette never left his mouth. After every inhalation on its Micronite filter, he spouted to his secretaries scribbling shorthand,

going through two or three girls in a night, dictating, dictating, dictating.

Hoping for another *Gone with the Wind*, which he had produced in his glory days, Selznick tried to make F. Scott Fitzgerald's *Tender Is the Night*. Through heavy horn-rimmed glasses, he saw Jane Fonda clear as day as the Roaring Twenties starlet sucked into the world of the impossibly glamorous Divers, to be played by Jason Robards and, of course, Jennifer, who finally would make her grand entrance. Selznick had no idea that the studio moles would *destroy* his vision, making it unwatchable, grotesque.

From the privileged view in the Selznick guest house, where the Hoppers were invited to stay until they could get back on their feet, Dennis witnessed the final throes of an old Hollywood giant whose tragic flaw was caring too much about the movies—a bottomless pit for his obsessive micromanaging.

Embracing a kindred spirit with open arms, David O. dictated: "Keep truckin' it, Dennis."

/ / /

"Oh, Bob, look at that!" said Hopper, glimpsing a knockout. "Oh wow, back up, back up!"

On the last bit of Route 66, Hopper snapped a photo of a Standard Oil station's twin signs. He called the resulting work *Double Standard*.

Dennis was hardly ever without his Nikon camera dangling around his neck, his twenty-fifth birthday present from Brooke. He rode shotgun down a ribbon of highway. At the wheel was the son of Jennifer Jones and actor Robert Walker, cinema's most infamous traveling companion—the bad guy in *Strangers on a Train*. Just getting his start on the hit television show *Route 66*, Bobby Walker Jr., who had the same wicked smile as his dad, drove Hopper around to ogle the fourteen-by-forty-eight-foot billboards along Sunset

Strip, a roadside gallery featuring the world's largest collection of these hand-painted signs. Perfectly rendering portraits of the stars, the billboard painters of Los Angeles were the best in the trade, making cans of Spam look glamorous.

Right around the corner was Barney's Beanery, packed with a group of hot-rod-loving California artists inspired by the futuristic emptiness of LA. Becoming a regular, Hopper drank with fellow Dodge City refugee Billy Al Bengston, who created motorcycle-inspired paintings, and artist Larry Bell, who fashioned chrome-edged glass cubes—sleek beauties befitting their world of freeways. Larry liked Hopper, a funny guy, not full of himself like most of Hollywood. Bell didn't think anyone in the LA art scene took Hopper's work very seriously, but Hopper kept at it, making bizarre sculptures, one incorporating a religious candle stand and Chiclets.

"You should *really* concentrate on your painting," encouraged Paul Newman, showing up to Dennis's first gallery opening in 1963.

Dapper art dealer Irving Blum was rather floored by Hopper's sixth sense about painting. Not that Blum ever offered to show Hopper's work at Ferus, which he was dragging out of the amphibian stages and into the limelight, but somehow Hopper always seemed to be ahead of the curve, finding by chance a style or movement before it really had a name.

Whaam!

"That's it," screamed Hopper, jumping up and down before the work of a New York City artist, Roy Lichtenstein, who saw comic strips as actual art. "That's the return to reality!"

Hopper also loved those Campbell's Soup cans by a slight white-haired commercial illustrator dying to break out as a *real* artist. Andy Warhol lived in New York but wanted to exhibit his work in Los Angeles, given the glamorous fantasy that Blum had whipped

up for him of a gallery *filled* with movie stars. This was a complete lie, the only movie star who ever came to Ferus being Hopper.

"Let's do it," said Andy.

Hung on the gallery walls, in thirty-two different creamy and chunky varieties, Warhol's soup can paintings heralded a new kind of ism, plastered in Hopper's childhood memory from those bold labels of Bar-B-Q Prunes and Tendersweet Sweet Corn, a wallpaper of fruit and vegetables at his father's grocery. This "commonism," as pop was initially called, was a revolution for Hopper. There would be no more slogging through that tortured mode of the abstract expressionists that went hand in hand with the Method. Why not be *electric*—bubbly, fizzy like soda pop, or those terrific Spam billboards? Hopper bought one of Warhol's first tomato soup can paintings for around $100. However, after selling his friend the painting, shrewd gallerist Blum decided to keep all thirty-two varieties together as a group. Hopper never got to taste his tomato soup.

Soon enough, Dennis would meet Andy in New York. Starring as a patricidal killer in "The Weeping Baboon" episode of *The Defenders*, a CBS courtroom drama, Dennis read the Declaration of Independence from the witness stand. Andy hadn't met many movie stars and, visiting the set at Filmways Studios in East Harlem, was starstruck, remembering Dennis as Billy the Kid in *Sugarfoot*.

"So crazy in the eyes," said Andy. "Billy the Maniac."

Dennis finally had a true fan, a pop genius who could appreciate his range—from Fritz in NBC's *Swiss Family Robinson* to a Nazi in *The Twilight Zone*.

Andy hadn't been able to make it to LA for his Campbell's Soup cans show, but Hopper promised if he came out for his upcoming Liz-Elvis one, he'd throw him a real movie-star party.

To prepare for Andy's arrival, Hopper drove to the Foster and Kleiser billboard company and bought a giant hamburger and a giant can of Spam to wallpaper his new Spanish stucco home in

North Crescent Heights. He slapped a gigantic toothpaste-white smile over the sink. By the toilet, a man fed his maniacally happy wife a hot dog. The bathroom decorated, much to Brooke's dismay, Hopper went to work on the rest of his mad pad, a pop art wonderland with his own fake saguaro cactus, a giant rubber Coca-Cola bottle, a carousel horse, pipe organ, mirror ball, and gumball machine.

After a three-thousand-mile road trip in a Ford Falcon station wagon, listening to hits like Bobby Vinton's "Blue Velvet," Andy rolled up with his entourage. He was simply *amazed* at the people dancing to those songs he'd heard on the car radio. There were all these sons of movie stars, Bobby Walker and Peter Fonda, who Andy thought looked like a "preppy mathematician." Andy went gaga over Troy Donahue and Russ Tamblyn from *Peyton Place*. He even heard a twisted bit of gossip about Hopper's sexual kinks. Andy *loved* scuttlebutt.

"This party was the most exciting thing that had ever happened to me," remembered Andy.

Cruising the LA freeways, Andy stared up at giant Liz Taylor. Cleopatra loomed over the Strip.

Driving past the suburb of Tarzana, Andy was inspired to shoot a short film: *Tarzan and Jane Regained . . . Sort of.* Rather than deal with the likes of David O. Selznick, so *boring*, he did it on the fly. Whipping out his Bolex at producer John Houseman's swimming pool, Andy directed Hopper to shimmy up a palm tree in a leopard-print towel and get a coconut.

No Method needed, just pound the chest, swing around as he once had back on the egg ranch.

It was all so totally fabulous for Andy. Overwhelmed at the black-tie opening of the Marcel Duchamp retrospective at the Pasadena art museum, Andy puked on too much pink champagne. The dizzying possibility of art lay *everywhere*.

Running amok in his black tie with his Nikon, Hopper spotted

a hand-painted sign with a finger pointing toward the entrance of the historic Hotel Green, where the gala was being held. Freeing the sign with a screwdriver in an act of artistic liberation, Hopper presented it to the godfather of pop, Duchamp, who allowed himself to produce in his lifetime no more than twenty "readymades." On this rare occasion, Duchamp signed.

Miraculously transformed into art, *Hotel Green* hung at Hopper's home, christened by *Vogue* as "the Prado of Pop." The Duchamp/Hopper collaboration was in good company with Andy's *Double Mona Lisa*, Ed Kienholz's sculpture of a mannequin's head picking her nose atop a roller skate, and Lichtenstein's *Mad Scientist* paid for by Brooke's $65-a-week unemployment checks.

"You're married to a wealthy woman," Hopper's agent told him. "You're squandering her money. Look at this. You're making a fool of yourself. Get rid of these things or I'm leaving."

Out went the agent, to whom all this seemed like a pile of worthless junk. In came pop artist James Rosenquist, whose woman with red-lacquered fingernails hung on the wall courtesy of the Hayward fortune. Rosenquist could tell Brooke was a little weary of her husband, who'd turned their home into a must-stop welcoming station on the pop circuit with parties all the time and people wandering in at odd hours.

A creepy fourteen-foot Mexican papier-mâché clown floated on the ceiling, looking down on the hungry children—the Hoppers' two-year-old daughter, Marin, and Brooke's two children from her previous marriage.

"I'm going out. I'm leaving," said Hopper. "We gotta go get some food for the kids."

At the supermarket, Rosenquist saw Rock Hudson at the meat counter, staring at his fellow slabs of beef. Returning to his pop palace, Hopper cooked dinner in the kitchen with collages of vintage soup can labels plastered on the cupboards. Brooke popped in and started being really nasty to Dennis.

"I wanna go out and score some grass," said Hopper.

He took Rosenquist on a sub rosa Hollywood house tour. The whole neighborhood kept their doors open. Creeping into one darkened house, they saw people sleeping all over the floor.

"Whatever you do," whispered Hopper, "don't say anything. Be quiet."

Stepping over bodies, Rosenquist saw, at the end of a long passage, John Barrymore's son holding a baby. They got some grass and tippy-toed out.

MALIBU COLONY

Bred despite the wild sterility of Dodge City, he is now morassed in a creativeness that is almost as hopelessly complete as that which spread and drowned the great Cocteau," Terry Southern wrote for *Vogue*'s profile, "The Loved House of the Dennis Hoppers." "The Den Hoppers are tops in their field. Precisely what their field is, is by no means certain—except that she is a Great Beauty, and he a kind of Mad Person."

Terry was the consummate hipster on the scene, the Academy Award–nominated screenwriter of the seriously groovy *Dr. Strangelove* and the author of *Candy*, the banned sex romp based on Voltaire's native, optimistic hero. Still, he couldn't keep up with peripatetic Hopper, whose Nikon was a barometer for what was *happening*.

Amid the chaos at Allen Ginsberg's East Village pad, a naked beauty flung a potpourri of rose petals and dog hair into an electric fan blowing up from the floor as Buñuel's surrealist film *L'Age d'Or* was projected in reverse.

"It was all pretty weird, now that I think about it," wrote Terry. "Hopper—who even then was probably one of the most talented actors alive—became quite excited by the spectacle and eager to take part, gliding around in a Marcel Marceau manner, grimacing

oddly, and, at the same time, attempting to take photographs with a 35-millimeter Nikon."

Not long after, in March 1965, Terry warned his friend against going on a "madcap jaunt" to march from Selma to Montgomery with Dr. King. Brando had sparked Hopper's sudden interest in civil rights, having called everyone in Hollywood, rallying them to the cause. Hopper took off.

"Hopper, take care!" warned Terry. "You are spreading yourself thin—in this case, perhaps down to the proverbial mincemeat!"

In Alabama, an onlooker pissed on Dennis, who was marching between Joan Baez and Peter, Paul, and Mary. "White trash!" the guy yelled. "Hippie, commie, longhair!"

"Wow," said Hopper. "I mean, I don't care if he has *short* hair!"

The Confederate flag flew proudly atop Old Glory at the state house in Montgomery. Hopper photographed MLK asking the gathered, "How long?" Hopper was then off to document the rock-and-roll scene for *Vogue*. An American carnival passed before his lens. James Brown grinned at the girls smiling next to the James Brown Productions jet. In a Russian Cossack hat, David Crosby perched with the Byrds outside the LA County Museum. Dennis shot Jefferson Airplane and even touched down in swinging London to shoot Brian Jones holding a sitar.

The Rolling Stone handed over his mirrored octagonal shades to give to Peter Fonda.

Nicknamed "the Tourist" for always showing up with a camera around his neck, Hopper captured his own kind: the Hollywood hip. Within the gates of exclusive Malibu Colony, his clique drifted in and out to the sounds of Peter, in a white floppy beach hat, strumming his twelve-string acoustic guitar. A huntress in a flower-print bikini, his sister, Jane, pulled back the string of her archery bow. The tension quivered down her toes into the soft sands of Malibu.

Hitting the bull's-eye, Hopper captured Janey's perfect ass in black-and-white. Except for Hopper, life was placid here.

"You gotta come, Fonda," Hopper demanded. "You gotta see *this*!"

Hooked into the scene at the Pasadena art museum, Dennis took Fonda to foreign film screenings that couldn't be seen anywhere else in Hollywood. Along with the Buñuel/Dalí collaboration, *Un Chien Andalou*, Peter was particularly taken by a 16mm print of the Marx Brothers' *Duck Soup*. He'd seen *Citizen Kane*, but Dennis introduced him to Welles's ill-fated follow-up, *The Magnificent Ambersons*, a cautionary tale with Welles losing control of his film, chopped up in editing by studio moles who slapped on a happy ending.

If ever given a chance to make a movie, Hopper would have to figure out how to steer it through this land of the Philistines. Of course it was a fantasy in '65, when no major studio would've considered handing over the money for a Dennis Hopper film. It was more like a joke, but not for Hopper.

Binging on European art films and reborn to the possibilities of moviemaking, twenty-nine-year-old Hopper lacked the needed millions to mount his own production. But with the world as his set, he snapped his Nikon as the waves soothed Malibu and the sun set on its languid shores. Then he drove his Corvair convertible through a wall of fire to shoot the riots raging in Watts, another spectacular scene for his increasingly strange and ever-expanding montage.

DURANGO

Somewhere high in the Sierra Madre, 6,800 feet above sea level in the craggy state of Durango, Mexico, the bad guy with six-guns awaited a five-car train with an antique Stephenson steam engine built in 1892.

Overnight the dusty village of Chupaderos, pop. 300, had transformed into the frontier town of Clearwater, Texas, circa 1889. On this Wild West set, complete with a saloon, a gun shop with a rifle plastered on its side, and the American flag hoisted high above the town square, the real villagers, working as extras, gathered to greet the sons of Katie Elder, blood brothers riding in for revenge.

The voice on the megaphone bellowed through the once-peaceful streets. "*Tighten up!* You're spread out like a widow woman's shit!"

Hardly mellowed after his recent colon cancer surgery, Hopper's old foe Hathaway chomped a cigar as he prepared to direct Big Duke—John Wayne—in the Marlboro Man's 165th picture. *The Sons of Katie Elder* was Wayne's first since licking the big C himself, leaving him saddled with half a lung and an oxygen tank. Manacled to his brother at the ankle, Big Duke as the eldest Elder was to jump off a bridge into the freezing waters of the Rio Chico.

"You can't use a double for that scene," ordered Hathaway. "Do it yourself."

Off the set, Big Duke warded off his oncoming pneumonia with a couple of vitamin C tablets courtesy of his third wife, Pilar, a former Peruvian actress thirty years his junior. He was ready to shoot it out in his climactic scene against Dennis, playing the twitchy son of a murderous gunsmith.

"Duke and I decided you should go back to work," Hathaway told Hopper back when he cast him, seeing as how he and Brooke, a Hayward, had a little girl to look out for now. Hathaway laid out the rules: "No trouble from you, kid. This is a Big Duke picture, and Big Duke don't understand that Method shit."

Big Duke kept an eye out, ready to relieve his itchy trigger finger if what they said about the kid was true. Word around the saloon was he was a *subversive*, trying to sneak psychology into the classic Western.

All eyes watched Hathaway deliver line readings to Dennis before he rolled camera. Rather than another three-day showdown in the middle of nowhere, where he might easily be chopped up and fed to the rattlesnakes, Hopper mimicked his director exactly, just as Hathaway wanted.

"That was beautiful, kid," said Hathaway. "That was beautiful."

"You see, Henry, I'm a much better actor now than I was eight years ago."

"You're not a better actor. You're just smarter."

It was steaks all around, flown in from the Sands Hotel in Las Vegas courtesy of Rat Pack crooner Dean Martin, cast as one of the blood brothers, stuck out here in the woods without any broads. Hathaway cooked the meat himself over an open fire under a cathedral of ahuehuete trees. By the flickering light, Hopper considered the movies—they had such a strong effect on those making them, but especially on those on the other side of the screen. The

movies sent audiences into tailspins, making his mother wish she was married to Errol Flynn instead of a grocer.

Even more trippy? In six weeks the production would be gone, but the sets would remain.

Big Duke had big plans for Durango. In front of the hotel on the plaza, Wayne hoisted his fist in the air and sunk it into a patch of wet cement laid down by the villagers, a crude ritual mimicking his handprint ceremony at Grauman's Chinese Theatre. He was intent on turning Durango into his personal Eden, a place to settle down and make Westerns, working by day, sleeping by night to a rattlesnake lullaby. All the while oblivious to the fact that these villagers were now living in a Wild West set. When they moseyed past these facades, would they begin to confuse their simple lives with the world of movie fantasy? Would they slip across that imaginary line and act like movie cowboys, playing shoot-'em-up, spurring real rage and violence? What the hell would happen to the villagers?

Big Duke pulled Hopper aside. "Ya gotta get off that loco weed, boy."

On his return to civilization, Hopper dashed off a manifesto about his epiphany and showed it to his friend, Stewart Stern. The *Rebel* screenwriter thought it was very interesting, though at times he couldn't help wondering if Hopper was a phony. Like the time Dennis told him he needed to get a road.

"What do you mean, Dennis?"

The afternoon's adventure led to a studio prop shop, featuring hundreds and hundreds of yards of fake roads from all over the world: Dorothy's yellow brick, endless stretches of gray American highway, English cobblestones and dirt paths constructed to look from as far off as Timbuktu. They were all made of rubber and ready to be rolled up and taken away. Hopper had promised a charity auction a piece of original art, so he bought fourteen yards of

ancient Roman Appian Way, attached a hefty price tag and a title: *Found Object: Dennis Hopper.*

Bang! It sold.

Realizing Hopper's manifesto was far more valuable than a stretch of yellow-brick rubber road, Stern asked Hopper to sign it, holding on to it with a hunch that it might someday be important.

What we need are good old American—and that's not to be confused with European—Art Films. But who delivers? Where do we find them? How much does it cost? Where do they get the quarter of a million dollars? . . . No one knows the answer. But they will appear. America's where it can be done. . . . Yes we'd better do it then. Or I'm going to die a very cranky Individual, and I won't be alone.

Dennis Hopper

PART 2

The Last Movie

Z PICTURES

At home in Beverly Hills on his two acres of land with a tennis court and swimming pool, Peter Fonda figured he could do a film for cheap like American International Pictures. The independent studio was servicing the drive-in market with all those Frankie and Annette beach party movies. AIP also single-handedly revived the career of Vincent Price, star of its Edgar Allan Poe films directed by Roger Corman, a no-budget auteur hailed as the Orson Welles of Z pictures (that much further down the alphabet from B).

Fresh off of playing an astronaut in AIP's *Queen of Blood*, Hopper was sick of Z pictures. He was meant for greater things than teaching an attractive green-skinned Martian how to suck water from a straw. And kiss.

"Man, we ought to make a movie," said Fonda over a beer at his place.

"Aw, everybody says that," said Hopper. "But nobody really *does* it."

"I'd like to make a movie about a man who's lookin' for love. He's lookin' everywhere. At the end he finds out that love was what he had at the beginning."

"You serious?"

"Yeah."

"I mean, you'll *pay* for it?"

"Fuckin' A, I'll pay for it."

Fonda formed his very own Pando Productions company, and the two friends excitedly set about working on their first film together. Hopper called it *The Ying and the Yang*.

"No, Dennis, it's *Yin/Yang*. It's a one-word concept."

"No, it's *The Ying and the Yang*."

"There's *no g*, Dennis!"

In a rented house in Sherman Oaks, they banged out a screenplay with a third wheel and a secretary taking dictation. *The Yin(g) and the Yang*, as they compromised on, would begin with a spectacular shot of the sun rising over one of those giant donuts along the highway, like Randy's Donuts in LA.

/ / /

With Peter starring and Dennis costarring and directing, the two were off to New York to look for money to finance their "insane comedy," reported *Variety* in December 1965. Fonda told legendary columnist Army Archerd he hoped his dad and sister would make cameos—Yin and Yang.

In New York, the boys landed at a big art happening full of rock and rollers and models orbiting a sculpture composed of all sorts of things: wheels, bicycles, tricycles, balloons, and a money thrower. On cue, this contraption catapulted coins into the audience as the clanking behemoth began to saw, hammer, and melt itself to the ground. Someone had paid an ungodly amount to commission this sculpture and watch the whole thing collapse on itself in a pile of rubble.

"This is chaos and anarchy in the top form!" said Peter.

With all this money flung about in the name of art, surely they would find someone to finance a good old American art film. Ripe

for the taking was a gang of rich kids funding acid guru Timothy Leary's research on the psychic powers of LSD. Dropping tabs to save America, they'd also pumped money into an animated *Wizard of Oz* with Oz as the Buddha in the center of a mandala.

"There's tons of bucks!" said Fonda.

First on the list were Peggy and Billy Hitchcock, the Mellon bank heirs. Hopper and Fonda drove upstate to Millbrook, New York, to visit the siblings in a far-out gothic mansion where Leary was now headquartered. Perhaps the Hitchcocks were too deep into their exploration of consciousness, as well as playing with Fang, Leary's psychedelic dog, but the meet dead-ended pretty quickly, a total bust.

Also connected to the scene was the mysterious Van Wolf. This entrepreneur invited potential *Yin(g) and the Yang* backers to his Manhattan pad painted in psychedelic colors. Among his eccentric guests was Salvador Dalí, as well as Dalí's mistress and girlfriend. The two women pretended to be witches, but unfortunately weren't "angels," as Hopper called the yet-to-be-seen beings who might bankroll a movie. Dalí did however invite Fonda to take part in a happening, where they'd all fling paint onto an inflated balloon projected with *L'Age d'Or*.

Perhaps the boys would have better luck with the exorbitantly rich A&P supermarket heir who had commissioned Dalí to do a surrealist painting about Columbus's discovery of America.

"If you can levitate," said George Huntington Hartford II, "I'll give you the money to make the film."

"That's pretty swift, Hunt," said Fonda.

Hopper was sick of this rich-kid shit. "What man? Man, are you *kidding*, man!"

Their last hope was the *Mérode Altarpiece* by the Master of Flémalle. This 1425 triptych featuring the Annunciation starred a teenage Mary, the angel Gabriel, and in the right panel, Joseph making rattraps to catch the devil. Pictured in the left panel, along

with the patrons who'd commissioned the work, was a strange bearded man in red tights. This was the artist, defiantly putting himself in the painting.

"He saved art, man," said Hopper. Just like he and Fonda were going to save the American movie. They later considered making a movie about the whole experience of looking for funding.

Cut To: An apartment on New York's ritzy Upper East Side. Inside are HOPPER, FONDA, gallerist WALTER HOPPS, and Fonda's GOOD FRIEND. Before them is a triptych the Good Friend pulled from her closet. In the center panel, under the gaze of the ANGEL GABRIEL, is MARY. Hopps recognizes the scene from the *Mérode Altarpiece* hanging in The Cloisters. Or *does* it?

"That's a great copy of the *Mérode Altarpiece*," Hopps said of this fake. Hopper's friend, the director of the Pasadena art museum, was a shadowy agent in thick glasses who addressed the mysteries of art in the tone of government secrets.

"It's not a copy," said Fonda's good friend. "My father bought it as an original in 1935."

After an intimate investigation, Hopps was verging on tears, shaking he was so excited. "The wood looks right! But we have to have it investigated."

If the triptych turned out to be the original, Fonda's friend promised to sell it and use the money to fund the movie. Ordering up an unmarked black Lincoln limo, Fonda swaddled three potentially precious pieces of medieval wood in pillowcases, stashed them in the Lincoln, and blended in with the traffic heading to a Fifth Avenue mansion housing the Columbia University School of the Arts.

After the triptych was unwrapped and put on the easel, the art experts copped an attitude.

"Well, that's *not* the original."

"The original is at the Cloisters."

Blah, blah, blah—just putting these *movie* guys down, like they were dealing with a bunch of cavemen. But in comes this creaky old Frenchman on loan from the Louvre. The main dude. The triptych stops him in his tracks.

"*Où est la neige?*"

"What's he saying, man? What's he saying?" asked Hopper.

In the right panel, snowflakes were falling in a window behind Joseph. *Un miracle*—it turned out.

Everyone was "Wow. Wow." The creaky old Frenchman was absolutely blown away with no qualms about the authenticity of Hopper and Fonda's *Mérode Altarpiece*.

Just to be sure, the art experts wanted to take the triptych away and *test* the paint.

"No."

All eyes were on Hopper.

"Whaddya mean 'no'?" asked Fonda.

"Come here, man!" Hopper hissed, pulling him aside. "You know what they're gonna *do*? They're gonna take it and keep it, and give us the copy back, 'cause this is the fuckin' original, *man*! You know, man, we gotta get outta here!"

"Fuck," thought Fonda, swayed by Hopper's conviction. "He's *right*."

Real or fake, the triptych went back into the closet. Fonda went back up to Millbrook. Leaving New York alone in a taxi on the way to JFK airport, Hopper looked back at the skyline as the criss-crossed steel girders on the bridge passed above and the Beatles' "We Can Work It Out" went to static on the radio.

THE ANGEL

The form is now fifty years old," preached Hopper. "We're in the same period as the artists were right after the Flemish Renaissance! Fifty years later, man, came the Italian Renaissance, and man, filmmakers should be making Sistine Chapels now! Michelangelo and da Vinci, they didn't dig working for that Establishment pope, but they didn't get negative about it. They tried to do something that was a little uplifting. Not dirty, not violent! And *that's* what it's about, man!"

Phil Spector dug. Dandified in gold-rimmed shades, a ruffled shirt, and a pocket watch dangling from his three-piece suit, the boy genius record producer behind the famed Wall of Sound was in the midst of big changes. He had made his fortune engineering creations by girl bands like the Ronettes and the Crystals but was about to chuck his pioneering brand of teenybopper bubblegum pop for a new sonic masterpiece, something revolutionary. The *Citizen Kane* of pop!

Nikon in hand, Hopper caught Spector at just the right moment, documenting his epic Gold Star Studios sessions with a sweat-drenched Tina Turner belting it out in her bra. Shooting the cover for the big gamble upon which Spector was banking his

future, *River Deep—Mountain High*, Hopper posed Ike and Tina in front of a gigantic billboard with a movie star's enormous teardrop. Fortunately for Hopper, the album tanked, debuting at 98 on Billboard's Top 100, a crushing blow that made Spector turn his gaze toward the movies. A journalist came to interview him within the confines of his gloomy Hollywood palace draped in British oil-painted landscapes.

"The sad thing," said Spector, "is that most great artists start playing to the public rather than for their own satisfaction. This is why I must move on. Hollywood taught everybody around the world how to make movies. Now they've all passed us by. That's why Hollywood has to make a great art film—to show the rest of the world. *The Last Movie* will be that film."

To be directed by Dennis Hopper with a screenplay by Stewart Stern, *The Last Movie* promised a postmodern twist on the classic Western. Starring two generations of Hollywood royalty—Jennifer Jones, Jason Robards, and Jane Fonda, it would feature the very cast David O. Selznick, dead for a year now, had dreamed about for his big *Tender Is the Night* comeback. The first great American art movie would be a new beginning for Hollywood. Shooting would start September 15, 1966. And if the Philistines at the studios wouldn't finance it?

"In that case," said Spector, devilishly flashing the diamond studded *S* on his ring, "I will."

Charging forth to Durango, Hopper embarked on location scouting. Everything screamed "Go!" Then he returned to Spector's Phillies Records, the studio where his wunderkind music-turned-film-producer had developed an eccentric habit of wandering off to study his book on how to care for Saint Bernards.

Passing the time, Hopper learned karate from Spector's thick Hungarian bodyguard, Emil, who protected his boss in the Rolls-Royce and fearsomely wielded a black cane topped with a white death head. There were delays and delays for *The Last Movie*, the

routine trials and tribulations of independent moviemaking, the glamorous business with which Spector was becoming increasingly bored.

As the cost of the great American art movie swelled past the million-dollar mark, Spector pulled out, unwilling to risk his fortune. Retiring to his castle, the fallen boy genius obsessively watched *Citizen Kane* over and over in his private screening room.

Hopper had to find another angel. One possibility was Doris Duke. So that Hopper could meet this fabulously wealthy woman, rumored to be the richest in the world, flamboyant interior designer Tony Duquette offered to throw one of his lavish black-tie dinners in his extravagantly gaudy West Hollywood palace, a former silent movie studio. It promised to be a grand affair.

/ / /

Somebody's little munchkin in a yellow cape was waving a flag with a pot leaf insignia onstage before the Grateful Dead, noodling away at the polo field in San Francisco's Golden Gate Park. Hopper was as high as the far-out parachutist flying above the idyllic scene spread out at the Human Be-In in January 1967.

Up and away went pinkish, opalescent, rainbow-colored soap bubbles, blown by groovy chicks in a sea of feathers, body paint, flowing skirts, and tie-dye. Everyone flocked to Ocean Beach to watch the sun set over the Pacific, its horizon line significantly altered by thousands of turkey sandwiches handed out for free and spiked with acid.

Oh, man, Hopper was going to be late for that dinner.

Coming down from his Be-In acid trip, he entered a far heavier scene at what looked like the temple of a Sun God, complete with a throne Tony Duquette had imported from Chapultepec Palace— in Aztecan meaning "the grasshopper's hill." Instead of a tie for his

big Doris Duke dinner, Hopper sported a mandala hanging from his favorite love beads.

Covered in filth and with bloodshot eyes, he crashed the party, bursting in well after it started. After fingerbowls, he drove Doris home in his own yellow Checker Cab. Careening toward Falcon Lair, her Beverly Hills estate, he ranted on about how Hollywood needed to be run on socialist principles.

Revolutionary ideas had been percolating in his brain since his recent return to Warner Bros., playing a mentally retarded convict named Babalugats in the prison movie *Cool Hand Luke*. He'd been shackled in a rural California prison camp draped with genuine Louisiana moss and guarded by a dozen purebred bloodhounds from the Ernie Smith School for Movie Dogs, including a liver-and-red-coated movie star named Blue. To get into character, Hopper was forced to sleep in his motel room in a prison uniform and chains. Come sunup, he was slaving away, doing backbreaking labor on a chain gang, shoveling hard earth on top of steaming blacktop along a mile of country highway on a sweltering day. He had no lines to ease the pain. He was covered in steaming tar. All the while, the camera gazed lovingly on the blazing blue eyes of the film's shirtless star, who was thriving in the Hollywood system while only pretending to beat it in his role as the nonconformist rebel.

When Hopper ran things, heads were going to roll. Then *Newman* would be in chains.

Fleeing the Checker Cab, a terrified Doris Duke ran into her lair and locked her gates.

Hopper had barely scratched the surface of his plans. As the husband of a Hayward, he was able to lob his opinions like grenades at Hollywood parties with the fabulously stiff old guard. To august director George Cukor, whose recent *My Fair Lady* was a sheer delight, Hopper said, "You are the old Hollywood and we're the new. We are going to *bury you*."

THE TRIP

Peter Fonda was rocketing to stardom after AIP director Roger Corman, playing directly to the teenyboppers, realized that the staple villain of the beach party movies, Eric Von Zipper, a portly, leather-clad motorcyclist who spun sand on teen heroes Frankie and Annette, should be the hero. Corman's Hells Angels-inspired film, *The Wild Angels*, became a smash at the box office, grossing $10 million on a mere $360,000 budget. Starring as Heavenly Blues, an Angel who just wants to get loaded, Fonda led an outlaw biker gang on the way to an Angel's funeral. In the church, a drunken orgy ensued, complete with an altar rape scene.

Next up for Fonda on Roger's Z pipeline was *The Trip*, an LSD shocker promising all the terror, exhilaration, and ecstatic loneliness of an acid trip—as if the movie were the tab. A guy around the scene, Jack Nicholson, had written the screenplay. He'd kicked around with Hopper's friend Bobby Walker on the set of 1964's *Ensign Pulver*.

On the tenth floor of the Acapulco Hilton, getting into his role as "the man with the most original mind in the Navy," Bobby smoked up while thinking how crazy it was how this guy charmed everybody.

"If they would put Jack in a movie where he could be free to be *Jack*," thought Bobby, lost in contemplation, "if he could *ever* let out that innate charm and devil-may-care kind of rakish, sardonic, charming-wise-guy personality, he'd be a *huge* hit."

Only Jack was trapped in Corman hell. *The Cry Baby Killer* was only the first in an ignominious string of Corman roles Jack had suffered through for the sake of his craft, including the masochistic dental patient in *The Little Shop of Horrors*. Figuring he had a better shot as a writer than as an actor, he tried a new path, turning to screenwriting.

After reading Jack's final draft of *The Trip*, full of weird cuts and visually groovy acid-trip flashes, Fonda put it down, moved to tears.

"*Oh my God*," he told himself. "I get to work in the first real American art film. This is like American art shit! This is gonna go out in the theaters! I can't wait till Hopper hears about this!"

Corman doled out a part for Hopper as a drug dealer who sports a necklace strung with human teeth. He also let Hopper and Fonda go out on their own to shoot some scenes for the acid trip. These Bergmanesque sequences featured Fonda wearing a puffy blouse and running around the sand dunes in Yuma, California, and eating gruel offered by a dwarf in the forest near Big Sur. The cloaked figure of Death awaited atop a rocky bluff.

No Man Is Above the Law, and No Man Is Below It
Life Magazine's Bikini-Revealing Coverage
American Airlines to New York—4½ Hours of High Living
Rolaids

Hopper filmed Fonda wandering around in a preppy red sweater, passing before a revolving Bullwinkle statue on Sunset Strip, lost in the neon glow of the Whisky A Go Go. Using intercut footage, the

giant hand-painted billboards were going to be part of the acid trip sequence. There would be none of that projected cosmic plasma fantasia shit littering the bars and clubs, but something much more real.

But AIP, unwilling to risk the bottom line on something genuinely arty, thought kids might instead enjoy a mini-carousel with a midget rider. Or Hopper dressed as a psychedelic priest absolving a monkey.

When *The Trip* was unleashed to audiences in '67, it was totally decked out in spinning spiral projections in a DayGlo nightclub with naked painted go-go girls who'd been selected during AIP's televised Psychedelic Paint-In casting party. So Hopper could still be the first out of the gates with the great American art film. Could everything still fall into place?

Sitting beside Dennis on the beach, Fonda, practically his brother, had already told *Variety* he was committed to *The Last Movie*. This was supposed to be a family affair with not only sister Jane but Henry, too. The Fonda patriarch had read *The Last Movie* and said it was the most original Western he'd ever read, a staggering compliment from the man who starred as Wyatt Earp in *My Darling Clementine*, directed by the master himself, John Ford. Bobby Walker was to play a part in the movie too, just like his mother, Jennifer Jones, who believed in Dennis as if she were his own mother, seeing his dedication and talent, warmed by his creative spark.

"Make grand entrances and quick exits," she would say. Hopper thought he would pave her triumphant return to the screen.

And there was screenwriter Stewart Stern, who kept an eye on the boys, all just a little younger than him. Sometimes he thought it was *awful* how illusion grabbed them.

The boys delved into the meaning of existence, only to come up lost. That day on the beach, they'd all been having this wonderful conversation, which turned *funny* for the boys, who were being

clever, then brilliant, only Stern saw that the more brilliant they thought they were, the dumber they were, leaving him odd man out. Stern did not get high eating magic mushrooms or go down LSD rabbit holes. As a writer, his hold on reality was too precious. He simply couldn't be like Hopper or Bobby Walker, the movie star's son, paddling away in his canoe from Malibu to Catalina Island to find his spirit self.

For Bobby, especially, it was all about the pilgrimage. Dennis had to be constantly moving, but Bobby didn't have to do anything. He didn't have to photograph anything or have his ego stroked by civilization. It was enough to be out in nature at two o'clock in the morning under the moon.

One night, these huge ships began to bear down on his canoe. Bobby saw himself trapped in a strange movie: "Are they gonna run me over? Why am I putting myself in harm's way like this? Am I an *idiot*? Who do I have to kiss to get off this movie?"

At the very least, Dennis, Peter, and Bobby wanted to direct the movie of their lives. They liked Baja and hatched a plan to buy some land together, where they could settle down with their families in this utopia. They went to meetings with the Mexican landowners. Clean-cut Fonda would show up in his suit and tie, holding an aluminum briefcase. Hopper and Bobby wore hippie beards. The boys went from landowner to landowner, trying to get someone to sell them just a sliver to settle on.

Fearing a hippie invasion, nobody even wanted them to talk to the motel maids.

Fonda cut out early. He was always in a bit more of a hurry. Dennis and Bobby still thought they needed to hang out, talk to the farmers. The two were so friendly and nice but bombed out of their minds. Nobody ended up giving them the time of day down in Baja.

The twin Robinson Crusoes did discover an exotic out-of-the-way beach where no tourist would ever think of going. Wading into

the warm water—you could stand in it up to your waist all day long and never get cold or bored—Dennis admitted he'd always been afraid of the water. He finally surrendered and floated on his back. Bobby thought it was a wonderful healing experience. If only Dennis could have carried that feeling on and not drifted away.

LOVE

A little monkey with LOVE painted on his cranium. Ravi Shankar's entourage garnishing the crowd of flower children with rose petals. Hopper opened his eyes to the Technicolor experience at the Monterey Pop Festival during the Summer of Love.

His hair grown out, he looked lost and loveless, dwarfed beside Nico, the Teutonic goddess of the Velvet Underground. Onstage against throbbing plasma projections wailed terrifying Grace Slick. Humongous Mama Cass of the Mamas and the Papas swayed beside her cassocked Papas and . . . *Gorgeous.*

Shimmering Mama Michelle Phillips was the ultimate fantasy with the face of an angel and the voice of a siren. She shone directly onto an ecstatic Hopper, who soaked in the purest, most beautiful moment of his whole trip.

The psychedelic experience had taken on religious dimensions for Hopper ever since that strange visit with Fonda to find angels. There in Manhattan, one night in a hotel lobby, Hopper had encountered a prostitute reading the Gospel according to Thomas. Translated from Coptic scrolls discovered in Nag Hammadi, Egypt, in 1945, the Gnostic Gospel floated among the spiritually

hip who liked to fuck and think about the meaning of gnosis, or "experience." During a walk through Muir Woods, Dennis recited the Gospel for Michael McClure, playwright of *The Beard*, in which Hopper would play the role of Billy the Kid. A fallen redwood lay in his path. Dennis laid a hand on it. His handprint seemed to sear into the bark. Was it the drugs or *real*?

Hopper was going a little crazy. Brooke felt her husband was getting dangerous.

Back at the Love-In, held on Easter Sunday before the Summer of Love, Hopper had snapped away with his Nikon. A fleshy conga line of flute players, wandering minstrels, and a girl with a heart painted on her forehead wound through the forest. A wild creature in a loincloth completely freaked out, gyrating naked and screaming incantations. Some dumbfounded cowpoke chewing gum watched from the sidelines.

Hopper showed Brooke the proofs of the groovy shots he'd taken, only she wasn't too impressed. She was in a rush to pick up the kids from school—"Well, Dennis . . ." He broke her nose with a single swipe.

POW!

A few months later, Brooke sat in the audience at the Warner Playhouse on La Cienega Boulevard, where Hopper was deep into rehearsal as Billy the Kid. *The Beard* was set in heaven, described by the playwright as a "blue-velvet dominated eternity." As Billy, the dandified killer, Hopper hurled insults at bubbly sexpot Jean Harlow. After she made fun of his long sissy hair, Billy ripped off her panties, as directed, and dove in headfirst.

Plagued by awful performance anxiety, Dennis went completely nuts after rehearsal. He wanted Brooke to stay, but she insisted she had to get home.

"I've left the children alone," said Brooke, impatiently. "I've got to go home."

"No, I don't want you to."

Out in the parking lot, as Brooke climbed into their Checker Cab, Dennis burst into a tantrum. In front of a dozen onlookers, he jumped on the yellow hood and kicked in the windshield while Brooke sat terrified in the driver's seat. She drove home with the wind blowing in her face.

/ / /

Dennis followed his light, dancing a path to the other side of Death Valley. The desert pit was too hot for any respectable film studio but perfect for AIP's latest shocker, *The Glory Stompers*, originally slated as a Western. But in Corman pics, entire plots could change overnight. The Indians became a menacing biker gang of well-oiled Black Souls. The traditional campfire scene metamorphosed into a leather-clad mosh pit of chicks with beer guts lubricated by the gasoline fumes spewing from a pack of revved-up Harleys.

In a cutoff jean vest, Hopper straddled his purple chopper as the leader of the Black Souls, then snuck off to the bushes to smoke dope. "Grasshopper," his fellow cast members called him.

Back in San Francisco, Grasshopper was hanging out with the Diggers, the guys who salted the turkey sandwiches with acid to turn everyone on at the Be-In. Led by Emmett Grogan, the Diggers were a self-described band of "community anarchists" in an underground rebellion. An offshoot of the Diggers, the San Francisco Mime Troupe floored Hopper with their bawdy, ribald free-for-all guerrilla theater like something from the Old Globe.

On this particular occasion, Emmett and the Mime Troupe director Peter Coyote were roaring on about some story—"Bein' profane, as we do," recalled Coyote—when suddenly, some guy

who was hanging around took offense and punched Emmett in the face. Hopper didn't miss a beat. Jumping up on the table, he drop-kicked that motherfucker in the cranium. Grasshopper was no one to fuck with.

The Diggers dug. Hopper was proving himself not just as an actor, but as a real motorcycle hell-raiser like Sweet Willie Tumbleweed. Held in high esteem by the Diggers, this unbeliev-ably poetic man spun great stories underneath his long hair and menacing leather-clad exterior. He could stop a crowd just by star-ing at them, but the Diggers saw him lie down like a dog before the raw masculinity of the Hells Angels. The Angels sort of took him over to the dark side, but he was a Digger first.

One night, the Diggers and Sweet Willie were all hanging out with Hopper and Fonda.

"You know, if I was gonna make a movie, I'd make a movie of me and a buddy ridin' around America, doin' what we do, seein' what we see," said the burly man prophetically, or so the Digger legend went about Sweet Willie Tumbleweed, spinner of stories, the kind that really stuck.

RED FLOCK ROOM

On his promotional tour for *The Trip* in Toronto, Peter Fonda enjoyed Z picture star treatment courtesy of AIP. Staring into the weird Victorian wallpaper in the Red Flock Room at the low-rent Lakeshore Motel, Fonda figured it was probably a hooker's room. He cracked open a Heineken, lit up a doobie, and commenced signing a stack of eight-by-ten *Wild Angels* glossies of him and his costar, Bruce Dern, riding a chopper. Six-foot-three Fonda wondered idly why he only looked about two-and-a-half inches in the photo.

Who in publicity picked this particular still? Even when he wrote, "Best Wishes, Peter Fonda," it was like, "Where am I?" You couldn't tell. You didn't know.

He and Hopper hadn't been on the best of terms, mainly because when he'd split for Toronto, Fonda didn't want Dennis to direct his yet-to-be-recorded album: *Got to Get You into My Life*. Fonda figured he could rip off the Beatles' song title because when he and John Lennon were tripping at the Playboy Mansion, Fonda kept whispering, "I know what it's like to be dead, man. I know what it's like to be dead," which was sort of true because Peter had

accidentally shot himself in the stomach when he was eleven. Lennon took Fonda's line for his song.

"Dennis, you can't keep a beat," said Peter, offering an explanation of why Hopper couldn't work on his album.

"No, I wanna direct it!"

"Dennis, you don't *direct* an album, you produce an album."

"No, no—"

"No, Dennis, this is sound, not imagery."

"I wanna direct the album, man. You know, man, I mean—" Hopper, a bullheaded Taurus, started grabbing his own earlobes.

That was the problem with Hopper, Fonda realized; he was a stubborn bull and his heart carried this paranoid thing. It was just part of his character. If you understood it and liked Dennis, and Peter did, you rolled with it. If you didn't, you'd call him out on it and end a friendship real quick.

Hopper stormed and ranted till finally, fed up, Fonda picked up his Nagra tape recorder with its reel-to-reel tape deck. He'd bought it to record the endless well wishes of strangers who stopped him on the street to gush, "You know, I really love your father. He's my favorite actor, and I love your sister!" He was planning to put all of this into his album, but instead smashed the Nagra to the ground.

"Dennis, when you can fix *that*, then you can direct the album."

"You're a fucking child! Did you hear yourself? I can't talk to you. I'm leaving! I'm leaving! I'm never gonna speak to you again! You steal *everything* from me!"

That passion was one of the great things about Hopper, figured Fonda. When he was set off, it was like lighting a fuse.

Fonda cracked another Heinie, fired up another doobie in his red-flocked cocoon. Up in the firmament, outside his window, Brando, Dean, and Clift twinkled in the cosmos. Marlon's comet shone brightest. It hooked around the sun, didn't get sucked in, and then seemed to orbit *around* it. A celestial navigator, Fonda watched

it come, exit—it was really incredible. The tail of that comet sent showers and meteors fizzling down through the atmosphere.

Being a Fonda, Peter had known Marlon from the time he was fifteen, meeting him the same year Jimmy died. Peter didn't know Jimmy, but he knew his work, so when he first met Hopper, ranting about those bloody chickens, Peter recognized him from Jimmy's movies and asked him about Dean. For Dennis, knowing Dean was a badge of access, like a backstage pass, something he always wore. Fonda knew how Hopper got *into* Dean, studied Dean, wanted to know why Dean would do this, why he would do that, what his process was for deciding how to fill the empty moment. Looking back at that glossy of him on the chopper, Peter figured, who better to have as his own riding partner—and director—than Hopper, who'd taken that road with Dean?

"That's it!" snapped Fonda, jolted out of his red-flocked haze— "It's not about one hundred Angels on the way to a Hells Angels funeral. It's about these two guys ridin' across John Ford's West."

It'd be just like *The Searchers*, with Big Duke on the trail from snowy Gunnison, Colorado, to Mexican Hat, Utah, hunting for his orphaned niece played by Natalie Wood, who'd been kidnapped by Comanche. Naturally Fonda would be Big Duke, being the Big Duke of biker Flicks, only he wouldn't be going west but east, like the seeker in Hermann Hesse's *Siddhartha*. And Fonda wouldn't really be Big Duke, but more like Wyatt Earp, whom his father once played, or better yet, Captain America! He'd need a floppy-hatted sidekick, of course. Maybe they'd call him Bucky—or Billy? Like Billy the Kid!

So who would play Natalie, the living embodiment of the hero's doomed existential quest?

Dig this. America. Far-out. Only they wouldn't find her. Anywhere. Fonda picked up the phone.

EASY RIDER

This is *my* fucking movie, and nobody's taking my fucking movie away from me!" Hopper screamed in the New Orleans Airport Hilton parking lot on a miserable early February morning in 1968 with unnaturally freezing temperatures and forecasted snow. Kicking off the first day of shooting on *Easy Rider* during Mardi Gras, somehow Hopper didn't seem like the same director who, all mellow, had told his cast and crew in California days earlier, "This is going to be a group of friends and we're all our own person. Do your own thing."

The assembled actors, documentary filmmakers, photographers, audiophiles, and assorted groovy characters listening to his parking lot tirade had been plucked from the underground LA movie scene. They'd been told they'd be taking a semidocumentary approach to the shoot, playing it loose, rolling with whatever came their way on the manic streets of Mardi Gras. Amid the chaos of drunkards, frat boys, and drag queens, they were to film the climactic scene of *Easy Rider* when the bikers Wyatt and Billy— Fonda and Hopper—traipse about with two whores from Madame Tinkertoy's bordello on their way to drop acid in one of the city's famous above ground cemeteries.

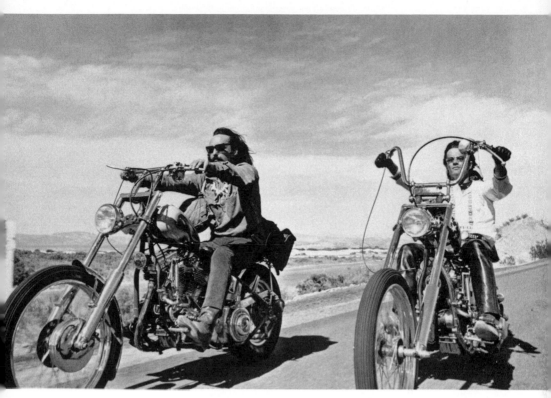

Billy and Wyatt riding choppers, Easy Rider, *1969*

Shivering in her costume of fishnet stockings and a glittery silver wisp of a dress, frizzy-haired Karen Black couldn't believe they were actually in New Orleans shooting among all these people.

"My God," she had thought when she first met Hopper in LA. "He's very full of life and energy." Immediately taken by his idiosyncratic, peculiar sort of genius, she typed up a contract for herself since her agent was out of town. For $300 she now found herself locked in a New Orleans antiques shop with the other actress cast as a bordello whore, vivacious, black-haired Toni Basil, because Hopper didn't want to misplace anyone.

"Okay, okay, come out, come out. Okay, are you there? Are you there?"

"Yeah, we're here. What do you want us to do?"

Flying in from New York to join the party was the screenwriter. Instead of hiring some nobody to write the script, Fonda had wooed Terry Southern, hot off of writing the screenplay for *Barbarella*, a space-age sex romp starring sister Jane. And just like some fucking writer, Terry had proceeded to change, in his own nomenclature, the "wrong-o" title of Hopper and Fonda's biker movie, which they originally called *The Loners*. Squaresville. Terry rechristened it *Easy Rider*, using the lingo for a whore's old man: not a pimp, just the guy who wants the easy ride.

"Well, that's what's happened to America, man," Fonda told *Rolling Stone*. "Liberty's become a whore, and we're all taking an easy ride."

Terry withdrew into the Clark Cortez motor home production vehicle/on-the-fly-story-conference-room rambling through the streets of New Orleans. Karen affectionately called the camper "the Winnie." Passersby might have seen a crumpled page of script ripped from the onboard typewriter go flying out a curtained window onto the bead- and confetti-littered street, or heard Southern, Hopper, or Fonda screaming inside—likely all three. The buzz among the crew was that Terry, being the screenwriter of the trio they called the "brain trust," was there to write scenes with Hopper and Fonda.

Nobody was sure what was giving them such a hellish time in there. Could they not decide on the scenes they were going to film in Mardi Gras? Was there even a script? Or was Hopper overly confident about his ability to make up scenes based on in-the-moment inspiration?

"I believe what Cocteau said," went the familiar Hopper rant. "Ninety-eight percent of all creation is accident, one percent intellect, and one percent logic!"

At any rate, something was being cooked up inside the roving Clark Cortez, which was like hell—or artistic creation and destruction—on wheels. The Winnie charged forth through

narrow cobbled streets bloated with revelers. A circus car that had lost its train, or Chitty Chitty Bang Bang on acid, this character with headlights for eyes emitted the strange shouts, shrieks, and hysterical laughter of its riders, typically heard at odd hours. She huffed, puffed, gurgled, and belched out a cloud of cigarette and marijuana smoke, seeing as everyone in the RV seemed pretty loaded. Terry was a big martini man, and Hopper enveloped everyone in his fairly continual cocktail of dope mixed with red wine, pills, speed, and whatever Cracker Jack prize made its way across the Winnie's communal table.

While the brain trust battled their demons inside the Winnie, some crew members dropped the occasional tab of acid, waiting around to be told what the hell they should go shoot today. Fed up, some simply got up—"Well, screw it. Let's just go out and start shooting things."

Like tourists with very expensive cameras—an Arriflex, a Bauer, an Eclair—the crew shot the big Mardi Gras parades rolling down Canal Street. Flambeau carriers lit the path of three golden seahorses in the Krewe of Endymion parade. Bandits and a train barreled into a fake tunnel on *The Great Train Robbery* float celebrating the 1903 silent film. Crowds cheered on Paul Bunyan and Daniel Boone taming the frontier.

Meanwhile, another character of American folklore was going a little nuts.

In his fringed buckskin jacket and a necklace strung with white seashells from Baja, Hopper pushed his way into the French Quarter with *his* movie, weaving through street vendors hawking footlongs and multicolored paper happy flowers in full blossom on long sticks.

"Be quiet, please. I'm trying to shoot a major motion picture over here!"

The crowd threw beer cans at him.

At night at the airport Hilton, Karen and Toni shared an

uncontrollable case of the giggles. They felt trapped in Dennis's movie. It was too funny. It was such a horrible disaster.

"We've made a terrible error in our lives!" squealed Karen.

They were laughing so hard, they fell off the bed. Suddenly a huge reel of black film came rolling through their door like a tumbleweed. Chasing after it was Hopper, followed by his cameraman. Apparently, Hopper was on a mission to collect all the canisters of the film they'd shot so far.

"I don't trust you. Gimme all your film. I want it in *my* room!"

CRAAAASSSHHHH!

In the course of the struggle, a television was hurled across the room. The two rolled over each other until finally Hopper found himself sitting on top of his cameraman, straddling him.

"I love you, man," said Hopper with genuine emotion. "Man, I *love* you."

Securing the film, Hopper proceeded to try to wrench away the camera to go out to the parking lot and shoot the fantastic neon signs caught in the puddles. Karen noticed that he was always out at night, shooting, shooting, shooting. She worried about him and offered him some health-food shop vitamin E to keep him going.

"What's that?" he said, examining the pill.

"It's a *vitamin*, Dennis. It's not gonna hurt you."

Capturing the neon in the puddles was the least of his worries. The final big day of Mardi Gras, Fat Tuesday was the next morning, and Hopper still hadn't gotten a shot of their characters—Billy, Wyatt, and their two whores—in one of the parades.

Unfortunately, nobody had a permit to film the actors in those official parades about to hit Canal Street. That left only the ramshackle African Zulu parade with blackface warriors dancing and gyrating in grass skirts. The whole procession disembarked from the royal barge and meandered uptown according to its own whims

and free will. With no set schedule, it was anyone's guess how to catch the parade.

Luckily, among Hopper's crew was cameraman Les Blank, self-schooled in the arcana of American spectacles—from kudzu to zydeco—and a dedicated student of the black Mardi Gras. A socially conscious great white hunter, Blank knew how to chase down the Zulu.

The Clark Cortez took off uptown as inside its tinny abdomen Hopper tried to work the Zulu into his script. The crew saw him constantly trying to control the chaos around him instead of just going with the flow—"Why doesn't he just roll with what's happening?" Deciding to leave the director behind for a little while, they went off and did what they thought needed to be done. Emerging from the Clark Cortez, which was parked on a little sandy spot near an intersection, Hopper got out and stewed in his sand pile as his movie walked away from him. Like Orson Welles once said, dashing off to Rio in a Mars flying boat to film Carnival, "You know, I *hate* carnivals." In the swirling chaos, Hopper now felt the same. Rio was where Orson had lost control of *The Magnificent Ambersons*. Sweat bubbling on his brow, Hopper was terrified of his own grandiose failure.

"Orson Welles failed, but like hell I'm going to fail," he told his crew throughout the shoot.

/ / /

"Where are we?" asked Karen, grabbed by one of these rogue cameramen. "How are we gonna shoot this movie when we don't have a director? We don't have Toni or Peter."

Feeling out to sea in the parades, Karen gave a local kid a buck to go find Hopper. But of course the kid went and got himself a soda and she never saw him again. Suddenly she heard the music and a thundering like a herd of approaching elephants.

"Mardi Gras is coming!" she cried. "What do we *do*?"

"Get in the Mardi Gras," one of the crew guys told her.

Karen reached out to touch a gigantic white-feathered head-dress that in keeping with the celebration's tradition, the Mardi Gras Indians wore as they faced off against each other, preening and fluffing their feathers and spewing their rhyming verbal throwdowns until one was finally forced to give in to the other by calling him the prettiest, thus submitting to his foe. The posturing was all part of an elaborate ritual of life and death from back in the day when the Mardi Gras chiefs, before going off to fight their bloody turf battles, abided by the saying, "Kiss your wife, hug your momma, sharpen your knife, and load your pistol."

The Indians swung their hatchets to make way for the chiefs. Karen was lost in the jewels and feathers of the Zulu parade. Suddenly Hopper was there. He steered his movie through uptown turf, clearing the path to be filmed.

His pudgy face masked by a droopy mustache and long greasy hair, Hopper, in his fringed buckskin, marched around the *real* star, Fonda, the chiseled motorcycle god in his black leather jacket with an American flag sewn on back. A walking piece of pop art.

Tourists puked Hurricanes onto Bourbon Street. Girls flashed their tits for baubles thrown from the wrought-iron balconies. Hopper got his parade shots, but would *Easy Rider* ever be *his* film? Would anyone even clearly remember Billy, the freak sidekick with the ill-defined, nearly blurry features, a giggling madman?

/ / /

"I'll tell you what made me want to become an actor," James Dean had once told Hopper, "what gave me that drive to want to be the best. My mother died when I was almost nine. I used to sneak out of my uncle's house at night and go to her grave, and I used to cry

and cry on her grave. 'Mother, why did you leave me? Why did you leave me? I need you . . . I want you.'"

Dean pounded on his mother's grave, cursing her and wailing, "I'll show you for leaving me . . . Fuck you, I'm gonna be so fuckin' great without you."

/ / /

"You see that guy?" Dennis asked no one in particular, peering out the window of the Clark Cortez. "I'm gonna get him. I'm gonna *get* that guy."

"What are you talking about?" asked Karen.

Karen was here in the Winnie, but Dennis was somewhere else entirely.

"Den-Den," Terry called his friend. When Den-Den went over the edge, Terry would say, knowing how much he worshipped Jimmy, "Jimmy wouldn't like that."

Perhaps that .45 Jimmy used to sleep with accounted for Dennis bringing loaded guns to Mardi Gras, keeping him safe at night in the airport Hilton. Terry dug the weirdness. Den-Den was a groove and a gas and a visual genius and all, but what was *with* him constantly screaming at him in the Clark Cortez? Feeling worn down to the nub like an eraser, an exasperated Terry, who spoke in beautiful sentences, most of the time anyway, said, "I can't any longer stand the cacophony of your speech."

"Ya can't stand the cacophony, huh? Cacophony, huh? Is that right?"

The following morning they were supposed to shoot the graveyard scene. Karen couldn't go to bed, so horrified because nothing seemed arranged. Nothing that needed to be decided had been decided—nothing, nothing, nothing!

"Well, I gotta sleep, and I'm real wakeful," she said.

Peter gave her some sort of pill, a sleeping pill, or who knows what-the-hell-kind-of-pill it was. Karen swallowed it, but instead of it getting dark inside her head, like a movie theater, to go to sleep . . .

"I can feel the outside of my skin," she whispered to Toni in their darkened hotel room. "I can feel the outside of my body, but I can't sort of, *get in.*"

The next morning, Toni announced to the brain trust, "You know Karen was saying some really *interesting* things last night about what her response was to whatever it was that Peter gave her, and I think she should write it."

Sitting in the Clark Cortez in her fishnets, Karen typed up some dialogue. Terry sat beside her giving her some writerly advice.

"I would really *love* it if you would give me your underpants so I can smell them."

The Winnie bumped along toward the cemetery. Mardi Gras was over, commencing the period of Lent, the time of penitence and prayer. From ashes they came, to ashes they'd go.

The cemetery gate creaked open with wrought-iron arrows pointing downward toward death. Stone angels watched Hopper enter their maze of crumbling tombs crowded onto shallow swampland. Here lay, among duelists and scoundrels, the Voodoo Queen High Priestess of New Orleans Marie Laveau. White chalk *X*s marked her resting place.

Despite Karen's jittery reservations, the graveyard scene had actually been scripted in the screenplay pages that emerged from the Clark Cortez madness. Her and Toni's time in the graveyard with Billy and Captain America was to be a holy communion of acid and red wine, everything in keeping with the Gospel according to Dennis Hopper.

Could they hope to reach the kingdom until they became little children again and took off their clothes and made merry? Billy

got inside one of the tombs with "his whore"—Karen—his lady of the night.

"You can go crawling in these walls," warned Terry from the sidelines. "But there's probably rats in there."

As the director, Hopper occasionally jumped out of the scene to look through the camera, then came back in as Billy and poured a bottle of wine down Karen's throat and laid on top of her and started kissing her, his princess goddess with her long reddish-brown hair and silver dress.

"I wanna be pretty," cried Karen, real tears starting to fall. "I just want to be pretty."

Looming above the scene was a beautiful stone woman nestled in the baroque marble mantle of the New Orleans Italian Mutual Benevolent Society Tomb. The Italian Statue of Liberty was what Hopper called her, or . . .

"It's your mother, man," Hopper directed, prepping Fonda before the shot.

"You can't ask me to do that," said Fonda. "Just 'cause you know my family history and because you married into it in a way doesn't give you the right to force me to do that. I'm not about to do that on film. I don't wanna do that at all."

"No, you *gotta* do it."

Even if it destroyed their friendship, Hopper was going to make Fonda get up on that statue and ask his mother why she copped out on him, killing herself in an insane asylum when he was only ten, the year before he shot himself in the stomach. In the Fonda family, she was treated as if she had simply ceased to exist. No service, memorial, nothing.

"No, I don't wanna do it. I'm not gonna do it, man."

Tears riddled their way down Hopper's face as he tried to make Fonda get up on that statue.

"Gimme one good reason," yelled Fonda, finally, out of total frustration.

"'Cause I'm the *director*."

Fonda climbed up. Cradled by the stone woman, he wailed to his mother, telling her how much he loved and hated her. It would work perfect for the acid montage. Hopper captured something for his film that was real. Hungry to break new ground, he wanted desperately to express something that the world needed. He could already feel this *biker flick* was gonna be major, just like he'd told the crowd of drunks at Mardi Gras.

The light was breaking out above the graveyard. Hopper directed the camera to tilt and crawl up the side of a stone crypt to the gray sky above, and the sun with all its crazy energy shot down upon him.

LEWIS AND CLARK

Herky-jerky shots plagued with light leaks. Erroneous exposures. Wrong focal length. Jumpy telephoto shots. Wet lenses.

Unfurling in the screening room, the Mardi Gras dailies were not a promising kickoff for Peter Fonda's Pando Productions. The movie seemed to have so much promise back when it was called *The Loners*, originally slated to be the ultimate AIP shocker fusing *Wild Angels* choppers with the druggy haze of *The Trip*. Z king Roger Corman had been on board as the executive producer. And as for the script?

Well, see, Corman had a philosophy about writers. Take Jack Nicholson, that actor-turned-writer who was always hanging around? Jack had actually refused to write *The Wild Angels* when Corman offered it to him. Because Jack wanted to be paid more than just scale. He kept on needling Corman about the downside of making movies for as cheap as possible, so Corman finally ended up giving Jack just a tad more to write *The Trip*. These two mega-hits ended up making $16 million on a combined budget of around $700,000. It was Z heaven for Corman to sit back and think about how little he could spend on a screenwriter while making millions

on *The Loners*, starring two bikers who make a big drug score, hit the road and retire to Florida.

"We're not arty-farty here," barked AIP executive vice president Samuel Z. Arkoff, bankroller of Z pictures, in case anyone misunderstood studio policy, or had pretensions of making a *great* biker flick. That sounded dangerously close to breaking the Z studio's golden rule: skimp by any means necessary. Smoking a fat cigar while calling the shots, Arkoff budgeted $340,000 for *The Loners*, twenty grand less than *The Wild Angels*. He drew up the contracts for Hopper and Fonda, who would both costar and write for cheap. Hopper would direct, sure, but Arkoff wasn't gonna give him an inch. To keep Hopper from being an arty-farty auteur on his dime, Arkoff included a flytrap—like Audrey Jr., Corman's giant human-eating plant in *The Little Shop of Horrors*. If Hopper fell more than *one day* behind schedule, AIP had the right to replace him—or else feed him to Audrey. AIP's way or the highway.

"I can't put that kind of pressure on Hoppy," said Fonda, going to bat for his eccentric friend.

Knowing all about these boys and their beefs with AIP's gangland restrictions, Jack slipped their potentially *great* motorcycle flick over to Raybert Productions. It so happened that Jack, also desperate to climb out of the Corman sale bin, was writing a psychedelic mind-bender starring the fake rock group that the hip production company had created for their hit TV show *The Monkees*. Raybert was into movies being really far-out, heady—something like Fellini's *8½*, but Jack figured nobody would put up money for a Dennis Hopper flick, so adding Terry Southern's name into the mix as a screenwriter brought real cred. "I mean, if you know Dennis," said Jack, "you don't exactly turn some money over to him and say, 'No problem.' You know what I mean?"

The Bert of Raybert, Bert Schneider, promised twenty grand more than AIP and no pressure on Hoppy, and with a check for a certain amount of Monkee money, the boys went off on their Mardi

Gras adventure. But after they returned from the Big Easy, the results projected on-screen for their backers were, well . . . *Jesus*.

"An endless pile of shit," remarked someone.

Fonda was prepared to give back the Monkee money. He personally didn't think the film could go on after Hopper's megalomania during Mardi Gras. If the dailies weren't enough evidence of Hopper's madness, Fonda had recordings of Hopper's manic ravings in the Clark Cortez from the soundman, a groovy guy of the audio persuasion who thought it would be interesting to stick a mike up in the ceiling and just roll tape, vérité-style. It wasn't that the guy had any particular plan of what to *do* with the tapes. He was just going with the flow. Or that's what he thought.

Weighing the available evidence, Bert judged whether or not to let the wild-man director run amok with more of his Monkee money. Any normal executive would've kicked Hopper to the curb, but Bert, steering Raybert's vanguard of hip, would've gladly made another *Head*—the Monkees movie that was a total box office flop—over the Beatles' *Hard Day's Night*, which was too predictable for his tastes.

Rather than take Hopper's movie away, Bert let him blaze forth. Believing in Hopper's vision, he figured Dennis just hadn't had enough time to properly prepare for his New Orleans shoot, with only a week of preproduction because Fonda had miscalculated the start date of Mardi Gras by a month, forcing everyone to hurry up and get there.

Besides, that Mardi Gras stuff looked kind of trippy. It wasn't Fonda running around the sand dunes with a dwarf trippy, but *trippy*. Maybe they could cut it up into something interesting . . .

Once again, the heavens opened for Dennis as his angel, Bert, bailed him out, out of jail, too, where Hopper stewed after getting busted for smoking a joint on Sunset Strip.

"They stopped me only because my hair was somewhat long, and I was driving an old car," bitched Dennis. "They said I'd

thrown a roach out of the car, which I had not. Well, I did have this roach in my pocket. Then, in court, they produce as evidence not my roach, which was wrapped in white paper, but somebody else's roach, which was wrapped in black paper. How ludicrous, man! It was dark, they couldn't even have seen a black roach!"

Bert assigned *Easy Rider* a new production manager, Paul Lewis, who was about the same size as Dennis, also with an outlaw mustache.

"You and Dennis would be a perfect match," assured Jack. "He's finally somebody you can drink with."

"I don't know you," Hopper told Lewis when he first met him. "I don't like you. I'm not going to listen to you."

So their journey began. They were off for sixteen days to scout locations for the next phase of *Easy Rider* shooting, wheeling along the gravel paths at the edge of Death Valley towards a mammoth steel bridge spanning the raging Colorado River, leading them into the Venusian landscape of Arizona. Hopper snapped mental Polaroids of the pop art of America, picked up by his senses along the roadside, all to be used someway, somehow. The pink-and-blue neon 76 circle atop the Pine Breeze Motel. The giant Paul Bunyan guarding the pancake house with his axe. The Santa Fe logo emblazoned on those old grounded railroad cars.

Past the Sacred Mountain gas station, the highway led to the woodsy north dotted with ponderosas. The Painted Desert's reds, oranges, and pinks led Hopper ever closer to the craggy peaks and cinematic heights of Monument Valley, the land where Big Duke, looking down on the Comanche encampment below, finally found what he was searching for.

"Dennis, close the window. It's cold."

"No, I have to look and see. The window distorts the colors. I can't see colors when I have the window closed. Look at the red on the road! We *gotta* shoot *this* red on the road—so we get a feeling of changing road."

This dialogue went on some eighteen hours a day. One night, Hopper and Lewis stopped at a bar in Farmington, New Mexico, where the local hotel was hosting a big convention of state police. Hopper had hair down to his shoulders, and Lewis had even longer hair.

"Let's put 'em up against the wall and see if they stick," someone threatened.

"We're never gonna get out of the fuckin' bar alive," said Lewis. Hopper just laughed. They got back into the car.

"You gotta let me drive, man!"

"No."

Riding down the path from Los Alamos, Lewis reached a fork in the road. Hopper and Lewis were arguing about how to get to Santa Fe, and somehow they went due north, the wrong direction, gravitating ever closer to Taos Mountain, a magnet for weirdos ever since the bearded conquistador Captain Hernando de Alvarado had approached it in 1540 scouting for Coronado's crazy quest to find the Seven Cities of Gold.

Hopper knew of Taos as an artist's colony, but he wasn't looking for an artists' colony; he was looking for a commune to film the commune scene in *Easy Rider*. As luck would have it, he found himself riding into the village of Arroyo Hondo, outside of Taos.

/ / /

At the New Buffalo Commune, city kids who had never worked outdoors before dipped soft hands into grain sacks, scattering seeds across 103 acres of high desert, planting corn and beans. Beautiful girls in billowy ankle-length dresses came back with currants picked by the Rio Grande. Brown goats provided milk. A few commune children, playing with matches, burned down the hay wall of the main building, torching the kitchen, but miraculously cooking to perfection the deer and a pot of chicos and beans. So the

commune had a feast the day before rebuilding. Getting in touch with his own wild man, Timothy Leary came.

Living in teepees, New Buffalo was in the midst of rebuilding its dream—even *more* natural this time—working in tandem with the Tiwa Indians of the nearby Taos Pueblo, with Little Joe Gomez teaching the palefaces how to make adobe bricks from the mud pits. Reality hit hard one winter, leaving the earthlings of New Buffalo to eat horsemeat they scraped up from road kill and kasha, only slightly tastier than starving.

The commune was living pretty close to the bone, but for Dennis, it was a glimpse of Eden he would portray in *Easy Rider*, with nymphs frolicking in hot springs, giving thanks for their meager food with a simple, "Amen, let's eat."

"I mean, it was like very mystical to me," said Hopper. "And I kept trying to get out of town and an Indian would come and say, 'The mountain is smiling on you. You must come and see this; you must come see that.'"

Hopper fell in love with a woman in Taos. With his marriage to Brooke on the rocks, it was hard for him to pull away from the spontaneous love found under Taos Mountain and continue with his movie, but he swore to himself he'd come back on his chopper to film Billy and Captain America, riding through Taos Pueblo. Split in two by a raging river fed by the sacred Blue Lake, the Tiwa place of creation, the bikers would ride into the commune, back from where they came after a thousand-year journey.

"I've got to get back to the country," swore Hopper. "To an earth feeling, like when I was a kid. Taos, man. Taos, New Mexico. There's freedom there. They don't mind long hair. The herds mingle."

The dream lingered for Hopper at an expensive Manhattan restaurant with glowing Tiffany lamps and Victorian trappings. Across the table was Fonda, Terry Southern, and Terry's fellow shit-kicking Texan, Rip Torn, whom Terry raved about as having

the greatest range of any living American actor, with the possible exception of Brando. *Writers.*

Terry loved to go on and on with his highfalutin' literary references, reminding Dennis how he'd written a part into *Easy Rider* that was modeled after one of Faulkner's Yoknapatawpha County characters, a brilliant young attorney who preferred getting liquored up on sour mash with the local yokels, despite his ability to talk fluently about Einstein with physics professors. Terry said he wrote it specifically for Rip Torn.

Yoknapa-*whata* the fuck? Hopper wasn't directing a book, and he didn't want some writer taking credit for *his* fucking movie. And he sure as shit didn't want Rip Torn, another fucking Texan, stealing any of his goddamn screen time.

Filthy and road weary after his sixteen-day scouting trip, Hopper commenced fighting words, ranting about how things were so rough out there in Texas, he had to fly over the goddamn state to location scout in Louisiana because he was afraid they'd catch him and cut off his hair with a rusty razor.

Rip stood up for the Lone Star State, so Hopper went for the steak knife on the table. Or was it a butter knife? Things were getting blurry at this late hour for Hopper the guerrilla artist, ready to attack any restriction on his sensibilities.

HOPPER AND JACK'S ACID TRIP

Setting on the Rio Grande, the sun cut through to the south, hovering just above eye level. Hopper was eight thousand feet high at the D. H. Lawrence Ranch on Lobo Mountain. Having finished the last day of shooting in Taos for *Easy Rider*, he'd taken Jack Nicholson on a pilgrimage to the shrine of old D.H., the ruddy, red-bearded writer who had lived and was buried here at the Kiowa Ranch near San Cristobal, outside of Taos. After he died, his wife, Frieda, had his body exhumed from its resting place in Italy. She sent him back to the land he loved best. Lying in front of D.H.'s tomb, Dennis Hopper, whose initials *matched* the writer's, noticed how the insects circled above in a relationship with the light from the sun.

"That's really what we are," said Jack. "Just insects."

Maybe for Jack, but life as an insect clashed with the magnitude of Hopper's vision for himself of resurrecting the movies, the equal of which rose upon the tomb, the phoenix rising out of the ashes, the symbol of Lawrence's failed utopia of Rananim. Believing man's only salvation was to return in haste to his primal nature, Lawrence had invited luminaries such as E. M. Forster to join, but in the end was able to convince only Frieda and a dotty,

deaf, aristocratic Englishwoman who lived in a small cabin on the ranch with her ear trumpet named Toby.

Hopper and Jack were now sitting on old D.H.'s tomb as the full moon cast a timeless glow over a big pine tree, which forty years before, in the 1920s, Lawrence had called his guardian spirit. In the morning, he would lean against his tree with his notebook, frail in body but with his bobble head full of ideas, and struggle with his place on earth. Ignoring his tubercular lungs, he spit blood while writing a story about a terrifying black stallion, perhaps the only beast he could ride to his ill-fated Rananim. Hopper and Jack told themselves they were going to make their stand in life here at Rananim. If *Easy Rider* wanted to go on, the *movie* would have to come here and *get* them because this was where they were and this was where they'd be. They were very tripped out on acid.

A little later, Hopper and Jack found themselves bubbling in a hot spring, swimming naked with a beautiful Indian woman.

"Let's run a little," said Jack, his voice echoing.

The woman drove a truck as the boys ran back and forth in front of the headlights.

"We're geniuses. You know that," Jack yelled out to Dennis. "We're both geniuses! Isn't it *great* to be a genius?"

It was almost sunrise, and Jack needed to get someplace where he could see the dawn. He climbed to the top of a forty-foot tree and breathed in his surroundings. A big white rock that lay in a meadow below suddenly stood and reared up, turning into a white horse.

Jack thought he'd peaked on the acid, but now he wasn't so sure.

The alabaster horse rose up on its muscular hindquarters like D.H.'s powerful stallion. Only *white*. The beast's tail wound around, a propeller or a crank of a machine winding to life, as if the creature were about to take off.

Later that day, on the set of *Easy Rider*, Jack waltzed out from the police station into the street of Las Vegas, New Mexico, a town

near Taos. A nip of Jack Daniel's before the cameras, a slight detour from the script.

"Well, here's to the first of the day, fellas," said Jack. "To old D. H. Lawrence."

Jack took his sip and gave the ol' *nic, nic, nic,* pumping his armpit like a wild turkey, a tic he'd picked up from one of the monkey wrenches in the crew who worked on the motorcycles.

After Hopper had brandished that knife at Rip Torn, Jack had managed to land the part of the alcoholic lawyer. Why not? Who else could work under a crazy knife-wielding director? Hopping on the back of Hopper's bike and wearing a gold high school football helmet, Jack got ready for his stoned awakening in the scene around the campfire under a nighttime sky. Filled with UFOs, man.

"They've been coming here since 1946 when the scientists first started bouncing radar beams off of the moon," explained Jack's character of the UFO-transported Venusians. "And they have been living and working among us in vast quantities ever since. The government knows all about 'em."

"What are you talking—man?" asked Hopper.

"Umm, well, you've just seen one of them, didn't ye?"

"Hey man, I saw something, man, but I didn't see 'em working here. You know what I mean?"

"Well, they are people just like us," said Jack, laying on the charm. "Their society is more highly evolved. I mean they don't have no wars; they got no monetary system; they don't have any leaders because, I mean, *each man* is a leader."

"*Wow,*" said Fonda.

"I think it's a crackpot idea," said Hopper. "I mean if they're so smart, why don't they just reveal themselves to us and get it over with?"

"Because if they did," said Jack, a knowing glint in his eyes, "it would cause a general panic."

Jack, in his first role as Jack, was brilliant. A huge hit.

/ / /

"I'm making a movie that's like nothing else!" Hopper told the New Buffalo commune.

"They wanted to *cater*," recalled its founder Rick Klein, looking back from his mountain chamber strewn with crystals. "But we were happy eating brown rice."

New Buffalo refused to let Hopper film the *Easy Rider* commune scene at their earthen home (usually welcome to all God's children), so a fake commune had to be built in the Santa Monica Mountains outside LA. Living for the duration of the shoot in Hopper's movie commune, the extras, listless souls who usually slept around Topanga Canyon, were entertained by the troubadours of the Gorilla Theater, a riff on the guerrilla theater performed by that offshoot of the Diggers. ("We took offense to that," said Peter Coyote on behalf of the San Francisco Mime Troupe.) For the communal mealtime scene, everyone held hands in a circle and gave thanks for their meager bounty grown on the rocky soil with a simple "Amen," spoken by a bearded, emaciated, blond Bobby Walker, cast as the commune leader, wearing a light-blue polka-dot work shirt. The drifting hippies, fucking around in nature, weren't intense enough for Hopper's Billy, depressed by the commune kids with their asinine Gorilla Theater troupe dressed up like fools in leotards.

"Man, look, I gotta get out of here, man. We got things we want to do, man," said Billy.

Bobby knew it was his real-life karma to be left behind by Hopper. Somehow Bobby knew he and Hopper would really—*diverge*. Bobby sensed Hopper's deep thirst for acceptance and need for his work to be acknowledged by millions. Hopper longed for the world's love, like a mother's encouragement: "Wow, Dennis, look at what you've done!"

It just wasn't Bobby's particular trip. His trip, in 1968, was just

to bob and bob and bob in the ocean. He'd found a company that built escape pods for oil platforms. This pod was round, twenty feet in diameter with a little motor and the ability to bob practically for an eternity in the sea. Bob was entranced by its terrific organic shape. He wasn't even gonna use the motor. He was going to set himself, his wife, and their three little kids adrift and just float around the world with the currents—going with the flow.

/ / /

Behind two sets of big, square movie-star shades, Billy and Captain America revved up their choppers and hit the open road. Wearing a groovy embroidered blouse and black leather pants, Fonda had also become a little sick of utopia. Off the set, he looked at the hippie, love, and flower power movement and considered all those guys who started fuckin' communes misogynists. Were they fucking *kidding*? Yeah, his eyes were open.

Peter didn't share the same love Dennis had for Taos. It didn't help that while filming the hot springs scene, the Big Duke of biker flicks caught bronchial pneumonia after Hopper insisted Peter jump into the freezing waters of the Rio Hondo that flowed down from the Sangre de Cristo Mountains (because the real hot springs Hopper scouted on his road trip were now under two feet of muddy runoff). Hopper constantly needled Peter throughout the shooting of *Easy Rider*, challenging him physically and mentally, as if he were expensive china fit only for the soft sands of Malibu Colony.

Dennis's marriage also fell apart during the making of his movie. He finally granted Brooke the divorce she had filed for around the time he broke her nose (and the windshield). He'd never forget her acid remark the day he started *Easy Rider*—"You are going after fool's gold," a line Brooke swore she never delivered.

"That didn't read too well with me," said Hopper. "Brooke is

groovy. We even have a beautiful little girl. But you don't say that to me, man, about something I've waited fifteen years—no, all my life—to do."

Cast from the Fonda dynasty for good, Hopper came to believe that Fonda had plotted against him after Mardi Gras, in that Shakespearean-worthy conspiracy to take his movie away from him. He believed Fonda inched him out of percentage points of *Easy Rider*, movie points that were as valuable as any gold mine ever hit in the wilds of California.

Billy and Captain America had really tapped a vein with their *great* biker flick. Opening on July 14, 1969, *Easy Rider* made all its money back in the first week—"in one theater," said Hopper—and it kept on flowing like manna from the heavens. The film that cost only $340,000 to make—in seven weeks—hit the scene by making upward of $40 million, with more to rain down.

Lines wound around the block at the Beekman Theatre in New York. Pot smoke wafted out of bathroom stalls, mingling with the smell of popcorn as young theatergoers lit up doobies in cahoots with Wyatt and Billy. Inspired by their epic American journey, seekers wanted to move to Taos and live in communes, and on the other side of all this peace and love, other types of thrill seekers were starting to score coke, because it was the hip new thing, because Billy and Wyatt dealt it. Businessmen began hitting the chop shops to buy customized Harleys. Scholars and academics wrote long treatises on the apocalyptic final scene when Captain America's chopper explodes in a fiery blaze on some nowhere stretch of highway after two rednecks blow Billy and Wyatt away—for having long hair.

An entire generation asked, "What did it mean when Wyatt told Billy, 'We blew it'?"

"Tell me," said British talk show host David Frost, interviewing the boys after *Easy Rider* became a megahit. "The film has become

a sort of cause célèbre. Are you at all surprised by that? Or did you have a sort of germ of a thought that you were going to become a prophet, *p-h-e-t*, as well as *p-r-o-f-i-t*?"

"Profit *i-t* we figured because the price was so low," Fonda said. "Prophet the other way I wasn't so sure of. But Dennis, he knew all the way."

After winning the 1969 Cannes Film Festival, Hopper traded in his Baja seashell necklace for a glowing medal for the best movie by a new director. High off his phenomenal success, having spun what began as a chaotic shoot in the midst of Mardi Gras into one of the greatest box office smashes in moviedom, our hero embarked on his overdue masterpiece, *The Last Movie*.

TEX

After his blazing success at Cannes for *Easy Rider*, Hopper left for London to meet screenwriter Stewart Stern and scheme about how they could make *The Last Movie*. Still wearing his leather and fringe like Billy, Hopper refused to take off his cowboy hat and wouldn't part with that Cannes medal hanging around his neck. Every morning, Stern arrived at Hopper's hotel room to work on the script. Having just woken up, the first thing Hopper did was fire up a joint and rant on about the movie. Smoking joint after joint, brandishing his medal and wearing his hat, he paced the carpeting while Stern tapped away at his typewriter.

In the beginning was Tex . . . Hopper's hero would be a stuntman cast in a lousy Western being filmed in Peru. At the climactic death scene at the end of this Western, Tex would be "shot" off his horse in the village's dusty plaza. The director yells, "Cut."

Seconds later, Tex dusts himself off, walks away. All this would happen to the amazement of the real villagers, who'd never seen a movie before: *¡Un milagro!* How can a man get up after he's been shot? A miracle! They don't understand the concept of using cardboard wads instead of bullets. When the film wraps and the movie

unit goes back to the States, Tex stays on in Peru to develop it as a location for Westerns.

"He's Mr. Middle America—he dreams of big cars, swimming pools, gorgeous girls. He's innocent. He doesn't realize he's living out a myth, nailing himself to a cross of gold," said Hopper. "But the Indians realize it. They stand for the world as it really is, and they see the lousy Western for what it really was, a tragic legend of greed and violence in which everybody died at the end. So they build a camera out of junk and reenact the movie as a religious rite. To play the victim in the ceremony, they pick the stuntman. The end is far-out."

Not being able to tell anymore where reality ends and fantasy begins, something strange begins to happen to the villagers as they mosey past the facades of a fake saloon, a fake gun shop, a fake church. Slipping into the setting, they begin to reenact their own version of the Hollywood movie and begin to "shoot" their own movie, using a camera made out of bamboo sticks. The camera is fake, but everything else is real: real bullets instead of cardboard wads, and real violence.

As much of a barbarian as Hathaway, the primitive "director" casts Tex as the hero, but this time really sentences him to death. Even the village priest is so caught between the fake and the real, he doesn't even know where to take the dying Tex, all bloody after being shot. The real church or the fake church?

Cut to: TEX's face is covered with buzzing flies. Almost arrived to the village, the people carry him to where the road and street come together, then they stop. To the right at the bottom of the street is the plaza, with its ancient REAL CHURCH. To the left is the movie street, with its CARDBOARD CHURCH at its head. The people stand there, looking from right to left and back again, not knowing what

to do. The flies buzz, the horse whinnies, no one says anything. They set the litter down on the street, look to the PRIEST for instruction. He comes to crouch in the dust beside the litter, fooling with his beads, looking at Tex, pondering. After a long time a MAN speaks. "Which one?" he asks in Spanish. "Which church?" The priest ponders, the people wait, some sit down in the road. MARIA clings to her fur stole, fussing the dust off, fluffing up the fur with her breath, weeping. The breeze disturbs the flowers on the camera made of sticks.

"Where is that, where is that *coming* from? How did you *do* that?" asked Hopper, peeking at the typewriter.

"Well, while you've been talking, I've been writing the script!"

"That's *amazing*."

Huffing and puffing, lighting up a new roach when the last had been misplaced, Dennis wasn't the same Dennis who Stern knew from their earlier years on *Rebel*. He was more unhinged.

/ / /

Hopper saw his follow-up to the money-making machine of *Easy Rider* as the great American art film. He had originally hoped to shoot *The Last Movie* in Big Duke's Wild West town of Durango, but because corrupt Mexican officials were eager to censor the picture, he decided to go to Peru. Over Christmas 1969, he flew to Lima to scout for locations. Everything was closed in the capital because a left-wing communist military dictatorship had declared a four-day holiday to celebrate its seizure of American oil interests.

Hopper took a rickety cab to a town in the Andes on the shores of the largest lake in the world, Lake Titicaca. Despite its stimulating name, Lake Titicaca was frigid. Hopper hated the goddamn

place, but as he walked down a street that was ragged with stray dogs, the sound of Bob Dylan playing on a jukebox wafted on to the lonesome path and led him inside a bar. In this watering hole, a couple of Peruvian kids were drinking beer and eating peanuts, tossing the shells on the floor. They agreed with Hopper. They all hated their town, too, but one of them told Hopper he must go to Cuzco, a city in southern Peru. Everybody knew the most beautiful women lived in Cuzco.

Yes, man, Hopper, the wild American, *had* to go to Cuzco!

On the way to this capital of the Inca Empire, the taxi driver had a curious habit of not letting anyone pass. It was very strange how as soon as Hopper arrived, he ran into a classmate from Helix High, a pretty far-out coincidence. A Helix Highlander living in Peru working as a travel agent? With his tendency toward paranoia, Hopper wondered who'd sent him. Was he an agent for the secret police?

"You're not going to find much here," said the Highlander. "But in the morning, you should take a cab to Machu Picchu."

The following morning, all the taxi drivers laughed when Hopper told them he wanted to go. Unless the crazy American wanted to hike up the Inca Trail for four days, the only way to get to Machu Picchu was by a train that had left three hours ago! Hopper slunk back to the Highlander. Tacked all over the travel agent's office wall, Polaroids featured the lush wonders of Peru, including the dreamy hillside village of Chincheros, where a stone fountain trickled in the middle of the dusty Spanish plaza with a gold conquistador statue.

That was where Hopper wanted to go, that strange, magical place in the photograph.

So, surviving on beer and dark chocolate, braving muddy hills, he took a cab that bumped up a rough Jeep trail strewn with enormous boulders, over stones laid by the Incas. Looming in the distance, 20,500 feet high, was the majestic bluish snowcapped mountain

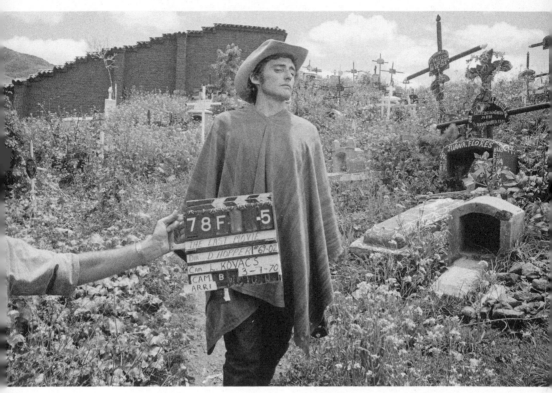

Graveyard scene in The Last Movie, *Peru, 1970*

Dennis had seen in the Polaroids. It looked just like the Paramount movie mountain, only the native Quechua Indians called their majestic mountain of dreams Mount Salkantay, or "savage mountain."

The last days of the sixties were upon Hopper, and as the new decade approached, he proceeded to drag his movie bit by bit up the mountain, an epic undertaking. A pack of trained movie horses was flown into Cuzco via cargo planes. Fifteen thousand pounds of camera and lighting equipment arrived, along with eight containers brimming with Western wear. Cutting off his dirty, matted hair, Hopper secured it in a Polaroid box and gave it as a Christmas present to his seven-year-old daughter.

No longer the unshaven hippie of *Easy Rider*, never without his buckskins and a lost-somewhere-faraway expression, Hopper was

now becoming a lean, rugged cowboy. To play Tex in *The Last Movie*, Hopper saw himself as Tex's alter ego and even took to calling himself Kansas. As the saying went, painted on the side of his muddy, red Ford pickup truck, KANSAS—HOLLYWOOD, CALIF. BROKEN BONES BUT RARIN' TO GO!

In filthy Levi's, a couple joints stashed in the pocket of his work shirt, a hat mashed on his head, boot on the gas, Hopper wheeled his truck down the treacherous Peruvian mountain path, terrifying a *Life* journalist sitting shotgun, and commenced his far-out tale.

"It's called *The Last Movie* and it's a story about America and how it's destroying itself."

PART 3

The Movie Within the Movie

PERU

Peru was a three-ring llama circus. Violent hailstorms bore down on Chincheros, beating Dennis's Wild West frontier town like a drum. It took three hours for a fleet of taxis to bring the production up the slippery slope of a mountain and back down to Cuzco. If one vehicle met another on the trail, whoever decided to pull over was in danger of getting stuck in the mud, a constant battle; often the road was impassable.

Melting in a sweltering Peruvian hotel room, the stench of failure lingered over the prophet of *Easy Rider*, who wore a silver coke spoon like a crucifix around his neck and reeked of marijuana and llama and funky body odor. The drapes were drawn and portraits of saints hung on the walls around him. Hopper had gone native and his indigenous lover was asleep in the bed. He took a sniff from his tiny coke spoon and continued ranting to one of the slew of visiting reporters from *Life*, the *New York Times*, *Esquire*, *Rolling Stone*, all hot to tell the story about what was next for Hollywood's rebel genius.

"Listen, everybody in Hollywood is saying that *Easy Rider* was a mistake and that I'm an undisciplined kook. Well, an undisciplined

kook doesn't make *Easy Rider* in seven weeks. I am not a paranoid. I'm just protecting myself, man, against an industry that could care less about me! When Michelangelo was lying on his back, painting that ceiling, did the Pope give a shit about his welfare? All they care about in Hollywood is that the ceiling—the movie—makes bread. It all goes back to Kipling's 'If,' one of my favorite numbers; it says something like, you can treat triumph and disaster the same, because they're both impostors."

The problem was if he spent too much and went over budget on *The Last Movie*, the studios could contractually take away his right to final cut. Maybe even send another director down to Peru to take his fucking movie away from him. He'd fought tooth and nail to get final cut of his movie so he wouldn't end up like Orson Welles on *The Magnificent Ambersons*, butchered by the studio.

"Well, that's not gonna happen, man! No way! This is my picture, nobody else is *gonna* get it!"

The whole production was threatening to collapse at any moment. Actors started throwing up from altitude sickness. One of the Mexicans attempted suicide after he was told there weren't any more rooms for him to stay with the Hollywood guys in the hotel. The star and director of *The Last Movie*, Hopper was saddled with the knowledge that, according to Peruvian law, if the suicide died, the production would be responsible. Hopper could probably take a night in a dank Peruvian jail cell, but it now seemed that the FBI was closing in on him on account of a "situation" in a chartered plane hired to fly actors into Cuzco. Some burly ding-a-ling in Hopper's cast had forced a Catholic stewardess to smoke a joint. She totally freaked out. The pilot had informed the head of the airline, and the Peruvian police threatened to arrest Hopper's entire company.

"Now there is an investigation going on, and I will probably be busted the minute I set foot back in the States," Hopper told a hip journalist from *Esquire*. "Can you imagine what's going to happen

to me, if the government decides my actors were offensive, smoking on that airplane? And what could happen to the *movie*?"

Fortunately, the police hadn't discovered the big carry-on duffel bag full of drugs, which shouldn't have been a problem because the cops were supposed to be paid off.

"For all I know, *man*," said Hopper, "they're telling the chief of police, between sessions, about how the hotel is full of junkies."

Hopper was getting paranoid in this room decorated with saints. Their innocently knowing eyes seemed to watch his every wrong move, pleading with him to stay sane—for the sake of his great movie.

"They didn't even leave me a joint, man," he complained of his stolen pot stash. Another day, the hotel manager, who had become a familiar face to the production, informed Hopper to get ready because the police were going to make a big bust and everybody's room was gonna be searched. Everyone had already split, so Hopper had to scoop up all the drugs floating around in the various rooms. Hiding them away only led everyone to suspect Hopper was doing most of them himself. Anyway, the real problem wasn't those drugs brought from Hollywood.

Peru was nose-deep in cocaine, and Hopper, with visions of his cast and crew smuggling home coke in film canisters, could already picture how this one would go down. Their director would be the prime target to be busted by the FBI for an international smuggling conspiracy. Certainly there were those among his production who had the idea they could make a fortune by smuggling out the pure snow-white Andes shit. And that would *really* set back his grandiose film.

"Wow, whew! I don't care for myself, man, but I've got to edit this picture when I get back," Hopper told the *Esquire* scribe. "I mean this could affect the picture! Even before I get out of Peru, there could be a bust with all the ding-a-lings running around loose."

Local authorities had already questioned him. If this wasn't enough, one of his actors, a persnickety type, was threatening to send a complaint letter to the Screen Actors Guild detailing the abominable conditions of his dressing room pigsty, literally full of pig and *llama* shit.

/ / /

As a director, Hopper could feel himself slipping into the part of Henry Hathaway. He'd actually cast his old nemesis as the director of the Western—"the movie within the movie"—that kicks off *The Last Movie*. It was a fair exchange, seeing as Hopper brought the *Easy Rider* multitude to see Hathaway's *True Grit*, which Dennis acted in after *Easy Rider*, the two films coming out around the same time. Even though he just played a bit part as a bad guy who gets his fingers chopped off, Hopper got equal billing with Big Duke. As for flying down to Peru to be in a Dennis Hopper movie? Hathaway backed out at the last minute. Hopper instead cast Sam Fuller, a real gun-toting wild-man director.

"Whaddya want me to do here?" asked Fuller, wearing a Civil War cavalry hat.

"You're the director, Sam, don't ask me. I'm doing *my* film. You do *your* film."

"Whaddya mean?"

Before Sam was an antiquated movie camera Hopper had acquired in Buenos Aires for the scene. Over *there* with Hopper, the real director, was a state-of-the-art 35mm movie camera expertly guided by his Hungarian cinematographer László Kovács. Hopper had yet to shoot the part about the camera the villagers make out of bamboo sticks.

"You see, Sam, that is *my* camera. This is *your* camera. You do whatever *you* wanna do."

Hopper's directing style was the complete antithesis of Hathaway's bulldozing. For now.

"Action!"

The movie within the movie starred Hopper's buddy Dean Stockwell as Billy the Kid riding in with his gang and getting shot off his horse. Dean had one line of dialogue, which he improvised. "Rose, my heart is burning!" Rose was the name of Dean's girlfriend at the time.

Dennis didn't direct Dean at all, but just went with the flow. As time on the shoot began to run out, new headaches arose hourly, the resounding theme being, "Who do I have to fuck to get *off* this picture?"—or this picture within a picture.

Take this ding-a-ling actor suddenly stalling the production by mumbling his lines like a fake James Dean. The guy was asking all sorts of questions that had no place in a goddamn Western!

"Cut! Now you listen to me, man!"

"Wait a minute, Dennis."

"Wait a minute for me, man! For me! I'll tell you one more time. If you elaborate on anything in this shot we are dead! Just do what we rehearsed, Mr. Actors Studio, or I'll cut off your cocaine supply. Now, *get it together!*"

On top of the multitude of problems threatening to blow his production over budget, Hopper had the local priest to deal with. The priest was becoming a problem. Not the actor who was playing the *fake* priest, Cuban-born Tomas Milian, who had made his name as an Italian film star playing the Mexican in spaghetti Westerns. Tomas was terrific. Hopper thought the *real* priest was the problem.

Most recently the real priest had complained to the archbishop that some of the scenes being shot violated church doctrine. Of course it hadn't helped that Hopper had held a special mass dedicated to James Dean.

"Here we go again," said the fake priest, Tomas, rolling his eyes. "Jimmy."

James Dean's presence haunted the set of *The Last Movie* down to one of the fake Wild West facades named Jimmy's Place. REMINDS YOU OF YOUR DESTINY was painted on the window. The *Life* photographer who'd taken those iconic rainy Times Square portraits of Dean, which essentially created his existential image, was strangely down in Peru, shooting Dennis. And acting *in* the movie, too. Throughout the production, there were all these kinds of coincidences and symbols pointing to Dean somehow being part of the production, or at least keeping an eye on it from above. Hopper showed off his talisman ring, "Jimmy's Aztec death ring," and he rubbed it raw. One night the ring broke off his finger. At the same exact moment, Hopper saw a comet soar overhead.

The fake priest, Tomas, had his own Dean hang-ups. Dean's *East of Eden* performance changed his destiny, inspiring him to leave Cuba and go to New York to the Actors Studio, where he had met Hopper. Lonely at times, away from his family, Dean regularly spoke to Milian from beyond the grave via a Ouija board, advising him to switch agents, going so far as to give him the name of a big shot Tomas had never heard of—and reminding when the struggling actor was feeling low and unwanted, "You are my Cuban Hamlet."

Milian had always done exactly what Jimmy told him to do and now fate brought him here to Peru, to play the fake priest for Jimmy's friend Dennis.

"I want you to meet the real priest that is a son of a bitch," Hopper told Tomas when he first arrived. "This is the type of priest I want you to play."

Visiting the *real* priest inside his little hut, with its two beds divided by a table with a smoldering oil lamp, Tomas couldn't help but share something personal weighing heavily on his heart. He

confessed to this priest. Before leaving Italy for Peru, Tomas had gone to church in Rome to get into a spiritual state. Confessing his sins, he asked the Roman priest to forgive him. The priest refused. Tomas had wanted only to play a good priest, but came to Peru feeling damned.

"Tomas, you are more of a priest than *I* am," said this real priest in his hut. "I *give* you permission to walk the town with your priest costume. I will tell the Indians that you are Padre Tomas that has come from Rome, Italy. This is a rosary that I give you as a present."

So the villagers greeted Padre Tomas from Rome. "*Buenos días, padrecito. Buenos días, padrecito. Buenos días. Buenos días.*"

Sitting one night in his black alpaca poncho at a ceremony at the mayor's home, Tomas was presented with a heavy tome with a leather cover. He ceremoniously entered in the words PADRE TOMAS MILIAN FROM ROME into its thick pages. A complete falsehood but there now for eternity, one more level of the production's mixing of fantasy and reality.

Meanwhile, and unaware of this latest impiety, the archbishop of Cuzco was getting ready to close down Hopper's entire blasphemous production. He summoned Hopper to him.

Sitting before the archbishop, Hopper laid on the charm. "We're not doing anything. We're really trying to . . ."

He hoped the archbishop didn't know anything about that letter from the pope, who'd declared him persona non grata for offensive and blasphemous imagery in *Easy Rider*. Hopper wasn't even Catholic.

"You know," interrupted the archbishop, a twinkle in his eye, "I wanted to be in showbiz myself once. I was gonna be a stand-up comic."

Really? Working the angle, Hopper managed to win over the archbishop and pull everything together to shoot the final grand processional scene, in which the village priest relocates his

congregation from their original church (built by conquistadors) to the fake movie church (built by Dennis Hopper).

Bamboo microphone booms? Check. Bamboo movie camera? Check.

Everything was ready for Tomas, the fake priest, to lead a gaudy religious procession in which stuntman Tex would be sacrificed. Starting at the original village church altar, Tomas, in flowing robes, walked holding the traditional processional monstrance adorned with a golden sunburst. The villagers walked in Padre Tomas's wake, playing harps and flutes and throwing rose petals in his path, innocently giving up reality for the fantasy of the movies.

"Cut," yelled Hopper, but nobody cut.

Something even more far-out had happened. While shooting the scene, Tomas truly believed he was Padre Tomas, leading a real procession. The villagers followed him, the camera was rolling. Setting the monstrance atop the fake altar, Tomas proceeded to consecrate the fake church and exited the set with a feeling of reverence and a holy glow. Hopper totally flipped out.

"Wow, man! I mean *wow*! Beautiful. You know, oh *wow*!"

"Oh my God," said everyone. "Tomas is gonna be *nominated*. Tomas is gonna get the Oscar!"

The camera operator looked as if he'd seen a miracle. "You don't know what *happened*," he told everyone. Apparently, while he zoomed the lens around the sunburst monstrance Tomas was holding, there was a sheep farmer with his herd in the distance; he passed right into the shot and everyone thought that was very groovy.

"Oh *wow*, man. Yeah, *wow*!"

The camera operator might win an Oscar! Tomas was going to win an Oscar! Hopper was definitely gonna win an Oscar and save the movies!

It was time for Padre Tomasito to return to Rome. On his last

night, he got drunk off of *chica*, the deathly local brew, and lashed out at the actor playing the "native director" of the villagers' movie shot with a bamboo camera. The native director had been nasty to Tomas, not liking it one bit how people were saying that Tomas was going to get an Oscar instead of him. That night Tomas was so provoked that he bonked the man on the head with a bamboo cross. The Indian villagers laughed like crazy at their irreverent Padre Tomas. But the next morning, after sleeping off his hangover, a very embarrassed Tomas gathered his flock.

"I confess. I am not what you saw yesterday. When I hit the guy in the head, I did that because I am not a *real* priest. I'm an actor playing a priest."

"Ohhhh, you are an *actor* priest!"

"No, no, no, no, no, I am an *actor*. A priest *actor*."

This was obviously going nowhere, so Tomas slipped back into his role.

"Yesterday I was drunk," Padre Tomas confessed. "It was not the priest who was drunk; it was the actor who was drunk. A priest should *never* do what I did yesterday, but the actor in me betrayed my character."

Tomas flew back to Rome and his spaghetti Westerns and thought the whole matter was over and done with, until a letter arrived from Peru addressed to Padre Tomas. It was from the real priest.

You don't know how many problems you have put me in. There was a strike here with the Indians. They didn't want to do anything because they wanted Padre Tomasito to come back. So the diocese in Lima had to put somebody else in my place and send me to a university to teach Quechua because the Indians wanted Padre Tomasito.

Miraculously, Hopper left Peru in early 1970. He had his footage, his film canisters were full, and he felt he had done right by the village.

"They thought we were going to destroy their village," said Hopper. "They thought we were stealing Inca stones and looking for gold, but we got all that straightened, man, and now the people are beginning to groove, man. They're gonna get their town together, man. They're gonna break with that priest, stand on their own. It's going to be gorgeous, man!"

PART 4

The Savage Journey

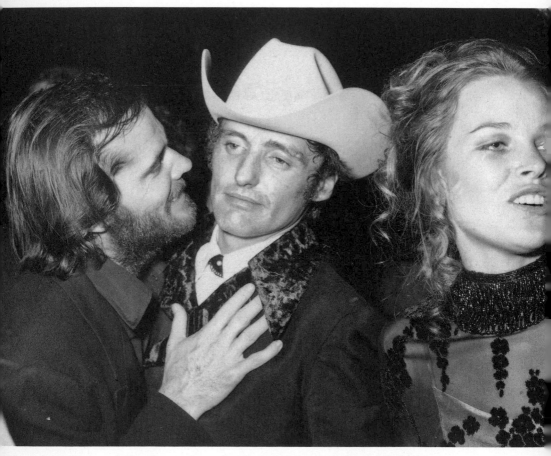

Academy Awards after-party with Jack Nicholson and Michelle Phillips

TAOS

I come from Kansas," said Hopper. "All my uncles and my grand-uncles, when they made it, they got a Stetson."

At the Academy Awards in 1970, held just after he returned from Peru, Hopper hoped to jump onstage and accept an *Easy Rider* win for the best original screenplay and story, for which he'd been nominated along with Terry Southern—and, of course, Fonda.

"You know, I'm suing Peter Fonda now," Hopper told the *New York Times*. "Because we started out equal partners on *Easy Rider*, and he ended up seven points ahead of me. Seven points at $150,000 a point. The movie cost $340,000, and it may end up being the fourth-biggest grosser of all time. This year alone, I'll make a million and a half on it—seventy percent of which will go to the government. The thing is *I* wrote the screenplay in two weeks and I never got paid a penny for it. At the time, I didn't care. Peter said we could straighten out the financial details later."

None of this raised our hero's estimation in the eyes of Peter's father.

"He's a total freak-out," retorted Henry Fonda, "stoned out of his mind all the time. Any man who insists on wearing his cowboy hat to the Academy Award ceremonies and keeps it on at the

dinner table afterward ought to be spanked. That is *not* off the record. Dennis Hopper is an idiot! Spell the name right: *D-e-n-n-i-s H-o-p-p-e-r*!"

"We're a new kind of human being," Hopper told *Life*, spreading the word about his people. "We're taking on more freedom and more risk. In a spiritual way, we may be the most creative generation in the last nineteen centuries. I think we're heroes. I want to make movies about us."

First, of course, he had to finish the movie he was working on. Armed with forty-two hours of uncut footage from Peru, he was about to stake his fortune on a compound, where he planned to edit *The Last Movie*. He'd originally thought of putting his monthly $100,000 *Easy Rider* installments toward buying Bing Crosby's ranch in Elko, Nevada.

"Best yearlings in the United States come off this ranch," said Hopper.

But he decided on Taos instead upon stepping into the sprawling three-story, twenty-two room adobe Mabel Dodge Luhan House, once owned by this wealthy heiress and doyenne of the arts who'd lived there like Gertrude Stein of the West. Mabel had christened her compound Los Gallos after the ceramic chickens dotting its clay roof. Behind the house stretched a dusty swath of Indian land with a large and mysterious wooden cross stuck into its earth like a conquistador's sword. Thirty-three-year-old Hopper felt the vibes fit his mood.

"A lot seems to happen to people at thirty-three, man," figured Dennis's friend country-and-western singer Kris Kristofferson, who'd been down in Peru acting in his first film role in *The Last Movie*. That's where he wrote his song "The Pilgrim: Chapter 33," a biblical ballad about Hopper. "Me, I'm thirty-three. Dennis is thirty-three. He has a real Christ thing goin'—pictures of himself everywhere. Christ was apparently thirty-three when he got wiped out."

All the same, Hopper didn't intend to be sacrificed like poor Billy the biker, blown apart on his chopper after the Mardi Gras trip in *Easy Rider*. Bob Dylan had been furious with Dennis about the ending. He hated to think that the two rednecks who blasted Billy and Captain America off the road at the end of the movie for having long hair got away with it. Dylan wanted revenge.

"Why can't a helicopter come down and blow *those* guys right off the road?" he suggested to Dennis.

Couldn't Fonda pull out a machine gun and go after them? How could Billy *die* in the end?

"What I want to say with *Easy Rider*," Hopper said to his flock, "is don't be scared, go and try to change America, but if you're gonna wear a badge, whether it's long hair, or black skin, learn to protect yourselves. Go in groups, but go. When people understand that they can't tromp you down, maybe they'll start accepting you. Accepting all the herds."

/ / /

A certain set of Taos locals were ready to crucify their newest citizen. After all, somebody needed to be blamed for all the hippies who arrived in droves to live in communes like the one in *Easy Rider*. Hopper decided to bring some backup on what should have been a peaceful literary pilgrimage to the El Salto waterfalls above the little village of Arroyo Seco, just north of Taos.

In this waterfall cave, the ancients had long ago performed human sacrifice, it was said, inspiring D. H. Lawrence to write a chilling fable warning against tampering with primal forces. The caves lay on land claimed some 370 years before by pockmarked Hernán Martín Serrano, whose seed still flourished centuries later here in Arroyo Seco, a hotspot of the so-called Chicano-Hippie War plaguing the region.

Not long before, this clash resulted in a few Chicano kids

jumping a smelly hippie invader who was on his way to his crash pad. When the proprietress of a local weaving shop ran out to help, the Arroyo Seco kids told her to go back to Russia, then beat up her son and blasted her window with a shotgun.

Strolling through Arroyo Seco with his posse—his brother David and two burly *Last Movie* actors—Hopper found himself facing off against a couple of Hispanic kids. On behalf of thirteen generations swearing allegiance to King Philip II of Spain, the kids called the international man of cinema a filthy hippie.

Hopper had no intention of drowning in the local murk. His plan was to remake Taos into a countercultural Hollywood with his Alta-Light Productions movie company. His list included Dean Stockwell's original screenplay *After the Gold Rush*, a script that inspired Neil Young's album, as well as *Me and Bobby McGee*, a movie to be based on the Kristofferson song. Maybe Dennis would do that film about his Kansas childhood he'd been dreaming about for practically his whole life. The future was limitless, but first Taos needed to be tamed.

Rather than give his usual rap—"We only *look* different; we're all part of the same herd"—Hopper trailed the kids back to one of their homes and drew out his gun for a citizen's arrest. As Hopper put it, "When the police came, they arrested *us* and held us on eight thousand dollars' bail."

"We're going to let you out a side door," said the cops before escorting Hopper out of the courthouse. "We can't protect you, because of the lynch situation."

As they walked out, one of the Hispanic onlookers, wearing waders since he'd been fly-fishing earlier that day, lunged at Hopper because he couldn't stop thinking about what his crying mother had told him when he came home: "Some hippies had your brother and his friends in a sitting position on the side of the road with *guns* pointed at them."

Hopper remembered there were sixty or eighty farmers outside the courthouse with pitchforks, and the story continued to grow.

"And then five guys just back from Vietnam came and told me, 'We're going to kill you.' I pointed out to the police that I'd just been threatened. 'Shut up,' they said. And then I went the next day and called all my friends, stuntmen, ex-Marines, to come to Taos and we went into town and bought every rifle and semiautomatic gun we could find."

Packing a submachine gun and flanked by the Mabel Dodge Luhan House's ceramic chickens, Hopper stood watch on his roof in case any Chicanos wheeled across the land in a horde of tricked-out all-terrain vehicles. What would happen to his *movie* if they dynamited his editing shack?

In an attempt to let the town know he meant business, he stormed a school assembly at Taos High School, which the boys on his watch list attended. Hopper addressed the students from the podium—an impromptu motivational speaker.

"Look, we know what you're doing and that may be fine for now, but there's a lot of people coming back from Vietnam and they're going to have long hair and they're going to look like me in this poncho and so on. But understand they're going to have one of these—"

Whipping out a machine gun from under his woolly poncho, he calmly walked out, leaving the local Chicanos and hippies to weave tales of their own about the gringo loco, Dennis Hopper.

"Hopper went to Seco and went into a bar, and I believe they threw him out," swore one hippie. "Then a bunch of local Chicanos came up and started fuckin' with him, hard. Hopper went back to his house and got his guns, strapped them on, came back, and walked into the bar. This dude that was fuckin' with him? Hopper shot him. Bam! That's a *true* story. The Hispanics didn't know what to do, piss or shit, but Hopper made it very clear up in Seco—their

turf—that there was a new boy in town and they'd better not fuck with him, and they'd better not fuck with the hippies, or he'd come back with a vengeance and beat the living fuck out of them."

Free from the distraction of his movie getting blown up, Hopper breathed in the deep, pure high desert air of Taos, and began editing *The Last Movie* in the fortress of his Mud Palace, as he'd rechristened the Mabel Dodge Luhan House to the dismay of certain society matrons. He even threatened to put up a blinking neon sign.

THE MUD PALACE

Hopper would always remember the road trip he took back in 1956 to Las Vegas to see Orson Welles, who was performing a magic show at the Riviera Hotel. In a tuxedo, Welles sandwiched in recitations from *The Merchant of Venice* while making a woman float in midair and passing a hoop over her body to show the trick was real.

A battered boy genius, Welles was broken in more ways than one after snapping his ankle under his three hundred pounds of girth. He'd scoured Europe for funding for his films and was devastated at his inability to make another film with anywhere near the grandiosity of *Citizen Kane*. He took the stage in New York and got a standing ovation as he launched into King Lear, but by the time the curtain closed he'd broken his other ankle. Escaping scathing reviews, rotund Welles limped off to Vegas to do his hocus-pocus.

Taking a break from editing *The Last Movie*, Hopper made an appearance in one of Welles's unfinished films, *The Other Side of the Wind*. In his cowboy hat, he played the autobiographical role of a "New Hollywood" director who wants John Wayne's audience to see his films. When the shoot was over, Hopper and John Huston, who had starred as the grizzled old director, left to visit John Ford

in a hospital in Palm Springs. With a black patch over his bad eye, Ford looked worse for the wear after a hip operation. He had only a year or two left in him.

If Hopper was *really* a man, he'd get in bed with Ford for a photo.

The shutter clicked on three trailblazing directors of the Western myth, all crowded into the same bed.

/ / /

Then came the torrential flood of articles from the media wave that had stormed darkest Peru, detailing Hopper's self-proclamation that, like Welles, he was a genius who was going to save American cinema. At a certain point in shooting *The Last Movie*, Hopper had decided he didn't need a *script*—the same script he and Stewart Stern had been crafting for five years.

"It's all dialectic, I either LOVE or I HATE," Hopper jabbered on to the *Los Angeles Times* down in Peru. "There are no maybes or supposes. It's one through nine. There are no fractions. There was no Inca Dinka Doo in the screenplay, but it's there now!"

Stern hadn't talked to Hopper for some time when his phone began to ring. It was Hopper—calling from Taos.

"You've *got* to look at the film," Dennis launched in. "I don't know what to do with it. I *bought* the local theater. The theater's *mine*. You can sit in it all day and watch every bit of film."

In addition to moving into the Mabel Dodge House, Hopper had purchased the El Cortez Theater, a few miles away in Ranchos de Taos, Taos's little sister community, so that he could screen his masterpiece-in-progress to a crowd of sycophants and locals, at least once a week. He pumped in thousands of dollars' worth of equipment, including a sync-sound system so that the community could experience the full effect of his vision.

On weekends, when he took a break from screenings of the evolving *Last Movie*, he played free Disney cartoons for the kids

and art house flicks at night—the new Truffaut, Bergman, Fellini. But he was not happy about the new Buñuel his theater manager had booked.

"You can't show this in a Catholic community!" said Hopper, playing film god.

"Dennis, first of all, the Spanish people don't come to art films! They don't come to Buñuel. Who do you think you are, anyway, censoring movies?"

Obviously the young man hadn't had the experience of being shuttered in a fortified compound, defending oneself against hordes of Chicanos threatening to completely waste Hopper's precious editing time.

Sitting at the El Cortez, Stewart Stern watched the latest editing-incarnation of *The Last Movie*.

"Glorious stuff," said Stern. "Heart-stopping."

Tex, played by Hopper, was great. But those actor friends of his that he had improvising their lines in the film, probably high as psychedelic llamas? Not so good. Still, Hopper maintained that he didn't need a script.

"I'm Fellini. I'm a genius. I just need notes. I don't need a screenplay," Hopper would say.

As a result, the film dragged, going here, there, and nowhere. Visually it was stunning, with lush greens set against the snow-capped savage mountain in the distance, and sometimes there were brilliant moments, but with all the input allowed in, the story structure of, say, *Easy Rider* was conspicuously absent. Hopper seemed unable to cut out anything.

Sitting in the darkened El Cortez as the forty-second hour of film approached, Stern was horrified. Where was the ending? That poignant scene in the screenplay Stern had typed out, illustrating how the villagers are so caught between their real world and this fake movie world, they don't even know which was the real church anymore.

"Dennis," said an exasperated Stern, "you never *shot the ending!*"

"I want the audience to be responsible for their part in it. They're responsible for *sitting* through it. That's what the movie's about, man."

Stern worried that Hopper had actually gone insane. Part of the problem was that after the phenomenal success of *Easy Rider*, Hopper had carte blanche to make any movie he'd ever dreamed about, the great American art movie with final cut! And what had he done with the opportunity? He'd turned Stern's carefully crafted script on its head and willingly destroyed their vision. The six or so editors working with Hopper in his editing shack in back of the Mud Palace actually considered turning the forty-two hours of sprawling footage into a *National Geographic* special. With that much footage, it could have been *anything*.

"What you have to do is go back down and shoot it again," said Stern. "First, get straight. Get sober. Get the way you were when you first submitted it to Jason Robards and Bobby Walker's mother and they wanted to do it. Go back to *that*."

By then it was too late for Hopper, preoccupied with other things like getting high almost continually and marrying that Mamas and Papas girl, Michelle Phillips. Dennis wanted her to star in *Me and Bobby McGee*.

They married on Halloween night 1970 with glowing orange candles burning in the courtyard in paper bags trailing the way up to the Mud Palace. A witness to the beautiful yet spooky occasion, Stern decided Hopper was definitely insane. And adorable. He couldn't help loving Hopper, but Hopper was so crazy it was terrifying.

Inside the Mud Palace, by the flicker of 150 tapers in silver candelabra, Dennis stood before his half-moon peyote fireplace inlaid in the Palace's cavernous red-and-brown-tiled dining room, filled with pumpkins and friends. He read his Gnostic Gospel— "Have you discovered the beginning so that you inquire about the

end? For where the beginning is, there shall be the end"—to the gathered. The double-ring ceremony was officiated by artist Bruce Conner, dressed up this night as a reverend of the Universal Life Church in San Francisco.

The queen of the Mud Palace donned her crown—but not for long. She left after eight days of marriage.

To this day, wishing not to speak ill of the dead, Michelle Phillips remains silent as to what transpired on the final eighth day of her marriage to Hopper, only saying that he did something "excruciating." A popular account puts Hopper firing guns in the house while accusing a handcuffed Michelle of witchcraft.

"Well, what am I going to do?" asked Hopper when she made her break. "I've been fixing up the new house for you."

"Have you ever thought about suicide?"

Rather than strip the nursery he'd decorated for Michelle's daughter, Chynna, Hopper left its flowered wallpaper to yellow as the autumn leaves fell on his courtyard. It was the witching season, and a deathly pallor draped over the Mud Palace.

The echoing adobe rooms filled like an overcrowded asylum with Dennis's collection of friends and hangers-on, a lot of Hollywood types who also wanted to make their own Westerns, psychedelic ones featuring their cowboy Jesus, Hopper. Flying in to join the decadent feast one day was the famous psychic to the stars, Peter Hurkos, ready to give extrasensory insight into Hopper's movie.

"You'd better stop," Hurkos warned Hopper's dinner guests, who tried to expose him as a fraud. "Or I'm gonna tell you when you're gonna die."

Holding court over the candlelit Mud Palace dining room, Hurkos talked about the Sharon Tate murders. Hopper claimed to know about some weird S&M videos recorded three days before the killings. They'd been filmed, Hopper heard, at the home of

Mama Cass, where twenty-five people had been invited to witness the whipping of a drug dealer from Sunset Strip who sold them bad dope.

Hurkos had visited the scene of the Tate murders, 10050 Cielo Drive, and kneeling down on the bloodstained carpet watched in his mind a replay of the killings that shook Hollywood and caused everyone to lock their doors. He envisioned Sharon and her friends tripping on LSD in a violent bacchanal inspired by what he called "goona-goona," a black magic ritual.

"I see pictures in my mind like on a television screen," said Hurkos. "When I touch something, I then tell what I see."

Holding on to the enormous Florentine dining room table that had been at the Mud Palace since Mabel's days, Hurkos started talking to himself, claiming to experience through the wood grains all that had ever happened at that table—for wood holds the vibrations of everyone who handles it.

The chocolate-brown wood harnessed visions of Mabel's long-ago esteemed guests: Georgia O'Keeffe, Ansel Adams, and D. H. Lawrence, struggling to create his utopia. Hopper had heard from the sole survivor of Rananim, the lady with the ear trumpet, how one night D. H., in the midst of a heavy peyote trip, thought he had turned into a coyote and that someone—perhaps his art patron, Mabel—had to chain him up in the Mud Palace courtyard.

/ / /

Come winter, Hopper sat by the fireplace in his lodge-like living room held up by two giant spiral carved wooden pillars, and chatted with a visiting Playboy bunny while a spacey-eyed girl perched behind him like a Cheshire Cat. The bunny admired Hopper's art collection, one he'd been rebuilding ever since Brooke won his first collection in their divorce. Luckily for Hopper, he had managed to keep his *Easy Rider* profits. Brooke

claimed she didn't even try to get a cut because she was scared he'd go after her with a shotgun.

Found among the Roy Lichtenstein comic strip fighter jet painting and "atomic artist" Tony Price's set of hydrogen bomb casings, rescued from a nearby Los Alamos scrapyard and transformed into a set of Tibetan peace gongs, was Hopper's own *Bomb Drop*, a huge seven-foot joystick that moved hypnotically back and forth, perpetually destroying the world in a mushroom cloud. Grotesque Peruvian masks grimaced on the wall near Andy Warhol's *Kiss*, featuring a still from 1931's *Dracula*, with fanged Bela Lugosi going for the throat.

Hopper turned to his bunny, telling her about a visit he'd made to meet Charles Manson in prison a few weeks before. He described it as casually as if he had gone to see a long-lost relative. There were some eerie similarities. After all, both Hopper and Manson had recently appeared on covers of *Life*. As their features revealed, their recent activities had both included their own strange B-movie fantasies played out on Western movie sets.

Manson's set was the Spahn Movie Ranch in the rolling Simi Hills outside LA, a historic movie ranch once used during Hollywood's golden age for filming Western movies and television shows. Amid the dilapidated fake Western facades—the Longhorn Saloon, the Rock City Cafe—Manson, like a lunatic director, had ruled over his hellacious Manson girls, riding around the ranch on armor-plated dune buggies, readying for the apocalypse. On trial for the Sharon Tate murders, Manson summoned Hopper to prison for the purpose of discussing a biopic, a dark and depraved American dream that he wanted Hopper to direct. Perhaps Manson saw Hopper as an outlaw brother who would be able to see beyond the conventional jeer of "madman."

"Did you see the newspaper? Did you read it last week?" Manson asked Hopper during their visit, explaining how he had stood up in court and started reciting the Declaration of Independence.

Hopper told Manson that he hadn't read about it. Manson seemed very excited.

"Oh? You don't read either?"

Hanging among the art in the Mud Palace was a poster from a Warhol exhibit with one of Andy's famous quotes.

I Never Read
I Just Look at Pictures

Hopper bragged to the bunny how Manson had told him all about what had really gone down at Spahn Ranch.

"He said that, like, you know, he was a big star and like his whole life, he'd been acting out a movie, but there hadn't been any movie cameras there."

The whole time Hopper spoke to his bunny, a camera was filming them for a documentary titled *The American Dreamer.* Self-proclaimed "idea man" Lawrence Schiller and his partner, Kit Carson, were down in Taos to film Hopper editing *The Last Movie.* The cameramen followed Hopper to the El Cortez Theater, where Dennis delivered lines while watching himself ride his horse through the grasslands of Peru.

On-screen, Hopper as the stuntman Tex looked clean-cut and sexy in his cowboy hat.

Off-screen he appeared feral with Manson-length hair and sex-crazed eyes. It was Hopper's reputed wild sexuality that Schiller was interested in exploring in the doc, which he figured would be like *Nanook of the North,* in a way. Everybody considers it a first-rate documentary while in fact it was staged because Nanook the Eskimo was an actor.

"Every guy wants to have an orgy," admitted Hopper to the doc guys, so they decided to stage one, even bigger than the champagne bubble bath Dennis once had with Natalie.

Where do you find horny, available, adventurous girls? The

doc guys figured the Santa Fe Airport was a good place to start. Girl after girl after girl walked through the Pueblo-style terminal. Schiller went up to them one by one and asked very politely, "Do you know Dennis Hopper?"

"Yes."

"Would you like to have an orgy with him?"

"Oh, yes."

A few hours later, a station wagon pulled up to the Mud Palace, and the curious girls came out, followed by another car. Assembled inside the living room, two dozen or so girls, picked up at airports and restaurants, began to disrobe. A few minutes later, a prepped Hopper walked in fully clothed.

"What do we have here?" He smiled at the boobs and buttocks, pretending to be surprised.

Going upstairs to Mabel's old bathroom with its windows painted by D. H. Lawrence, each pane adorned with different symbols—stars and sunbursts, Indian feathers and totems, swans and roosters—Hopper lowered himself into the bathtub with two chicks. The scene was terrific. Great stuff. The highlight of the documentary. But after shadowing Hopper for weeks fumbling through his editing of *The Last Movie*, something gnawed at Schiller.

Here's an actor who's making a film for Universal, who's on the upswing of his career, and he's letting it all hang out over the edge, letting the camera capture him wriggling in the bathtub with these two chicks. Why? But on a more serious level, why was Hopper willingly destroying his career? It wasn't the acid. Nobody was forcing him. Nobody had a gun to his head. The doc guys, Larry and Kit, were certainly not holding a check and saying, "Do this scene and we'll give you ten million dollars." Hopper appeared to be doing it because it was the image that was right to lead to a glorious, spectacular failure. Perhaps a work of art in itself.

"I can sleep on a mattress again. I have friends," said Hopper,

watching himself in the latest cut of *The Last Movie* at the El Cortez. "And if it's nothing more than, like, you know, *The Magnificent Ambersons*, which was Orson Welles's second film . . . I can become Orson Welles, poor bastard."

The way he talked about Welles and *The Magnificent Ambersons*, Schiller thought Hopper knew what his end was gonna be. Hopper was really fucking smart. He was consciously using his ability as an actor—a movie man—to play the role of an artist who was going to spectacularly, gloriously, magnificently fail. As the doc guys filmed Hopper watching *The Last Movie* in his own theater, Schiller knew that the end of their doc was going to be Hopper's failure. The only question was: How was Hopper gonna get to his end?

THE SPRUCE GOOSE

The idea to bring in a cinematic mystic to guest edit *The Last Movie* flashed before Hopper one day at the El Cortez Theater during back-to-back screenings of *The Last Movie*, *Fellini Satyricon*, and the unofficial world premiere of *El Topo*, an allegorical Western directed by Chilean director Alejandro Jodorowsky about a black-clad gunfighter on a quest for enlightenment. Ending on a shot of a grave swarming with ants, *El Topo* blew Hopper's mind. So he summoned Jodorowsky for a visit to the Mud Palace.

All ideas were welcome on the creative ant mound of the Palace, the editing taking place in a log cabin in the courtyard outfitted with three Moviola editing machines, seven horseshoes tacked to the wall, an Indian arrow stuck into the high viga-beamed ceiling for good luck, and six-foot metal shelves stacked with film canisters. Without a mother to force him to change his clothes, Hopper wore the same outfit for days on end, reeking of what hard-line Broadway musical directors call "flop sweat." Jodorowsky lined up ten of the Hopper girls buzzing about the Mud Palace and made them smell "the perfume of Dennis Hopper."

His only drug being a lack of sleep, Jodorowsky claimed that

in two days he edited a version of *The Last Movie* into one of the greatest pictures ever. Only to have Hopper destroy it once he left.

The myth around *The Last Movie* grew to epic proportions. For Dennis, it couldn't just be a great picture anymore. It had to change the course of cinematic history. It had to live up to its title: an omega to the alpha of cinema, a Judgment Day of the screen. It had to be a searing projection of light exposing all the audience's accumulated delusions since the most famous early Western, 1903's *The Great Train Robbery*, starring traveling salesman-cum-actor G. M. Anderson, who put on a ten-gallon hat and shot his six-gun blanks at the camera. It sent audiences screaming and fainting and wanting more!

One of the herd of editors left to sweep up the editing shack floor was intense young Todd Colombo. Actually, after several particularly trying months, Todd was the *only* editor left hanging around the Mud Palace. With long stringy hair, glasses, and a quiet intensity that reminded one of the student revolutionary in *Dr. Zhivago*, Todd possessed the Zenlike patience necessary for exploring Hopper's constantly sliding vision about what *The Last Movie* should be. Willing to try out different possibilities, Todd would sit for hours, staring into his Moviola like a mad scientist over a microscope, reordering and cutting the scenes so Hopper could tell him what felt right. Todd was content to work late into the night just so long as Hopper kept his Irish coffee out of his trim bin.

Todd thought *The Last Movie* was truly magnificent. It was a living, breathing thing, and it evolved. Changes came in all different styles, making it sometimes hard for local hippies and commune kids to keep up with the screenings at the El Cortez. The work in progress had become something of a ritual social event in town. Dennis would invite his fabulous friends from Hollywood, as well as some of the hard-core commune guys who were a little off—just to see what their reaction might be. Like the local guy who never

bathed and had supposedly pulled a Van Gogh, cutting off an ear to send to a girlfriend.

"That movie is just *soaked* in cocaine."

"I just thought it was so self-indulgent."

"A great idea, but that weird sex scene? Who could give a shit?"

So went some of the responses to scenes Hopper included, like Tex lapping up breast milk squirted into his mouth by this Peruvian woman. On another night it was:

"Fucking brilliant."

"The Plato's Cave of cinema."

"Get it? *The Last Movie.* This is a new dawn, man . . . "

One night, Hopper screened an eight-hour cut. He loved it at eight hours. On another, bent on making his audience suffer, he loved it at forty-two, his film spreading out before his dazzled eyes like an enormous tapestry. He hated to snip away a single frame. It got to the point where the movie was so big it couldn't fit through the projection room door. Editors gave up, split for other gigs, or were fired, leaving our hero to his mammoth vision.

Todd Colombo decided to call in a linchpin, his friend Rol Murrow, who hadn't worked on anything other than UCLA student films. Rol wasn't in the industry but promised to edit on the cheap. Besides, he had the mechanical DNA to make an albatross soar.

"My dad designed the Spruce Goose," said Rol, speaking of the Herculean airplane Howard Hughes built, which the critics said would never fly. "He worked with Howard for two solid years from initial concept of the plane through the complete design."

In the editing shack, the three—Hopper, Todd, and Rol—worked around the clock. Some of what the newspapers wrote about the editing process being total pandemonium and out of control? Maybe it was out of control in Hollywood terms, but Rol really just felt they were all working their asses off. There wasn't too much time to get into trouble.

Preparing for the arrival of this French guy—the president of the Cannes Film Festival, Robert Favre Le Bret, who was making a special trip to Taos just to evaluate the *Easy Rider* follow-up—they worked fifty-two hours straight. Finally, they got *The Last Movie* down to a five-hour version, just as Le Bret rolled into town with his gofers.

"You talk about some pissed-off Frenchman," said Todd.

It wasn't the story—because the story of *The Last Movie* was always brilliant. The frogs were offended that they had to sit through an unfinished film. It didn't help that there wasn't any wine to procure in Taos, seeing as it was a Sunday. How barbaric! Hopper managed to get some bottles out of the back door from a local merchant.

As Hopper whittled his dream down to orthodox movie length, word spread further about his outlandish cinematic outpost in the West, a haven where a Hollywood outlaw like Jack Nicholson could raise hell unbothered. All sorts came—from presidential candidate Eugene McGovern to Big Duke, arriving on Hopper's thirty-fifth birthday, pulling up a chair and sitting around the kitchen, entertaining the ladies. Bo Diddley was there one day, makin' sweet potato pie in the kitchen, like a line from an old blues song. Everybody was curious to see what was cooking at the Mud Palace. Bob Dylan came through after hitchhiking across the country. He'd gotten a ride with some Jehovah's Witnesses, or Sikhs, and was said to have written a song about it.

Spring came, thawing the Mud Palace, bringing new life. The craggy Sangre de Cristo Mountains turned blood red. The giant cross stabbed into the Indian land behind the Mud Palace was for the rites of the Penitentes, a shadowy Inquisition-era sect that had been left to fend for themselves in the Southwest after the Spanish Empire fell. Surviving on raw belief, their members continued the ritual defacing of their backs, whipping themselves bloody to strengthen their conviction. One of Hopper's artist friends, Ron

Cooper, was driving on a mud road through the snow when all of a sudden he saw something that made him turn off his ignition and slide down in the front seat. He watched these cats come by carrying a cross. Someone was actually nailed to it. Crucified.

The question at the Mud Palace was whether the Penitentes would actually "do their thing" on that cross come Easter. As the day approached, Hopper did his thing in the editing shack, watching over and over the decisive moment unfurl—Tex dies, Tex dies, Tex dies, sentenced to his terrific death scene by his native director.

THE BLACK TOWER

Ragged and unwashed, with long, greasy hair and a bandanna wrapped around his head, Hopper emerged from his year in the desert with a ninety-three-minute version shaped by mystics and madmen. It was 1971. Up went the elevator, taking him to the top of Hollywood's Black Tower, a foreboding monolith of smoked glass and steel looming over Universal City.

Bing!

Sitting behind his desk in his office on the eleventh floor was Danny Selznick, David O.'s son, who'd been a fan of *The Last Movie* ever since it had been a screenplay sent down from his boss, Ned Tanen, the studio executive later to be the inspiration for the bully Biff Tannen in *Back to the Future*.

"I don't have a lot of patience for reading scripts. You read, don't you?" Tanen had asked.

Right off the bat, Danny could see this screenplay wasn't your typical piece of Hollywood fluff. Danny, who admittedly wasn't hip, had seen *Easy Rider* and thought it was really original and daring. He thought *The Last Movie* was a fascinating idea: a village that has this stuntman ritually sacrificed.

"*Heavy*, you know," he said, using the lingo, "but very interesting."

Once *The Last Movie* got the green light, Danny had thought about going down to Peru. He really wanted to see Machu Picchu, but he just knew, given the cast, they'd all be high as the Andes. He was a little intimidated.

"Ned, you know, I'm gonna just come off as such a square. I will just feel like a fish out of water. Why don't I just wait and we'll see in the cutting room?"

When the time came, Danny showed up at the Mud Palace, knocked on the door of the editing shack.

"Come in, Danny," welcomed Dennis.

The log cabin, outfitted with three Moviolas, reeked of body odor. Seven horseshoes were still tacked to the wall, so was the Indian arrow stuck into the ceiling for good luck. But the six-foot metal shelves for stacking film canisters were completely empty.

"Where's the film?"

"Gone. It's gone."

"What do you mean it's gone?"

"You know, man, it's in my head."

Bing!

On the fourteenth floor, Tanen listened to Danny's report. Broad-shouldered in his signature tan suit and sideburns, Tanen, who was hailed for his seat-of-the-pants savvy, played the part of the studio wunderkind as Universal's counterpart to the too-cool-for-school Raybert Productions' Bert Schneider, who'd financed and produced *Easy Rider*. Tanen was the head of a low-budget division connected to but independent of Universal, just like Raybert's association with Columbia Pictures. Taking its cue from Raybert, Tanen's division was charged with the mission of making movies for a million dollars and then raking in forty times that amount. The *Easy Rider* model. Easy-peasy.

Tanen chuckled at Danny's description. Ned was hip, he could dig it.

"Whaddya expect from someone who's on weed twenty-four hours a day?"

Tanen had witnessed a fuckin' orgy when he'd gone out to Taos, but, hey, that was just the deal that Hopper was doin'. Tanen had adopted the motto of his hipper Bert prototype over at Columbia: the filmmaker is always right. So nobody interfered. Even Lew Wasserman next door, the power-drunk chief executive of Universal, a.k.a. the King of Hollywood, had to stay out of it. Hey, Tanen was *independent*.

Danny eventually returned to Taos. He sat at the El Cortez and watched a cut of the film. He thought Hopper gave a good performance as Tex. Or was his name Kansas? It was a little hard to tell.

The movie was . . . well, it was really well made! It wasn't necessarily a film for America, but maybe it could find an audience that appreciated its artistry—an international audience, perhaps? Any son of David O. knew it was critical to wow the audience with the ending. If you could wow them as the curtain closed, it didn't matter what smaller missteps you had made along the way, you were golden.

So the movie played on until Tex lay dead, crucified by the village. He was the victim of their misunderstanding, a grand critique of American identity seen through its most treasured genre: the Western. It was haunting and frightening. Powerful, especially if you knew the story going into the theater. Really, really terrific!

And then . . . well, what was with that *ending*?

"You're not gonna leave that in? I mean, really, you *can't* do that."

"Well, yeah, man, that's what I wanna do."

"But Dennis, it's so self-destructive. This is such a beautiful movie. Why would you do that?"

"Well, it's existential."

"To hell with existential, you know, it's such a powerful story—so well made. You know, you're harming its potential."

Bing!

"You do know, Danny," said Tanen—he'd been getting the part of the hip executive down—"the whole basis of our unit's reputation is that we give filmmakers final cut. We don't interfere. We don't tell them. You're *not* David O. Selznick. We don't tell them how to edit their picture."

"You mean we let them sink publicly?"

Tanen had a hell of a lot riding on this film—like his job with Universal. True, it made him antsy to have Dennis Hopper all the way out in Taos, beyond grabbing distance. And then there were all those magazines littering the publicity department, reports of monstrosities that had gone on in Peru. What the hell had Hopper been *doing* down there anyway? *Rolling Stone* had quoted him threatening to stick a rotating pineapple up Hollywood's "giggie."

What the fuck was a giggie? Tanen had to play it cool. That was his role.

"Well, we have to give them a chance to expose it somewhere, where maybe he'll get a public reaction and maybe your point of view will prevail."

"You mean *our* point of view will prevail."

"Okay, our point of view will prevail."

At last Tanen was about to see the results for himself as he took the elevator up to the private screening room of the venerable Dr. Stein, as underlings respectfully called Universal's chairman of the board. The benevolent corporate sage had his own private elevator to transport him to the heights of his penthouse office.

Bing!

The doors opened to a palatial chamber lovingly filled with big band mementos. Dr. Stein had brought on Dennis Hopper in the first place. Unshaven and dirty, Hopper had showed up at his house one day during a luncheon. He was a friend of Dr. Stein's daughter,

Jean. Ordering an extra place to be set for him, Dr. Stein turned to the publisher of *Time*, or some major publication, and commented how this boy had just made $40 million for Columbia Pictures. Universal had *lost* $40 million in 1968.

A former ophthalmologist, Dr. Stein had dedicated his life to seeing clearly, and with Dennis Hopper the writing on the wall seemed hard to miss. The old ways of Hollywood weren't working anymore, saddling Universal with *Thoroughly Modern Millie*— about as modern as Guy Lombardo and his Royal Canadians, the swing band Dr. Stein had signed half a century earlier.

"Give the kid what he wants," ordered Dr. Stein.

Now Dr. Stein sat down on a spindly chair in his French drawing/screening room. Joining him were his execs and Hopper's weird-looking gang from Taos, including his editors Todd and Rol.

Stepping into the projection room to help thread the film, Rol was *amazed*. Spotless. Meticulous. He could have eaten off the floor, walls, in this perfectly clean projection room. It was nothing like most projection rooms, typically holes from hell. Rol peered out at everybody sitting on the beautiful furniture. The gigantic oil painting they all were facing suddenly went away, revealing a pristine screen. More paintings came off the projector portals.

The film began with Hopper as Tex riding through the lush Peruvian grassland. (Where was the simple plot line like in *Easy Rider* of two guys riding bikes across America?) It was dead silence for an hour and a half until Tex lay dead at the hands of the villagers. But in the interim the camera kept rolling. And rolling. Tanen got antsy. End the goddamn picture! All of a sudden, Tex got up from his supine position, brushed himself off, and turned into Hopper, saying, "Well, you know, here I am," or some such nonsense remark, and that was the end of *The Last Movie*!

The lights came on. The beautiful painting returned to position. Tanen swore he heard the projectionist say, "They sure named

this movie right, because this is gonna be the last movie this guy ever makes."

Maybe it was Tanen's fear talking, because other witnesses simply remembered dead silence with everybody watching Dr. Stein get up from his chair. He just shook his head.

"Well, I just don't *understand* this younger generation."

Baffled as he had been with that strange $40 million–making acid trip in *Easy Rider* that the kids seemed to like so much, he doddered off to his office, which was comforting with all of his mementos. He didn't say he *hated* it, though anybody could see how the old man might be a little confused by the breast-milk scene, and the one where Hopper gets on his knees before a socialite so she can smack him around. They didn't have strange Peruvian rituals with bamboo movie cameras back in Guy Lombardo's day.

"I wish we were dealing with him," said Hopper, wistfully watching Dr. Stein go, but they weren't dealing with him.

They were now dealing with Lew Wasserman, and the King of Hollywood didn't get this *Easy Rider* phenomenon. Why didn't the kids like *Thoroughly Modern Millie*? It had Julie Andrews for chrissakes! Didn't the kids like Mary Poppins anymore? Who was this filthy, unwashed, long-haired cowboy freak who'd been running around telling Hollywood he'd *bury* them, put them in chains?

Well, nobody was gonna stick anything up Lew's giggie, whatever the fuck that meant. He'd shove quality entertainment down the kids' goddamn throats until they *choked* on it. What the hell was Tanen doing next door anyway? What the hell kind of show was he running independent of Lew Wasserman? Wasn't *The Last Movie* a Universal picture and didn't Lew run the show? What the fuck was Lew gonna do with this weirdo film? Lew had heard Selznick on the eleventh floor actually *liked* it—if only Hopper would've frozen the frame on the dead stuntman. Fade out. Maybe Selznick was right. The kid better *die* at the end.

CANING

Lew Wasserman's office was decorated with a cane, the cane George Washington carried during that winter of suffering at Valley Forge, Lew told Hopper. Getting the screws put in him, Hopper ran out of the office, literally screaming in pain down the halls of Universal. Lew was killing him.

Downing Scotch at the Chateau Marmont, Hopper couldn't understand the insatiable bloodlust of the despot desperate to kill him off in the finale, too calcified by his evil Black Tower to even want to try to understand his vision. Why were the herds trying to stomp on him?

A reporter sat before him at the Chateau. "They wanted me to kill the guy at the end. They didn't care how I killed him, just kill him at the end."

The executive producer, Michael Gruskoff, tried bringing his director back to reality. He always tried to be straight with Hopper, ever since becoming his agent after *Easy Rider*. He adored Hopper. He'd never forget the night he went with Hopper and Fonda to see the Rolling Stones play at the Forum in LA. They had all dropped acid and stood on their chairs for the entire show. It was the best rock show Gruskoff had ever seen. At the end, Ike and

Tina got onstage, invited up because the Stones really dug *River Deep—Mountain High*. Genius. Genius. After the show ended in the early morning, everyone went over to Fonda's. Mick. *Everyone*. They hung out till the sun came up. When Gruskoff got home, his kids stared at him like, where the hell were you?

Where the hell was he now?

Hopper got his revolution, all right. After *Easy Rider*, a lot of studios started independent, low-budget divisions. It radically altered the Hollywood landscape. An entire younger generation of filmmakers now had an open field, old Hollywood practically served to them on a silver platter.

Gruskoff had worked the angle. He got his client an extraordinary once-in-a-lifetime deal and final cut on *The Last Movie*. So long as Hopper kept within budget.

Getting his client this deal was one thing, but Gruskoff always knew it was a dangerous proposition having Hopper do a movie. What you see is what you get, and you didn't know *what* you were gonna get. But Gruskoff took the gamble and decided to become Hopper's *producer*, too. Why did he have to get Hopper at the worst time?

It was all those drugs. When you do all those drugs, you get very paranoid. And Hopper was paranoid to begin with. So paranoid that Gruskoff visited Taos every few weeks to hang out, see the editing, try to talk to him. Only Hopper was living such a chaotic life—walkin' around with two holsters. Still, there was also just something so *sweet* about Dennis that even if he fucked with you, you had to love him. He knew how to get to you, no matter what. They'd have a little problem, then Hopper would just hug him and say, "Oh, *Michael*."

Why did he get Hopper final cut? That extraordinary deal came back to plague him.

Hopper was fearless and didn't give a shit about Lew Wasserman. But this was the King of Hollywood they were dealing with.

Lew Wasserman could wreck a career in ways Hathaway couldn't imagine—an honest-to-God blackball.

"Let's find a middle ground somewhere. Let's keep the film that *you* want and you'll have it. We'll print your film, but let's see what film they want, and see what it's like. They can't distribute it because you have final cut."

That's the angle Gruskoff worked, but again, what he saw is what he got with Hopper.

/ / /

Rol worked into the early hours in the editing room they were using in LA, getting the print ready, laying in the tracks, syncing the sound. It was like setting up a complicated toy train—albeit one made of celluloid. He started feeling a glow about the film. Had Dennis Hopper been the Howard Hughes of his time? Rol could just imagine if *Hopper* were handed a billion dollars—the teams he would put together and the projects he would engage.

Rol was very pleased. He thought they had created such a meaningful movie, one that finally fulfilled Hopper's outrageous ambition of what a movie could be.

All of a sudden, Hopper burst in. Rol could see from the look in his eyes, Dennis was charged with purpose.

"I have a *vision*."

Oh no, not another one. Not now. When they were finally putting the baby to bed. Rocking it in its cradle.

"Nothing led up to it," Rol remembered years later, looking back to the strange night they finished editing. "Other than his frustration with Hollywood, and his fear that the movie would be taken away from him, and the way people related to his art and this film."

His friend Todd Colombo added, "It was a mind-bogglin' cut to me. Somebody must've said something. We may never know

who that was or what was said. Dennis respected people who had done something. He listened. He sought advice and counsel from people who had really done something in their lives. So perhaps some artistic person he respected said something. Anybody with a real creative heart can succumb to the pressures of the corporate world of the movies, but Dennis wanted to walk that fine line. He was sort of fearless."

It was the way he said, "I have a vision" that was spooky.

"I want to put the end at the beginning," said Hopper.

On the director's orders, Rol proceeded to lop off the last ten minutes of the film and surgically splice them onto the opening. It was very hard for Rol to make that cut. After that, it took people in Europe to appreciate the film.

Premiering at the Venice Film Festival in 1971, *The Last Movie* won best feature, about which Lew Wasserman could give a fuck. If Hopper wouldn't reedit, Wasserman was going to show it for Universal's contractually obligated time in New York and Los Angeles, then shelve it.

"You can't win this battle with Universal on the editing of the movie," said Gruskoff. He gave it to Hopper straight—if he'd rein his vision back just a little, he could become one of the elite directors in the world. The thing was, Gruskoff realized, Dennis was an artist. Still, it seemed too bad.

Danny Selznick felt terrible. He had great affection for Hopper. They had recently discovered they were born less than twenty-four hours apart. Hopper in Kansas, Danny in Hollywood. Two guys on the Universal lot, worlds apart. Each a bullheaded Taurus. He thought the future was wide open for Dennis. He wanted him to keep making movies.

Selznick Memo to Self:
What about a freeze-frame on
the dead stuntman in the end?

Then again, even if Dennis recut the film, there was something about the public building people up after a great success like *Easy Rider*, then gleefully tearing them down. Critics were itching to attack Hopper, a terrific target given his totally over-the-top persona. Danny hated the thought of Hopper ending up like his father, David O., who by the end of his life was unable to get anyone to finance a picture.

"Are there going to be any changes?" asked Danny when it came to the final decision.

"No," said Hopper.

Hopper said the same thing when summoned back to the Black Tower to be judged by Lew Wasserman. Hopper eyeballed that prop cane billed as George Washington's. His brother David had suggested he try to steal it. Hopper was just about to leave when—

"By the way, Mr. Wasserman, how do you know that's *really* George Washington's cane? Could you explain that to me before I walk out of here?"

"Get the fuck out of here."

The Last Movie was sentenced to a death as primitive as the villagers killing the stuntman, perhaps more savage. Hopper referred to it until the end of his days as "assassination time." Hopper had to recruit Bert Schneider for Columbia's help with the release since Universal basically bailed. On September 29, 1971, the film set an opening day record at RKO's Fifty-Ninth Street Twin Theatre in Manhattan. Then the critics attacked. "One would have to be playing Judas to the public to advise anyone to go see *The Last Movie*," wrote Pauline Kael in *The New Yorker*, railing against it just as she railed against *2001: A Space Odyssey* and *The Graduate*. The public forewarned, *The Last Movie* made only $5,000 in its fourth and final week at the Twin, then vanished into obscurity in the Universal vaults. Hopper's suffering only strengthened his belief in his film.

"Well, the movie's in their hands now," said Hopper. "And their hands are full of blood. Corporate blood."

Despite his lashings, Hopper lived to tell his story at the restaurant in the Chelsea Hotel, El Quijote, decorated with thousands of Don Quixote statuettes. Hopper wore a dark-brown cowboy hat over a red bandana headband. A small cross hung around his neck. He didn't have enough money to pay his hotel bill. He slipped out in a taxi while his old Digger friend, Emmett Grogan—for whom he'd drop-kicked a man during the Summer of Love—repaid him by blocking the desk clerk waving the bill.

"Mr. Hopper! Oh, Mr. Hopper!"

Hopper was off to play a train robber in *Kid Blue*, a comic Western shot in Durango, Mexico, where Big Duke had planted roots. Who knew? Maybe there'd even be hope for a resurrection of *The Last Movie*. For at the end lay the beginning.

THE GHOST

One night at the Mud Palace, Dennis heard something moving upstairs. He had heard these rustlings before, but this time, it was distinctly coming from the second floor bedroom at the end of the hall. Ever since Dennis had moved in, the room was always freezing, cold even in the summer and strangely impossible to heat. It was where Mabel Dodge Luhan, the doyenne of the Southwest, dead some ten years, had once slept.

In the 1920s, Mabel had written to D. H. Lawrence, who was living in Europe, engaged in his "savage pilgrimage" wanderings around the Continent. She pleaded with him to move to Taos. While not an artist herself, she prided herself on having an intimate understanding of the artistic temperament, especially that of the male artist, and his huge capacity for love, suffering, and lust. When D. H. came to live with her, she learned how quickly he could spin off into violent rages. After intercourse with his wife, he often beat her, furious at himself for succumbing to the baser weakness of sinking his "pecker" into her fatty flesh. D. H. might be a barking mad coyote, chained in her courtyard, but Mabel forgave him, for he was her genius.

Mabel had imported the writer to Taos for a purpose. She wanted

him to write the Great American Novel about Taos. At times she was a very demanding art patron.

"You need something new and different," Mabel had told her treasured houseguest. "You need a new mother!"

Her ghost chased Hopper around the Mud Palace. Packing up, he moved out of the Mud Palace and into another adobe building on the compound, across the courtyard, known as the Tony House. Mabel had built the Tony House for her Tiwa Indian husband, Tony Luhan, stoic with his long braids and chiseled monument face. Hopper would get to play cowboys and Indians again as he had as a boy in Dodge, except now he had a .38 to fire up into the vigas.

"You might hurt somebody," warned his friend Dean Stockwell.

Attracted by Taos's primordial power, Hopper's friend had been coming here ever since he'd played the lead in the film version of D. H. Lawrence's *Sons and Lovers*. On set in England, he'd read D. H.'s writings about the Indian dances in this mystical place called Taos, which he'd never heard of before. When Dean got back, he "got a car, got a broad," and took off. Taos was truly an enchanted spot.

Dean was one of the few who could deal with Dennis, a *super*-energized being who started talking and wouldn't stop. *Couldn't* stop. And when you mixed that with cocaine and alcohol?

"Oh, Jesus!" said Dean, who just got stoned, but Hopper got stoned and *energized*—going from one idea to another, just— "Ahblahblabibblielbialagh!"

Dean wasn't scared of the man in any real sense. He fervently believed that Hopper would never actually *shoot* anybody. Hopper just loved his own outrageousness, digging the way he was. It was just the vibe he was affecting. Wasn't it?

One crazy night at the Mud Palace, Hopper fired two shots at the Warhol silk screen of Mao hanging in the kitchen—blue face, green blubbery lips. Pow!

Around the same time, Hopper's art dealer friend who owned the Ferus Gallery, Irving Blum, came to Taos to visit and found Hopper in the midst of a bunch of bikers and odd types hanging around. Hopper was so spaced out, Blum thought he was a goner for sure.

The Taos artists mostly got the feeling Hopper wasn't doing much of anything in terms of making art anymore. He wasn't doing much of anything except going totally nuts, stoned all the time with guns *everywhere*, like he was expecting the CIA to storm him. Friends felt he was amped up on the paranoia that comes with doing way too much blow.

One time, Hopper and his roughhousing pals were shooting guns and doing all sorts of crazy stuff. Hopper's young daughter with Brooke, Marin, was visiting. She called a friend of the family, who then called artist Larry Bell, who'd moved to Taos to get some peace.

"Can you get her out of there?"

Larry picked up Marin at the end of the long driveway at the Mud Palace. She was terrified. She was just a little kid. Larry figured Dennis didn't even realize she was *gone*.

From the perspective of Hollywood, Hopper had gone totally off-the-grid nuts.

From the perspective of New Buffalo and the Taos commune scene, Hopper was living the sixties dream large with lots of money, a very selfish existence. For one, they were hoping he'd set up a needed community medical clinic. He wasn't creating crash pads for people like they thought he should with all that dough. He was just having a good time. Still, it was a bit of a thrill for everyone whenever Hopper showed up to New Buffalo. Some girl would usually give him a blow job.

One night the Eagles were staying at New Buffalo after a gig in Albuquerque. Dennis came over strapped with a pistol and in the

middle of an argument with a Chicano, pulled it out and aimed it at the guy's head. The party went on, but a commune girl grabbed a knife from the kitchen and went after Hopper for some wrong he'd done to her. Another time someone held up a watermelon against Hopper in self-defense. Hopper stuck his knife right in.

It was all part of the Dennis Hopper psychodrama cowboy act, figured New Buffalo. The bad karma justified their decision to not let him film *Easy Rider* there. A couple of the commune guys really dug the movie, but others thought it was pure counterpropaganda. Hopper didn't live on a *commune*. He had rich friends and an indulgent life, so how could he be qualified to show what living was really like on a hardscrabble dirt farm with no money and workin' hard, tryin' to live his life? (Even if a handful of these dirt farmers were rich kids, too.) Bore about as much relevance to the truth as any Hollywood movie.

/ / /

The founder of New Buffalo, Rick Klein had taken to hanging out with Hopper ever since his band, the Oriental Blue Streaks, had moved into the Mud Palace. Hopper would come over to have dinner from the Tony House, where he was sequestered with his guns and coke.

"This friend of mine is makin' this movie and needs a soundtrack and I thought of you guys," said Dennis. "He's gonna fly you out to Hollywood. You'll see the movie and see what you think."

"Oh man, we can really be creative!"

The Blue Streaks imagined they were going to be doing something along the lines of *Easy Rider*. Only they didn't quite realize that after *The Last Movie*, Hopper was totally persona non grata in Hollywood. The band worked on something for the movie Hopper set them up with, *The Young Nurses*, a real B-grade one with the

most memorable scene being when the nurses tie a helium-filled balloon to a guy's dick. All the Streaks could come up with was "Bedpan Blues."

Drinking at a bar on the Taos plaza, Hopper and Rick hung out for hours and talked about old times. A few years at the beginning of the love movement were truly magic. People were just feelin' it. You would be walking along the street and if your *vibes* were right, you could walk up to a girl . . .

"You're so beautiful. I'd really like to make love to you."

"Sure, brother. I'd like to make love to you, too."

"We were going to hold hands, take LSD, find God—and what happened?" asked Hopper. "We ended up at the drug dealer's door, carrying guns, and in total madness."

When cocaine came in, a lot of the kinder souls began to see the destruction of the sixties.

"*You* come into the bathroom with me and *you* come into the bathroom with me, but *fuck* these other people."

That was the vibe. It started getting selfish because of all the money that was involved.

"The cocaine problem in the United States is really because of me," Hopper would brag. "There was no cocaine before *Easy Rider* on the street. After *Easy Rider* it was everywhere."

Hopper disappeared into the bathroom at the bar and didn't come out for hours. He'd been getting pretty reclusive ever since moving to the Tony House. Rick figured the fallout was bound to happen—you're takin' a lot of cocaine, you gotta drink to come down. Pretty much leads to madness.

TRAIN TO THE STARS

A pariah to all, Hopper took the train to nowhere. And it was dingy, for nevermore would the fiery Warbonnet red and yellow Train to the Stars from his boyhood streak across the West. This was thanks to the honchos at the Santa Fe Railroad who refused to relinquish the name of the Super Chief to Amtrak. Apparently they found its service lacking and unbefitting a storied legacy that once featured those luxurious sleepers christened "Taos," adorned with Navajo rugs.

It was 1976. Hopper was stuck riding the rails back and forth for a month with a camera crew in his face for the independent film *Tracks*, shot almost entirely on Amtrak. Filmy with sweat, playing a soldier coming home from Vietnam, a greenish Hopper lapped his tongue into the mouth of the pretty girl playing a preppy college coed. He *loved*, but he *hated* to love.

The role wasn't much of a stretch for Hopper, who'd just lost his third wife, Daria Halprin. He'd met the beautiful, earthy star of the cult film *Zabriskie Point* during a screening of *Easy Rider* at the first Belgrade International Film Festival—gathering under the slogan of "A Brave New World."

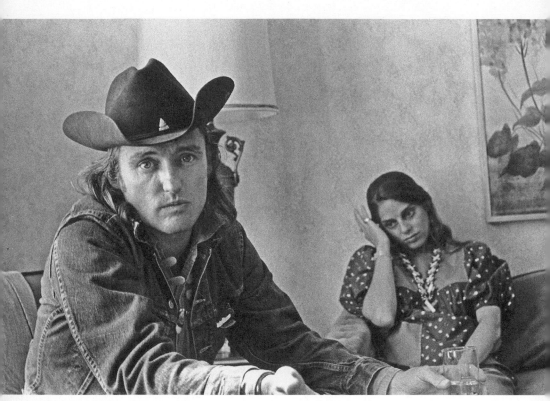

Portrait with Daria Halprin, shot by Robert Altman,
San Francisco, 1972

They married in a hillside ceremony overlooking San Francisco Bay. Beginning the processional was a synthesizer medley of ram's horn and flute. The blast of a Yemenite trumpet brought Daria, dressed in a Spanish fiesta skirt and traditional purple velvet Navajo blouse festooned with a hundred silver buttons. Holding her hand high in the seaside air, her landscape architect father led the bride down curving steps to the canopy, presenting her to Hopper, togged out in a claret velvet shirt. Everyone sat on rustic benches. Crushing the traditional wineglass underfoot, Hopper danced the hora to a conga and electric guitar arrangement of "Hava Nagila."

Daria gave him a child, Ruthanna, then divorced him.

Looking out the train window while the cameras rolled on

Tracks, Hopper listened to Dean Stockwell, his traveling companion sitting beside him, also starring in the film. The two Hollywood runaways, Dennis and Dean, swapped childhood stories.

When Dean was a child actor, squeezed between Frank Sinatra and Gene Kelly in the sailor musical, *Anchors Aweigh*, Errol Flynn had given him a set of pilot's wings with three interlocking *F*s. Turning it over revealed a big cock and balls. Flynn told the boy it stood for "Flynn's Flying Fuckers."

Tracks director Henry Jaglom gave his actors the space to improvise—slip into the record groove of themselves for their characters.

Hopper as the soldier spun a riff of autobiographical dialogue about wanting to go where the trains went because he was poor and he couldn't go anywhere. So the railroad tracks led him into the service.

Hopper walked up the aisle of the *Tracks* train to another car. Waiting for him was a woman playing a freak who rode the rails just for kicks. She got off on how Hopper's soldier told her he'd lie on the kitchen floor, pretending to do his homework. Just so he could peer up Mommy's dress.

The director had known Hopper since *Easy Rider*. Jaglom had helped on the edits, though he believed it was Hopper's film in every sense, reflecting his spirit, feelings, and essence. Pure Hopper. So was *The Last Movie*. Jaglom had gone down to the Andes to play a role but, being a little guy, was dwarfed by the burly six-four actors hanging around in cowboy hats. They all thought Jaglom was a sissy for not plunging in and consuming the juggernaut quantities of the local brew while snorting mountainous quantities of coke and then going riding on shaggy horses.

All Jaglom had wanted was a Bufferin. An aspirin. He was having trouble breathing at the high altitude, but he couldn't even procure a goddamn Bufferin. Those big, tanned llama hunks all thought it was a big joke. Peru had been a total madhouse, like the

lunatics taking over the asylum. After several days, Jaglom got too sick to stay, but not before he put the finishing touches on his letter to the Screen Actors Guild about the filthy llama-sty dressing room conditions.

"Sure, send it in," said Hopper.

Yes, Jaglom knew exactly what kind of madman he was dealing with. Before they filmed *Tracks*, Jaglom was eating with Hopper and his girlfriend at a restaurant. Hopper casually offered her to him, like a bite of steak, and when Jaglom politely turned down the offer, Hopper threw him to the ground and lifted a Heinz bottle over his head to smash his face. The sweetest man in the world one minute, the most violent and out of control the next.

Sometimes it was hard to tell whether this line existed, if Hopper was putting on an act or really out of his mind, trying to kill him with a ketchup bottle. They laughed it off.

Jaglom scheduled all of Hopper's scenes early for *Tracks*, knowing if he shot Hopper before noon, he'd be great. But come one o'clock, given the enormous amounts of alcohol and whatever else Hopper was consuming daily, it was impossible to get a performance out of him. The only quality Jaglom could use him for in the afternoon was raw anger.

It was getting late one day as Hopper, in his army dress greens with "US" embroidered on the collar and colorful decorations on his chest, stood before the open grave of the dead soldier his character had brought home in a casket in the train's luggage car. Standing over the grave, Hopper was supposed to recite this wonderfully shaded speech that Jaglom had written about America losing its innocence.

"Action."

Hopper tore up the speech, threw it down into the pit of the earth, and started shouting furiously.

"You motherfuckers, you motherfuckers, you wanna go to *Nam*?

You wanna go to *Nam*? You motherfuckers? *You* motherfuckers? You wanna go to Nam?"

Jumping down into the grave, he tore open the coffin with his bare hands and unzipped the body bag stuffed with ammunition and machine guns, all of which his character was going to use to bring Nam to small-town America.

"Great. Cut."

Crouched in full gear like an abused animal, helmet on and rifle ready, Hopper was not ready to jump out of the movie. Instead, he turned his back on Jaglom and the crew and began walking off the set. He seemed wounded and angry.

"Dennis? What are you doing?"

"You don't need me anymore. You don't care about me anymore. Movie's over."

DESIRE

"Bring me Coors, turn the heater on, and put some more water on that radiator," Hopper yelled downstairs through a hole in the floor beside his sprawling bed at the Tony House. He called it the intercom.

Desiree did as she was told. With no daughter of his own around, even though he had two of them, Hopper practically adopted her. He'd met Desiree at a Kris Kristofferson concert when she was twelve. Hopper was larger than life, and she was mesmerized. Even though Desiree was a kid, people said she was an old soul. She felt she knew Hopper from somewhere, like she felt she knew James Dean. She carried around Dean fan books in her backpack at school.

Taking the train to Albuquerque from Los Angeles (where she lived with her mother, who had worked on some Elvis movies) and then hitching a ride to Taos, she started spending summers at the Tony House, sleeping in a heap of blankets downstairs by the kiva fireplace. Her favorite thing was when Dennis, sort of like her weird uncle, taught her about art. On the days when the art that Dennis had bought arrived in trucks, he would order Desiree to unwrap it, like huge brown-paper Christmas presents. Then he

told her to figure out what the art meant. Desiree thought that Bruce Conner's assemblage piece hanging by the bathroom looked like junk—cigarette butts, an ashtray, a bottle cap, all stuck with nails in this box.

One day the IRS came and took Hopper's entire collection away.

Desiree knew when to make herself scarce. Like when these girls came over in their squaw skirts, wearing no underwear. Desiree remembered everything. People would tell her, "You are always the one in the corner just observing everyone and watching, like you're filming it in your head." She knew not to go where she wasn't supposed to.

Hopper freaked out after she found his guns in the closet, but somehow the Monster Room, which even Hopper didn't go into, kept on calling her name. One day Desiree psyched herself up, told herself, "I'm gonna go in there. I'm gonna be brave today." She poked in. In the middle of the room was a carved wooden folk figure of Death, hooded and riding this crazy animal cart, aiming her bow and arrow. That really scared the hell out of her. She ran out.

The summer she turned fifteen, Desiree took the love bus up to Taos. A bunch of Hopper's friends went to the El Cortez Theater to see *Pat Garrett and Billy the Kid* with Kris Kristofferson playing Billy, blasting anyone who dared mess with him in the dusty town. During the movie, Hopper was sitting next to Desiree and kept twitching about, getting up and leaving, leaving and coming back. He was really nervous because it was the evening of their special ceremony.

Kids who hung around Topanga Canyon back in LA had been pressuring Desiree to have sex to see what it was all about. Even though Desiree's friend, the actor and martial arts expert David Carradine, warned her to stay away from Dennis, she loved Dennis. She told Dennis she wanted him to be the one to deflower her.

Hopper gave her all this stuff that night, a mix of mescaline and peyote and cocaine. They cuddled and hugged, but afterward

Desiree wondered what happened to the big bang she'd heard about. She would have known, right? She was feeling pretty fuzzy herself and thought perhaps Dennis was too stoned to get it up.

"Is that it?" she asked.

Hopper got really mad. "How dare you, I'm a grown man, whaddya talking about—"

Leaving Desiree at the Tony House, he headed out the door with a .357 Magnum to the La Fonda hotel on the town plaza, where the owner kept a collection of D. H. Lawrence's paintings of orgies. There were men and women, women and mythic beasts, really dirty stuff. Old D. H. proudly adorned every canvas with a pecker—the phallus being the great sacred image for him, symbolizing the deep life force civilization tried to squash. After winning some acid in a hand of poker, Hopper stepped out onto the plaza and a giant tree appeared before him. It looked like a terrifying grizzly bear.

Bam! Bam! Bam!

He shot several times, blasting away at the grizzly, drawing the law. Making a break for it, he tried to run like hell back over to the Mud Palace, to make it to the Indian land in back, federal land out of jurisdiction, but the cops caught him, handcuffed him, and roughed him up pretty good. The pigs threw him in Taos jail, where Hopper had filmed the scene in *Easy Rider* when Jack Nicholson first appears, locked in the drunk tank with Billy and Captain America. Jack was about to be fully unleashed to America in the film version of Ken Kesey's book about madness being the true sanity, *One Flew Over the Cuckoo's Nest.*

Goddamn it, motherfuckers. Fuckers. Fucking. Fuckers.

By morning, Desiree was on the phone with the bondsman, trying to free Hopper from counts of disorderly conduct and possession of a deadly weapon, two of verbal assault, and the final count

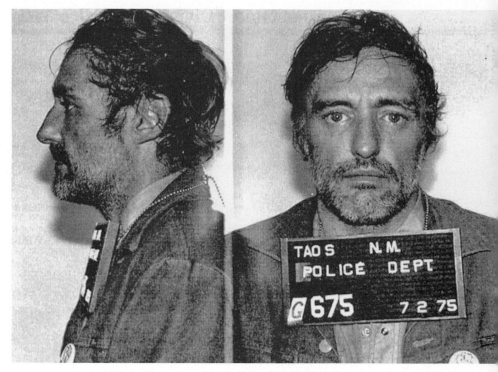

Mug shot, arrested by Taos police, 1975

of resisting arrest. After he was sprung that afternoon, Hopper came back to Desiree. Like a mother, Desiree cooked him eggs. She cleaned his wounds. The cops had been really bad to him, beat the shit out of him, and hadn't even cleaned his eyes. She nursed him back to health.

/ / /

Driving his bullet-riddled pickup to the Taos airport, Hopper stood at the end of the runway with a rifle to greet Philippe Mora, the director of *Mad Dog Morgan*. Hopper left no doubt in Mora's mind as to his ability to incarnate the legendary Aussie bushranger who defied a corrupt system that shackled, branded, and buggered him. Though the system might hunt him down, shoot him down

like a mad dog, cut off his head, and fashion his scrotum into a tobacco pouch, never would they break his spirit.

Dropping the director outside the La Fonda hotel, the scene of the crime, Hopper instructed, "Give the guy behind the desk ten dollars and tell him Dennis said to show you the 'French pictures.'" Being a painter, Mora appreciated the dirty D.H.s.

Hopper was soon off to Australia to shoot *Mad Dog Morgan*. To upright Aussies, it seemed like every drug dealer in the southern hemisphere was parachuting in to score big on the actor's legendary coke habit. To throw them off track, the director told some gung-ho grips on his crew to turn around every road sign within a two-mile radius of their shooting location, topsy-turvy.

In swashbuckling Mad Dog style, Hopper drank staggering quantities of rum. However out of it he appeared, as soon as he heard action:

BAM

A finely trained actor, he rode through the bush, performing horse tricks learned long ago on the Warner Bros. backlot.

Still, Hopper might drop dead from all the excess—enough for an Australian judge to declare that Hopper should clinically be dead. And if he did kick the bucket, what would happen to the film?

Preparing for the worst, Mora had a silicone mask made of Hopper's face. If the worst happened, they could put it on a stuntman and at least shoot all the long shots. The Hopper mask would be like those James Dean heads they used to sell for five dollars, coated in MiracleFlesh faux flesh, kissable for the lonely night. Makeup artists started putting on the first layer of latex.

"What's this fuckin' plastic thing on my face?"

"I just got this idea, Dennis. You're riding along on your horse, you see your own face in the sky, and it *blows up*."

"Far-out. Fantastic. Far-out, man."

One day, Mad Dog Hopper's sidekick, played by the ubiquitous Aboriginal actor David Gulpilil, disappeared into the bush saying he'd be back in ten minutes. But in dreamtime, the Aborigines' fluid sense of time and space, ten minutes might mean an endless shoot, so Mora recruited two native trackers with lean brown bodies and long white beards to bring back Gulpilil. They returned with him days later. It turned out Gulpilil had gone on walkabout to ask the kookaburras in the gum trees about Hopper's soul.

"Well? What did they say to you?" asked the director.

"The kookaburras in the trees, they all say Dennis is crazy."

By the end of the film, everyone was exhausted, but Hopper was ready for more.

"What about that scene where I'm riding along on my horse and my face blows up? You haven't *shot* that."

After all of the mysteries he'd experienced on the shoot, one left Mora completely perplexed. It was about three o'clock in the bush—it was just Mora and Hopper and the kookaburras' maniacal cackling.

By now Mora had come to realize that his star wasn't the tough guy biker rebel of *Easy Rider*. Dennis was an incredibly sensitive being. He started crying as he started to tell Mora about James Dean. Hopper broke down, trembling like Dean. His face got younger, as if it were turning back the years, and then, as if by movie magic, his face *turned into* Dean's. Mora had never seen anything like it.

NAM

At the bar of the Pagsanjan Falls Resort in the Philippines, cast members threw knives in the air, swung from chandeliers, all going nutty after another day of endlessly filming *Apocalypse Now* in the jungle. Stuck in the shit was Frederic Forrest, a young actor from Waxahachie, Texas, who had been drafted to play the sweet-natured New Orleans saucier, Chef. On the night Hopper arrived, Forrest cornered him.

"What was it like with Jimmy? I wanna know everything."

Back home in Waxahachie, all the older kids used to talk about James Dean. The newspapers wrote how he was just a copycat Brando, and Forrest and his friends didn't like that at all—"They're full of shit. Jimmy's not acting. He's just like us!" Forrest hadn't even seen Jimmy in anything since movies didn't come to Waxahachie until they'd been out for a while. When the *Dallas Morning News* reported ACTOR KILLED IN PORSCHE, Forrest didn't even know what a Porsche *was*. When he finally saw *East of Eden*, Forrest knew Dean was as brilliant and powerful as Marlon, *lighter* than Brando.

Over a bottle of tequila, Hopper and Forrest talked all night long about Jimmy, who *worshipped* Brando.

Hopper told Forrest how Dean fused two worlds together—by

carrying Monty Clift in his lowered left hand pleading, "Please forgive me," and Brando in his raised right fist, telling his audience, "Go *fuck* yourself."

As Forrest asked Hopper everything he could think of about Jimmy, this crazy guy walked up, pulled out a machete, and slung it down in the table between them.

Thwack!

"I've had a contract out on you for three years," said the man, glowering at Hopper.

Forrest was terrified. He thought the dude looked like Charlie Manson. Hopper barely glanced up or stopped talking to give the guy the time of day, like the guy didn't exist. Hopper just kept rappin' on about Jimmy. Finally the guy slunk away.

Hungover the next day in the middle of the Pagsanjan Falls jungle, Forrest was feeling woozy and dropped like a fly, passed out cold.

"What the fuck?" asked Hopper. "Who do we have here? Humphrey Bogart?"

/ / /

Hopper was ready to roll, Jack. Director Francis Ford Coppola had originally cast him to play the part of Colby, a rogue soldier with ten lines who serves under Colonel Kurtz, played by Marlon Brando. The brilliant Kurtz had gone native, lording godlike over the ferocious Montagnard tribe of headhunters at the end of the Nung River. After observing Hopper's erratic behavior, Coppola decided to switch Dennis's role to play the incessantly snapping photojournalist, wearing cameras like shrunken heads around his neck. (Hopper claimed the switch was Brando's suggestion.)

To get into his character, Hopper made a connection with the

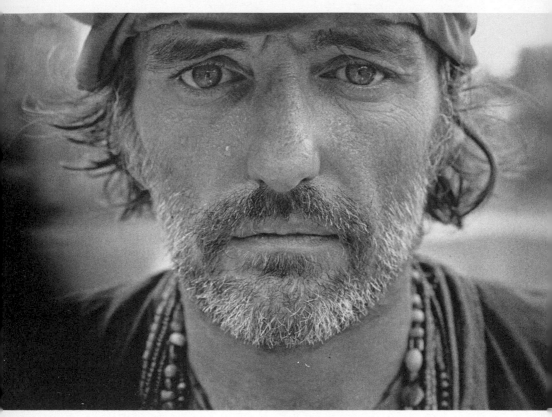

Apocalypse Now, *Pagsanjan, Philippines, 1976*

Fool from the tarot deck. He knew about the card from filming *Night Tide* years before, in which he played a scene as a sailor visiting a bejeweled fortune-teller. The Fool knows the secret wonders of the world, he was told—only he can't remember where he's stashed them away.

"I'm an American! American civilian! Hi, Yanks!"

Hopper thrust out a hand to greet the Yankees coming in up the murky Nung, including Forrest, who was wearing a giant banana leaf on his head to keep cool. Forrest was ready to get the hell out of the jungle. He had tickets to go on leave to Hong Kong for the weekend. He wanted to finish this scene and make his flight. But Hopper refused to do the part the way Coppola wanted.

"Cut! What the fuck is this goin' on?"

Coppola tried to give Hopper direction. Each time, it seemed like a breakthrough.

"Oh yeah," said Hopper. "Right, right, okay, I got it."

Then Hopper did it the exact same way again, well on his way to another climactic showdown with his director.

"Gimme just one, Dennis. I've given you forty-four takes. Just gimme one."

"Yes! I got you. Okay! Let's do it again!"

Forrest was getting really squirrely: "Shit, Dennis, can't you just do *one* for him? I gotta get to Hong Kong! Can't you just fuckin' do one? Hell, you've alienated yourself from everybody here already."

"That never bothered me before," Hopper told him. Suddenly it hit Forrest under that banana leaf: he was being selfish while Hopper was being strong.

"When they make me hurry," Hopper told him, "that's when I go *slower*."

Fuckin' *A*. Hopper was strong. He even smelled strong. Everyone on the production could smell him comin' like an animal. He didn't bathe. Not once did he wash his costume.

One day at the mess hall where the cast and crew took their meals, Dennis was jabbering away, trying to talk to Brando, who didn't give Hopper the time of day. Bloated from the years, Marlon slowly unfolded a napkin and draped it over his sweaty bald head, shaven like a monk's to keep off the flies, and kept eating. Brando *knew* that would really hurt Hopper. He knew how much Hopper adored him.

Being swatted off tortured Hopper, who wore his pain plainly on his face.

Brando always hated the ceremony of people around him. It drove him to distraction: "You're the best. You're the greatest. You're a god."

Hopper buzzing and mewling about his table was too much. Hopper made his stomach churn. Brando classified him as a kiss-ass, just like Dean before him. Jimmy had been pathologically obsessed with Brando.

Brando had even pulled Dean aside once and, trying to help the kid, told him that he was sick. Dean agreed.

/ / /

"Don't hang out with that person," Brando warned about Hopper. "He's too violent."

Traveling along with Brando into the heart of darkness was his personal photographer, attractive nineteen-year-old Stefani Kong. She was adventuresome enough to say to herself, "Well, we'll see how violent of a person he is."

One night, when it seemed most of the cast and crew had lost their minds and left, Stefani and Hopper decided to go over to the art department compound, and stay out past curfew. At the time, there was martial law in the Philippines. The curfew was midnight in the city, and in the provinces and the jungle where they were, it was ten.

On this night, it was about three in the morning when Stef and Dennis came into this village clearing, with a cluster of people sitting on the dirt road, the full moon shining down on them. Hopper really reeked that night. Stefani could smell him.

Suddenly, a pack of wild dogs appeared. The road was suddenly empty. Stef freaked out.

They'd all been given health information by the production on arrival, like: Do not share your utensils with the headhunters; they have leprosy. Southeast Asian venereal disease—incurable. If you get bitten by a mad dog—just lie down because you're gonna die a slow, painful rabies death. No such thing as a rabies shot here.

"Don't worry, Stefani," said Hopper. "I'm gonna take care of this."

"Oh my God, I mean there's like a lotta dogs. There's only *one* of you."

Hopper went out in the middle of the dirt road. He started chanting a song and doing this wild Indian dance. The bewildered dogs just looked at him and finally, not knowing what to make of his performance, slunk off. Hopper removed his worn-in cowboy hat, stuck with an eagle feather, and took a bow for his audience—"Thank you very much."

/ / /

Hopper moved out of the resort, where the rest of the production was only too happy to stay and escape the tropical heat and helicopter-size mosquitoes. Getting deeper into his character, he moved into the Angkor Wat–style Kurtz temple set, located on an uncharted pocket of tangled jungle. The set was populated with the Ifugao tribe that Coppola had imported from the mountains to the north. They were portraying the Vietnamese Montagnard, warrior tribesmen famed for their ferocity. As part of their scene, they sang the Doors in unison, "Kum on bay-bee lite my fi-uh." Soon the tribesmen started imitating Hopper, laughing, "Hey, man."

The cameras turned off for the night, but Hopper remained among the Ifugao. The Kurtz/Brando compound was littered with the heads of rebels, stuck on sticks like death lollipops.

As the sun set over the temple, Hopper considered one of his gods. Everything Brando touched he made scorchingly real. After all these years, Hopper still found himself flailing around. Brando didn't even want to be in the same *room* as him. In the event it happened, Brando would lay down his pink veiny head

and go to sleep on cue. He hated stinking Hopper, the pathetic little mutt who wanted to lick his boots.

Reveling in his self-loathing, Hopper returned for the final round in his very own Thrilla in Manila.

Throughout the shoot, Marlon had refused to film a scene in the same room as Hopper, but Brando *finally* agreed to work with Hopper on one condition—he could throw things at him.

"Yeah, go ahead," said Hopper.

Working with this great man was worth having things thrown at him like a dog. Shutterbug Stefani captured Hopper between takes. He wasn't miserable at all but laughing like this was the best thing that ever happened to him. Brando's throwing shit at me, I'm in pig heaven!

> WE ARE THE HOLLOW MEN
> WE ARE THE STUFFED MEN
> LEANING TOGETHER
> HEADPIECE FILLED WITH STRAW. ALAS!

As Kurtz, Brando laboriously recited T. S. Eliot for his scene with Hopper.

Oh, ho! Was somebody trying to best Hopper in dramatic declamation? Taking over "The Hollow Men" poem, Hopper spun it around with no fractions, no maybes, no supposes! It was all dialectics! He either *loved* or he *hated*.

> THIS IS THE WAY THE WORLD ENDS
> THIS IS THE WAY THE WORLD ENDS
> THIS IS THE WAY THE WORLD ENDS
> NOT WITH A BANG BUT A WHIMPER.

Brando threw bananas at him, and with a whimper, Hopper was splitting, Jack! Mixing in a dash of "I should have been a pair of ragged claws" from Eliot's "Prufrock" along with Kipling's "If"—with "if" being the middle word in life—Hopper juggled everything like a Shakespearean fool, rhyming and preening like a crazed Mardi Gras Indian and dropping in all the elements to make his performance pure, genuine:

HOPPER!

"We have done this scene three hundred fucking times," called out an exasperated Coppola. "Would you just do it once my way?"

"Your fuckin' way? I could've made *Easy Rider* five times with all the fucking film you've lost here! What is your fuckin' way?"

Frederic Forrest couldn't believe it. Hopper didn't need some director yakkin' to him. He knew how to create an unforgettable character within himself. He was a rebel, always. Hopper was their whole generation, like a comet shooting across the sky. He was an extension of Jimmy, but all his own. So what if Jimmy was a fake Brando—the Warhol soup can to the real soup can? If Hopper was a fake Jimmy, then he was really a genius too! Forrest admired Hopper more than any other actor because he wouldn't let the system put him down. Like a star in the firmament with Jimmy, Hopper had his *own* light.

Hopper stayed at the Kurtz temple, remaining there in character for the rest of his shoot. The day he left for Germany for his next role—to star as the psychopathic Tom Ripley in Wim Wenders's *The American Friend*—Hopper was all of a sudden shaven, cleaned up. You wouldn't know it was the same human being! He'd totally changed.

So was he insane or was it just for the shoot? The cast and crew placed bets among themselves.

Hopper left them all and boarded the plane, departing

victorious. Going head-to-head with Brando and, dare one say, coming out on top, had freed him in a way. He'd killed the Buddha, as Eastern-tinged Brando might have put it, or as Jim Morrison wailed at the end of *Apocalypse Now*, playing over the ritual butchering of Colonel Kurtz:

Father?
Yes, son?
I want to kill you?
Mother? I want to . . . fuuccc—

Now that he'd taken on the father, all that was left was his mother.

MEXICO

Dennis is wanting me to go to Mexico to meet some friends of his," Andy Warhol wrote in his diary on March 8, 1979. "Dennis and his group always did know all the rich people, but they're so sixties and they're crazy."

Still hopeful that he could find an audience who would appreciate his masterpiece, Hopper was promoting *The Last Movie* in Mexico. Aside from a stint in Paris, he mostly lived in Mexico City in the late seventies, working when asked and doing research for *The Death Ship*, a film he wanted to base on the book by enigmatic author B. Traven. Virtually every detail of Traven's life was up for debate and hotly disputed. Hopper discovered many theories about this chimera's true identity, some wildly fantastic.

SHADOWY FIGURE OF B. TRAVEN
EMERGES IN RECENT STUDIES
Variety
May 2, 1979
His name is B. Traven, the author of *The Treasure of the Sierra Madre* and *The Death Ship*. But his film name was "Hal

Croves," under which he worked with John Huston on *The Treasure of the Sierra Madre* and signed the register of Berlin's Kempinksi Hotel while attending the premiere (or a subsequent showing) of the German production of *The Death Ship*. Since his death a decade ago, on March 26, 1969, in Mexico City, a filmmaker (Dennis Hopper) and a doctoral candidate in contemporary literature have tackled the mystery.

Dennis was on location scouting around Cuernavaca, reportedly with Jack Nicholson, who was slated to star in the movie. Only it never materialized. Jack rocketed farther into the stratosphere with his role as Jack the writer who goes off the deep end in *The Shining*.

Hopper submerged himself deeper in B. Traven, an obsession shared with Dean Stockwell.

"I honest to God can't remember why in the hell the both of us were there," recalled Stockwell of the time they found themselves in a Mexico City hotel.

Dean heard this commotion goin' on upstairs in Dennis's room. It turned out that Dennis had locked and bolted himself in their room and was making a big scene, having practically kidnapped a woman in there, scaring her to death. He was throwing knives. Dean saw them stickin' through the door. Hopper would pull 'em out and go back to the end of the room and start throwin' 'em again.

Finally the police broke down the door and they subdued Hopper, brought him downstairs to the lobby. They were going to arrest Dean too.

By pure happenstance, this Mexican aristocrat with a pompadour was walking in. This high-level guy had met Dennis a couple days before. He interceded and got them out of there.

"We flew out the next day," said Dean, "or else we both would've been in a fuckin' Mexican jail."

BLUE MOVIE

You buy a bag of popcorn and go to the movie house and sit there and say, 'Oh boy! I'm going to see a movie.' Well, it's not going to be Cary Grant anymore, but I'll take a Dennis Hopper movie over most any day," said Don Gordon, the actor who starred in *Bullitt* with Steve McQueen. "Hey, the guy was an artist. His art was about collecting paintings, making movies, taking pictures and making pictures. It was about having women and living life to the fullest. You have to understand when you are talking about Dennis, all of it is really all bundled up into one. It's like the Medusa, man. His movies are like the Medusa head. It's all snakes and things, but if you look at it very carefully, and it doesn't turn you to stone? It's coooool."

/ / /

"Don, it's Dennis. You gotta come right away. You gotta save my film. You gotta come up here to Canada and save my film. I'm in trouble!"

Don Gordon hung up the phone and called bullshit on that one. Don knew he wasn't gonna save his movie, but Hopper needed a

good actor for his comeback movie he'd inherited, *Out of the Blue*. Hopper always surprised Don. They'd be filming one scene and then all of a sudden, hop to another—

"What the f—?"

"No, no," Don told himself. "Don't *go* there, don't even *think* about whether it makes sense, or it doesn't make sense. It makes sense to *Dennis*. So he's gonna put it all together. Someday."

/ / /

"What are we gonna do today?"

This had happened early one morning during Don's stint acting in *Peru*, for chrissakes, on *The Last Movie*, way back when, up in the Andes.

"Well, we're gonna shoot the scene with the two girls and you getting drunk on Pisco Sours."

"Dennis, I don't drink anymore."

"Aw, come on, have one Pisco Sour."

"Aw, fuck it, whatever happens happens."

/ / /

Cut to 1979. Stepping in at the last minute to replace the original director, Hopper was directing his first film since *The Last Movie*. He had named it *Out of the Blue* after his friend Neil Young's song about a forgotten burnout, which Dennis happened to hear on the car radio on his way to the first day of shooting. His film starred teenage Linda Manz as a young girl so into punk music that the only adult she admires is Johnny Rotten of the Sex Pistols. Her ex-con, truck-driver dad, played by Hopper, loves her so much that he tries to get into her cotton panties.

Don could tell that Dennis was still a little fucked up, but just

like everyone gets once in a while, right? Knowing Dennis, Don felt he knew approximately where his head was, so he just went with the flow. Often, the cast sat around waiting and wondering.

It wasn't up to Don to know, he'd tell them. This was Hopper's movie. Don came from the old school. The director's the boss. You do what you're told. You wait until somebody comes along and says, "Go home," or "We'll start shooting in ten minutes." So Don waited—nine hours.

"Well, fuck that. I'm not gonna sit around for *nine hours*!" Don banged on the door. "I'm goin' home. That's it. Fuck it. I'm outta here. I'm packin' my bags!"

Dennis opened the door and they did a little bit of shooting and the next day everything was okay.

/ / /

"Whatever happened to Linda Manz?" asked Don. "I liked the kid. I liked her a lot. To me she was a special kind of actor. *Out of the Blue* is a kind of dream movie for me. It's its own movie. It's its own story."

/ / /

"Here's Don Gordon; he was his buddy," said Linda Manz, paging through her sticker-strewn scrapbook. The enigmatic cult actress had mysteriously disappeared from Hollywood years ago to live hidden away somewhere in the deserts of Southern California.

"That's *Out of the Blue*. That's Dennis. When he first met me, or I met him, he grabbed me by the clothes and put me up against the elevator to say hello. I thought that was wild. Good times. Happy times. Got to work with all these great actors, directors, sometimes I think, 'Do they ever think about me?' I dunno."

Turning a page, she brightened. "That's me. Who's on my

T-shirt? Probably Fonzie. I always thought I was the reincarnation of James Dean 'cause everybody said I looked like James Dean. I even got his widow's peak. I think Dennis Hopper's awesome. I always did. I had a lot of fun with Dennis. Both of us, we kept it real."

THE GAS

Dennis had been traveling on the tracks, back and forth, only to skip off to Australia, then the Philippines, Germany, Paris, Mexico City, and Canada. In '79, he tucked himself away in the Sunset Marquis, the real-life Hotel California, secluded off of Sunset Strip. If those walls could talk.

Nearly all grown up, Desiree was with him and had never seen Hopper so fucked up. Something had happened to his brain. It seemed to be melting. He was all crumpled, really dirty. She put him in the bathtub and scrubbed him. That night they went out to dinner at the Imperial Gardens Japanese restaurant on the Strip. Dennis introduced her to Ringo Starr. The next morning there was a knock on the door. Hopper hadn't told Desiree he was doing voiceovers for a movie. The production had come to pick him up, and he was *really* out of it. Desiree had to shape him up.

Before he left, Hopper asked her to get him some amyl nitrate.

"What is it?"

"It's the gas you inhale. You know, it gives you a buzz. All the gay guys are doing it at the clubs. When I come back today, just have some."

"Where do I *get* it?"

"A head shop."

"Can I get it? I'm eighteen."

"Yeah, you can get it."

sniffffffffffFFFFFFFFFFFFFFFF

The gas induced an intense short-lived euphoria, a bit like a head rush or standing up too fast. His head felt like it was going to explode and he heard his heart thumping in his ears, coming like a train piercing the darkness, flushing his maniacal face. This was a sick little game they were playing.

"Mommy, MOMMMMEEEEEEE!!!"

"Okay," said Desiree, "I'm not taking this."

Desiree didn't need this shit. When he got crazy, she'd always say, "You're getting crazy now. Stop it!"

The other girls who saw Hopper would just go, "Oh, that's Dennis. Do whatever you want to me. Beat me."

Acting like a good mommy, Desiree took his amyl away.

"No, you're not having this. You can't handle this and you're fucked up and we gotta get you sober, and you're working."

So she cleaned him up, again, sent his clothes out to the laundry, did all that stuff. She started feeling positive about Hopper. They'd decided when she was old enough, say twenty-five, they'd have a kid and name him Henry. Like Hathaway.

Desiree left after Dean Stockwell came over, ready to party. She couldn't control Hopper when Dean was around.

/ / /

Watching golf out of the corner of his eye, Dean recalled those years.

"I just temporarily left this reality and got involved in another reality that was very primal and had a lot to do with good and evil,"

he said. "I'd been doing a lot of amphetamines, so I'm sure that was a contributing factor. It's impossible to explain. You just leave one reality, and go into another reality, and are fully in this new reality that is incompatible with regular reality."

Dean found himself in Cedars-Sinai hospital in LA on the third-floor. The psycho ward.

"I was in there for a few months gettin' pumped full of Thorazine. A couple years later, Dennis had his episode. He went off the edge. You're aware of that, right?"

DYNAMITE DEATH CHAIR

Stick around after the race, folks! Watch a famous Hollywood film personality perform the Russian Dynamite Death Chair Act. That's right, folks, he'll sit in a chair with six sticks of dynamite and light the fuse!"

The carnival barker roared over the loudspeakers at the Big H Motors Speedway outside of Houston. Earlier that evening, Hopper had screened *Out of the Blue* for a group of Rice University students. Kind of arty, but here at the Big H, the human stick of dynamite was sure to please everyone. Hopper had first seen the stunt performed at a rodeo back when he was a farm-raised runt.

In a disheveled suit and earplugs, his face ashen and going gray at the temples, Hopper sat in the middle of the huge speedway, crouched in a chair laced with dozens of bundled sticks of dynamite surrounding him. He was having trouble with the lighter to spark the fuse under him. Jesus.

KA-BOOM!

"Whoa! I want to tell you one thing," said Hopper emerging stumbling and wide-eyed from a huge blast of smoke. "That ain't no joke, boys! Whoa! It's like being hit by Muhammad Ali, man! Beers? It's a theory I had about how solar systems are made. You see, dynamite doesn't blow in on itself."

THE JUNGLE

Playing the head of the Drug Enforcement Administration in *Euer Weg Führt durch die Hölle*, or *Jungle Fever*, a German production's white-hot tale about caged women, Hopper found himself, just before shooting began, wandering in his pajamas in the Mexican jungle after becoming fascinated with some outer-space holograms he saw flashing and dancing in his periphery. He had to follow those lights. He had a cinematic narrative playing in his head that put him in the middle of a war . . .

A few hours later, the sun came up on naked Hopper walking down a road into the Mexican city of Cuernavaca. He began to masturbate on a tree. The police came to arrest him and tried dressing him.

"No," said Hopper. "Kill me like this."

Inside a Mexican jail, Hopper thought he heard the cries of his friends getting lined up and machine-gunned down outside. The authorities brought him to a hospital, where his lungs didn't feel like lungs anymore. Sitting on the airplane, fired from the movie and being sent out of the country, Hopper thought he saw cameras everywhere—floating in the sky, hovering over the silver wings.

Once again, he was starring in his own movie (within the movie). He even thought he was flanked by a couple of stuntmen. No one else was aware of this, of course, as the plane sat unmoving on the runway. By now Hopper thought the plane was on fire. He busted through an escape hatch and walked out onto the wing.

THE GAME

Emerging late one night in the early eighties from partying with the cast of *Saturday Night Live*, Hopper wandered in disarray down Madison Avenue. As cabs sped by him heading uptown, he ran into his friend and executive producer from *The Last Movie*, Michael Gruskoff, now dealing in much more successful films like *Young Frankenstein*.

"You're in the game, you *play* the game," Gruskoff liked to say. "And this is all a big fuckin' game."

The thing was? Hopper *knew* the game. He had a lot of calling cards. He directed and starred in a great film, *Easy Rider*. Gruskoff hadn't seen many who could play the Hollywood game like Dennis. Only Dennis wanted to play his own game.

"God, I fell asleep on a couch and I just got up," Hopper told him of his night with the SNL gang. "I was with these fuckin' kids; all of them were standing on me when I closed my eyes."

Gruskoff took him out for a cup of coffee and gave it to him straight.

"*You* are Wild Bill Hickok. *You* are the fastest gun in the West. *You* have your rep as being— Nobody can do as much drugs as you. So when these kids see you, who idolize you? They raise you one all the time. There's a new gun in town. New *guns*."

"Yeah, that's it," said Hopper. "They put me *away*. These fuckin' kids, they put me away. They put me *away*. I can't do it like they do."

Not long after, Gruskoff saw Hopper at a Hollywood party at Carrie Fisher's. Hopper was in even worse shape this time. He had to be taken away from Carrie's party to the emergency room.

"I just know that this time it's gonna work," said Dennis's mother, Marjorie, calling up her cousin Ruth from her home in Lemon Grove.

Dennis went to drug rehab in Century City to kick his coke habit. This was rehab when it was really fucking rehab.

Hopper's whole world was nearly destroyed at this point. This time it was his own decision to make a major overhaul, and there to help was his child bride/surrogate mother figure, Desiree, who thought it was going to be great to see Dennis sober. They were going to have fun again! Every day she went to the hospital and asked him how he was doing.

"Again, I was hearing voices," he recalled. "People came to see me. After they left I'd hear them being tortured and murdered."

On his first day out in the real world, Desiree took a zonked but sober Hopper to play volleyball at Roxbury Park in Beverly Hills. He was on suicide watch and therefore wasn't allowed to wear a belt, so his pants kept falling off. He hitched up his pants and tried again.

"Stay here, please. Stay with me. I want you to stay with me," Dennis pleaded with her.

"I can't stay with you. One, you're in the hospital and you don't always understand you're in the hospital 'cause you're on medication. Two, I'm married."

The day he finally got out of rehab, he swore to *Tracks* director Henry Jaglom he'd never touch anything again.

"Sure, Dennis," thought Henry. "You're gonna be dead in a year or two."

FRANK BOOTH

Frank Booth wriggled out from the darkest recesses of the mind, the embodiment of the ugly evil reality lurking under the gingham-print of small-town America. Envisioning his villain, director David Lynch realized Hopper might just be the perfect one to play Frank Booth. Besides *Apocalypse Now*, Hopper hadn't really played a defining role in his career yet, and none of his previous bad guy roles stood out in Lynch's mind. But he just had a feeling about Hopper as Frank.

Lynch felt it was very important that Hopper came from Kansas. The place had a completely different feel from the rest of the country, in a way Hollywood's flip side as Dorothy's home in *The Wizard of Oz*, with undercurrents that were perhaps felt but unseen. For Lynch, Hopper seemed to say something about the art life in a country way—in a very cool, quintessentially American way, as a rebel who was fighting against the bullshit.

"No way, you can't work with him," the casting people told Lynch.

So the script for *Blue Velvet* was sent to another road-weary Hollywood outlaw, Harry Dean Stanton. Only Harry Dean didn't want to do Frank Booth at the time because, even as a character,

he didn't want to kill people. It was just the particular pacifist state he was in. Harry Dean had played a lot of bad guys in his day, back when he was pissed off, at least as many as Hopper. Harry'd go into auditions with his surly attitude and the casting directors knew they had the right bad guy.

Then one time Jack Nicholson, back in the Corman hell days, wrote the part for Harry Dean of one-eyed Blind Dick Reilly in a low-budget Western.

"Harry, I got this part for you, but I don't want you to do *anything*. Let the wardrobe do the character."

That's when Harry Dean realized that all he had to do was be Harry Dean, plus an eye patch. From then on he played himself, with each new role becoming more personal and linked to his own experience, his childhood, his parents, even his grandparents and the rugged settlers before them. But he didn't right now feel like digging into the violent side of himself. He just wasn't Frank Booth.

The phone rang. David Lynch picked up and pressed the receiver to his ear.

"I have to play Frank Booth," said Hopper, "because I *am* Frank Booth."

It was a terrifying confession. Frank Booth was a masochistic killer who shows up in the movie to beat the object of his warped desire, the sultry lounge singer Dorothy Vallens cloaked in blue velvet, heating up the little white-picket-fenced town of Lumberton to a boiling point. Hopper was only two months out of rehab, and Lynch first wanted it confirmed from Hopper's manager that Dennis was now clean and sober. Just in case, he called Dean Stockwell, whom he'd cast for the part of Ben, Frank Booth's creepy pimp drug-dealer friend. Lynch wanted to make sure playing Frank wouldn't send Hopper back to the bottle or the booby hatch.

"Can Hopper do this?"

"Are you kidding? Of course he can do it! He's a professional.

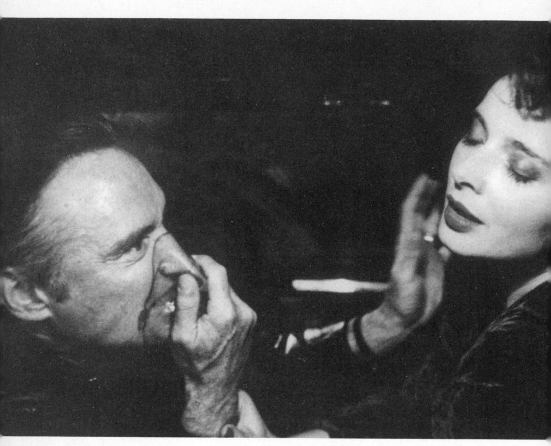

As Frank Booth, 1986

Get him. Fast as you can," said Dean, who knew how far Dennis would take this role.

So Frank Booth prepared for his entrance. Before smacking Dorothy around, Frank Booth was to pull a vinyl mask out of his pocket and inhale, sucking in the gas, all part of a well-choreographed, twisted sex ritual. While writing the screenplay, Lynch had imagined the gas would be helium and give Frank Booth a high-pitched, squeaky voice like an evil carny. But Dennis had a better idea.

"David, you know? I thought of this as nitric oxide or amyl nitrate."

"What's that?"

Here in Dorothy Vallens's cheap boardinghouse room, Hopper stormed in wearing a slick, black, ass-kicking leather jacket, a getup Jimmy might've chosen for himself had he lived to see forty-nine, like Hopper.

"Hello, bay-bee," said Dorothy sweetly and a bit vapidly, welcoming him to her maroon cocoon.

"Shut up. It's Daddy, you shithead. Where's my bourbon?"

Taking a mean sip of his highball, Frank Booth sat before Isabella Rossellini, luxuriously matronly in her thick blue velvet robe.

"Spread your legs," said Hopper. "Show it to me."

She spread her legs and exposed herself. ("Whew, that was a shock," said Hopper. "Because she really did and nobody could see it but me.")

Frank pulled a vinyl mask out of his pocket, mashed it against his nose, and took a deep connoisseur's whiff.

snifffff

Her legs spread before him, her robe enveloping him in glinting pool blue, Mommy coaxed her little boy to wriggle back in and take the plunge, face-first. Diving into the blue, Hopper submerged himself into his emotional depths. He threw himself on Isabella Rossellini like a fiend from the fiery depths of hell.

Mommmmmmeeeeeeeeeeee????
Baby
Wantsta
Fucccckkkkk

"When people ask what I was inhaling in the mask," said Hopper, "I say it was Lee Strasberg."

David Lynch watched the character he'd dreamed up become terrifyingly real.

"Cut!"

Hopper didn't scream at him like James Dean, but snap—he reverted back to Hopper.

"The word 'professional'? You could stamp that right on him," said Lynch. "When the camera started rolling, he was Frank Booth—but one hundred percent. It was surprising how Dennis understood every single thing and brought it to life so perfectly. He *is* Frank Booth and the only one who could've played him. That is good news and bad news at the same time. The bad news being that he's Frank Booth."

Frank Booth rolled along to another scene with his suave alter ego, Ben, his face painted in thick whiteface and eyeliner like a freaky mime. Realizing how twisted Frank was and how Frank held Ben in such high esteem, Dean knew Ben had to be farther out than Booth.

Dean and Hopper got together to work on the scene when Frank was supposed to grab an old studio microphone and sing the Roy Orbison song "In Dreams," about the candy-colored clown, but Hopper couldn't remember the lines. When they were rehearsing in front of Lynch, it became apparent that Dean, who knew all the lyrics, was going to sing that one, lip-syncing Roy's trippy tune, flouncing about in his louche lounge-lizard outfit.

"These things happen," said Lynch. "They're meant to be. How you get there sometimes is a strange route. I'd worked before with Dean on *Dune* and there's a film *Sons and Lovers* that I thought Dean Stockwell was incredible in and that's how he got into *Dune*. In a way, it was just one of those things that kind of works out perfect. You just get this feeling of a shared past. It just shows their friendship. They knew a life in Hollywood that I wish they'd write a book about. There's probably ten million stories that would illustrate what was goin' on."

"All right, I'll give you one," said Dean, caving after being prodded for a wild tale from the bad old days. "We were in Cannes for *Tracks* and a friend of Dennis, a long-term fan, had a big château. We stayed there. Wonderful time, you know, couple of women, enjoyed the festival. They had a gambling joint, a casino, so we decided to go hit the casino. Only Dennis couldn't go because he'd gone before and they'd kicked him out and they wouldn't let him back in. So he had the I Ching out and was throwin' up I Ching about everything in the world. When it comes down to going to gamble—he goes to the I Ching for him, myself, for one of the girls. There were five numbers. All right, so I'm entrusted with these numbers. These are all on roulette, at thirty-two to one, okay? I get *four* out of *five* of them. The whole joint went nuts. I had to scurry to get out with all this money—I came to Dennis and I threw it in his lap."

Thinking of another time, Dean's eyes got unusually wide.

"You wanna talk about parallels? We were in the same hospital, on the same floor, and Dennis got the *same* psychiatrist as I did when I went far-out. You wanna find a couple common things between friends? That's gettin' out there. Same psycho ward. What are the odds? I'm sorry. That's *weird*."

PART 5
The American Dream

SHOOTER

Having tapped the twisted roots of his psyche without sniffing any real amyl nitrate or drinking a gallon of Pabst Blue Ribbon to get into character, Hopper soberly expelled the beast. A bona fide actor in mastery of his craft—without having to put a paper bag over his head to smoke dope like he did with Jimmy, or drop acid or snort coke, Dennis Hopper was off to the wholesome heartland, to Indiana. Late for the shoot because his flight had been delayed, Hopper entered a packed gymnasium in Brownsburg. He was playing Shooter, the drunken dad in *Hoosiers*, a basketball movie about Milan High School, the Indiana State champions etched in real Hoosier lore as the little team that could. His first scene was to walk across the waxed court in a hobo's stovepipe hat, which he'd selected himself, stumbling drunk before the crowd.

"Just give me about ten seconds before you're ready to roll."

The first-time director, David Anspaugh, had a hunch about Hopper working out. He'd originally wanted Harry Dean Stanton for the role of Shooter, as did Angelo, his screenwriter frat brother from days at the University of Indiana. Harry Dean couldn't see himself in the role, though, which left the director in

a bind until he caught *King of the Mountain*, playing one night on television as the Movie of the Week. Part of a thrill-seeking gang that races cars up and down Mulholland Drive, Hopper burned up his tires in a blasted-out Stingray, screaming, locked in a death race against a silver Porsche, only to crash in flaming glory. Basically a recap of Hopper's teenage years.

"Angelo, don't laugh at this idea but I'm watchin' this movie with Dennis Hopper," said Anspaugh, picking up the phone.

"What the hell's he been doing?"

"I dunno. I've always kind of thought he was strange. I don't know if this is a recent MOW, but what happened after *Easy Rider*? Isn't he like *insane*?"

/ / /

"Okay, Dennis, we're ready," said Anspaugh, directing. "You want your ten seconds?"

Spinning around and around like a whirling dervish, Hopper stumbled out on the basketball court trying to catch his balance.

"Where did you learn *that*?" asked the director, amazed at the "drunk" trick.

Next up for Hopper was the big game at Hinkle Fieldhouse, where the Milan High coach gets everyone in a huddle and tells the guys he loves them. Suddenly Shooter bursts through the door with his coat on over his pj's, having busted out of the hospital where he'd been detoxing, because he wants to be there with the guys, for the team.

"This has *really* been bothering me," Hopper told his director. "Really, really been bothering me. I should not be in this scene. It's wrong, it's just wrong."

"It's the complete circle," argued the screenwriter. "The whole family comes together!"

"If I leave the hospital," said Dennis, "it suggests that I didn't have the strength to stay sober. If I don't commit to staying in there, and this is coming from experience, it would be wrong for this character."

"No, you *gotta* do it," insisted the director.

Hopper made an impassioned case: if Shooter leaves the hospital, it suggests he doesn't have the strength to stay sober. Even if his son is playing the state championship, if he's drying out, *that*'s where he has to be. Sure as Jett Rink would never drink from the tables of those rich Texans who used to look down on him, that's how much Dennis knew his character.

"In fact, a lot of people recall that as one of their favorite moments in the movie," recalled Anspaugh, battling a cold over a Coke at O'Brien's, a Santa Monica pub. "Seeing him jump up and down on that hospital bed. Listening to that Philco when they won. Oooooh, I just got little goose bumps."

Every day Hopper was on set, he was always making jokes and keeping things light, coaching the movie along. Everybody loved him, the kids on the team particularly. They were too young to realize who they were dealing with, but he would teach them little acting tricks: how to find the camera lens and what their best angles were, and how to get the most screen time. By the end of the shoot these kids had become savvy, mostly due to Dennis.

"Actually, he created little monsters," said David.

During the filming, Hopper went on a pilgrimage out to Fairmount, Indiana, the hometown of another famous Indiana high school basketball player, the spectacled Jimmy Dean of the Fairmount High Quakers. Hopper had never been to Dean's grave, but had always promised himself he'd go. After Jimmy died, he'd stood one night in Laurel Canyon, looking up at the nighttime sky, and shouted to the heavens, "Jimmy, Jimmy, which star are you?"

The lonely boy stood silently by Jimmy's grave. Some black hole

out there was bound to try to suck the light out of his association with Dean, questioning whether he really knew Dean as well as he said he did.

Did it even matter? Who else learned from or suffered more for Jimmy than Hopper? For over thirty years he had followed Jimmy's star, nearly killing himself in the course of his search again and again and again, only to survive another chapter and live on to boldly perform another of his Dean variations, in all thirty-two Campbell's varieties.

HOPPERS OF YORE

"What *is* the story of Dennis Hopper's life?" asked Charlie Rose.

Well, Charlie, if you really want to know, it began with the tenacious Hopper stock, a line going all the way back some four hundred years ago to the Hoppers of yore, stuck in the bogs of Britannia. This rugged clan dreamed of that American land beyond the imaginary horizon, publicized as a fantastical dreamscape of soaring eagles, fish that looked like Saint George's dragon, lusty soil bearing three sorts of plums, and other such wonders detailed in the day's best-selling true tales of a swashbuckling Captain John Smith, including the cock-and-bull one about him being saved by the luscious thirteen-year-old Indian princess, Pocahontas.

So the restless, nervy Hoppers set sail for the shores of the New World.

As president of the San Diego Genealogical Society, Marjorie Hopper traced the line back to the head branches of Deep River, where George Washington later owned land and one Blackgrove Hopper abided by the Hopper family crest—A SUBJECT FAITHFUL TO HIS KING IS THE SAFETY OF THE KINGDOM—until, hellfire and brimstone, he could take it no more! Pulling himself out of the

mire of civilization, Blackgrove headed for the hills of East Tennessee. Drinking deep the untainted waters of Lick Creek Baptist Church, he had a vision of a string of frontier churches glowing through the darkness. Theaters of the soul!

Pushing deeper into Appalachia, Blackgrove braved cussed highwaymen and ornery mountain folk in the hollows of the Cumberland Valley to forge his particular American dream with his itinerant preacher son in tow, his God-given talent for performance earning such a reputation that the *Barbourville Mountain Advocate* plainly asked its readers:

Who that ever went to hear him was not fascinated and chained to his seat, however protracted the discourse, until the last word was uttered, not withstanding his uncouth gestures and repulsive drawling intonations?

Then one Thomas Hopper was born in 1825, the year Senator Thomas Hart Benton told colleagues in the staid Senate chamber to rally America toward the uncharted West, evoking an exotic land of ivory, apes, and peacocks.

"There lies the East," Senator Benton cried. "There lies the road to India."

Thomas Hopper didn't make it all the way there, instead settling in Missouri, leaving his great-great-grandson Dennis to blaze trails on the westward path, and reach for himself that fantastical land.

/ / /

Like those Hoppers of old, an imaginary dreamscape filled his head, and one day in Kansas City, Missouri—where his family

moved for a stint before relocating permanently to California—Dennis Hopper tried depicting those fantastic Technicolor mountains of his dreams during children's Saturday painting classes at the Nelson art museum, his replacement for the matinees.

Then one day the renowned Thomas Hart Benton took over the class. It wasn't Senator Benton, who had rallied the nation long ago toward Manifest Destiny, but his great-nephew, the artist who packed up his paintbrushes and hit the road in a rickety Ford to see for himself what was out there. He didn't find India but a fabled land of a quintessentially American art, where the artist had to be a fighter and wrestle his vision down.

"What are you doing?" asked Benton, pomaded hair jet black, looming over this young Hopper.

"I'm painting this rock and river and so on," said twelve-year-old Dennis.

"You're little, so you might be too young to understand what I'm about to say to you. But one day you're going to have to get tight and paint loose."

If the squirt wanted fantastic blue mesas like the ones in Thomas Hart Benton's epic mural of America, he'd need to go over to Kellys Westport Inn, the local watering hole, get himself a stiff highball, and get behind the canvas and plow.

Too bad the boy was doomed to rot in the land of extravagant idiocy. Yet drink he did.

/ / /

"I was doing half an ounce of cocaine every few days," Dennis told Charlie Rose. "I was drinking like a half gallon of rum, then a couple bags of coke to sober up. And that wasn't getting high, that was just to keep going, man." (Or more pharmacologically correct, he was drinking a half gallon of rum, with a fifth of rum on the side, twenty-eight beers, and snorting three grams of cocaine a day.)

Hopper let it all out, in its god-awful, staggering multitude. Now that he was confessing his sins, America was suddenly paying attention after almost twenty years of writing him off. He was invited on the talk shows after the '87 Oscar race for his tour de force as Frank Booth in *Blue Velvet* and his role as Shooter in *Hoosiers*, for which he was nominated for Best Supporting Actor.

"How he got out of this whole fuckin' thing is an amazing thing," marveled his old pal, Michael Gruskoff. "He should've been gone the way he was doing it. Not many people come back like he did. Came back twice. Came back after Hathaway. Came back after *The Last Movie*. He started building up his career. He was making a new reputation because of people who were starting to get into art in Hollywood and wanted his advice. He started to do things that were not adolescent. People appreciated him for the talent he had.

"Haven't seen many people who know the town like he did—who knows how to use the town. He knew how to use those calling cards. He played the game. He played it as good as you can get—and had the rest of his life. You know what I mean?"

Hopper's dramatic Hollywood comeback—one of the most awe-inspiring in industry history—was featured in *Vanity Fair* three years after he returned to Hollywood from New Mexico. On the cover, a sophisticatedly gray Hopper held a cigar and stared down America for the feature—"How the Mad, Bad & Dangerous Movie Star Came Back from the Dead & Took the Town by Storm."

"I mean, what—when you sit here today"—even Charlie Rose stumbled to take in the full breadth of Hopper's winding journey—"it's the best of times for you? *Right?*"

"Yes, it is. But you know, I tell you very honestly, Charlie, I don't feel I have *done* it yet. I mean I look at Anthony Hopkins, and I look at *Remains of the Day*, and I go, 'Where is that part? Where is a movie like this that I could do?' You know, why am I never even *seeing* these kinds of scripts? Why do they never even come close to me?"

CULL-UHS

In a tweed suit, Hopper moseyed through the land of the unwanted. Abandoned autos. Burned-down homes. Trash-littered sidewalks. He was accompanied by his female bodybuilder friend from Beverly Hills who'd recently appeared in *Playboy* and was a muse for fine art photographer Robert Mapplethorpe. He climbed over a graffiti-littered wall at the end of a dead-end alley. Three silver futuristic bunkers loomed in the wasteland of Venice Beach, California.

"I *looooooove* 'em," said Hopper. "I just love 'em. Those are so amazing and *genius*."

The trio of shacks seemed to have been built for Hopper. He felt as if he'd commissioned them, much to the delight of Venice artists Laddie John Dill and Chuck Arnoldi, up a creek financially on their artist colony sinkhole, in the ghetto, that they'd gotten budding architect Frank Gehry to design. Only the buildings were built *backward* because the blueprints were read that way.

One would-be tenant, a UCLA student, squinted at the graffiti and deciphered a death threat and split. The only takers so far were the cops, who'd been using the bunkers for surveillance to bust a crack house across the street. Hopper snapped one up in 1987, with

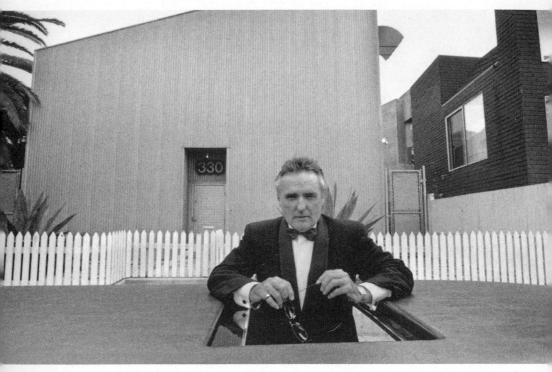

The Gehry fortress, Venice Beach, 1993

plans to get the others when he could. In gangsta style, he rolled around his hood in a two-tone brown Cadillac Seville with gold-wire rims, surveying the turf for his new movie, *Colors*, starring bad boy actor Sean Penn.

"We're here to learn about gangs," announced Sean at a meeting of CRASH, Community Resources Against Street Hoodlums, the LAPD gang unit.

"Good fuckin' luck, pal," said Detective Dennis Fanning.

/ / /

Detective Fanning was recruited as the technical adviser on *Colors*, and for three months, the LAPD stuck Sean Penn in the backseat of his squad car. "Sometimes when you're with someone, a partner,

they could be the greatest cop in the world, and you could be the greatest cop in the world, but you don't have karma when you're in a car together," explained Fanning at an Orange County Starbucks: "It's just you're always ten seconds late. The bad guy just left. The shooting just went down.

"Other times, you get in the car with somebody, and boom, it's right there. The karma's there. You turn the corner; there's the guy with the gun. You walk in the store; it's gettin' robbed. You pull up to the light; there's the stolen car. That's pretty much how it was with Seany. He got into the car and it turned into a shit magnet, which is nice because guys who consider themselves good street cops like to be considered shit magnets."

Shit-magnet Seany wanted nobody else to direct *Colors* but Dennis Hopper, seeing as he and his wife, Madonna ("Mo" in cop talk), were big fans of *Out of the Blue*.

Colors was originally scripted to be about cough syrup abuse, but Hopper drastically recast it to explore the volatile LA gang scene, with Crips and Bloods killing each other off on the streets of South Central like cowboys and Indians. His subject was considered so outlandish at the time that some critics actually thought he'd made it up. Living in Venice Beach, homeboy Dennis got to know the local gang kids on a personal level. He thought it was such a waste of meaningful talent, thoughtfulness, and energy.

/ / /

"Dennis told me his crazy stories when he left the hospital and of walkin' down the road in his fuckin' pj's," recounted Fanning of war stories Hopper told him about rehab and out-of-his-tree wanderings in the Mexican jungle. "Me and him had the same stories, just different sides of the fence. We got along famously. I got like ten or fifteen real cops into the movie. They wanted the realism. They used real gangsters, so that made for real fun breakin' for

lunchtime on the set. Real cops on one side. Real gangsters on the other."

"It's heavy, man," said rapper Ice T. "You gotta think, okay he's in *Easy Rider*—rocked-out white guy gettin' high, riding motorcycles. You say, 'Okay, he's on some rebel white shit.' Then to do a movie only about blacks and Mexicans?"

Hopper wanted Ice T's "Yo Homeboy, Squeeze the Trigger" on the soundtrack, so T went to a screening: "Okay, the movie's good. It had kind of a fictional line because the Mexicans and the blacks didn't fight at that time, but overall, I was kinda like, pro it. Rick James had the title song, 'Look at all these Cull-uhs,' or some shit"—T doing his funkiest Rick James impression. "So without asking, I left the studio and we laid the song 'Colors.' Just submitted it. Cold."

All of a sudden, this ripple effect happened and everybody was like, "Yo. Dennis Hopper wants to meet you."

"Yo bro-tha, this song is the shit, it's what the movie is, and it's all that. Yo! This is the essence; this is what it is; this is like beyond what I meant."

That was homeboy Dennis talking. Ice T suddenly thought he was in *Apocalypse Now*. He'd always been a fan of Hopper's rap in the movie. "It's like he's talkin' about Kurtz, you know, the way he just takes the words and jumbles 'em and spins 'em and drops 'em?" As a fellow artist, Ice T appreciated how Hopper always really felt whatever he was doing.

No stranger to controversy himself, Ice T thought it was unfortunate when the media lashed out at Hopper's finished vision, calling *Colors* a disgrace and accusing him of fabricating a gang situation. Orion Pictures was afraid that if they distributed *Colors* in wide release, blood was going to run in the streets. So the studio offered to pay for security guards in all the release theaters, with protection outside and inside, but still a lot of theaters were too nervous to show the movie. When *Colors* opened in LA in '88, cops

arrested nearly 150 gang members. A gang member was shot to death outside a theater in Stockton.

Colors was hot! Unfortunately for the producers, nobody got killed in the second week, so the controversy died and *Colors* was buried.

If only the suits had put it in wide release more aggressively that first week, they could've made a fortune on Hopper!

In what felt like a flashback to his days under siege in the Mud Palace, Hopper was left to the pack of red-bereted Guardian Angels outside his compound, protesting his depiction of inner-city youth. Clearly he needed to fortify. Buying the Gehry shack on the vacant lot behind him, Hopper proceeded with phase two of his compound. Up went a silver futuristic fortress skin with a wavelike hyperbolic roof and an asymmetrical, windowless industrial corrugated steel facade. Hopper connected his original Gehry shack to the second he'd procured with a series of jarring heavy-duty catwalks. He bought a third a few years later.

Like a paranoid cocaine drug lord's insane bunker, only sober, video monitors played for him an ongoing surveillance loop, which fed his paranoia and served as artful background footage. All the lights in his house flashed at any unauthorized footstep. The compound was buttressed by a handgun stuffed into one of Hopper's socks and a backup shotgun tucked away on the premises.

Completing his American dream house, Hopper put up a white picket fence, like the kind at Auntie Em's in *The Wizard of Oz* or along the streets of *Blue Velvet*'s Lumberton, separating him from Venice's mean streets.

"There's a little door on one side of the fence at the back with razor wire all around it," explained Hopper of one of the compound's secret features. "After I put it up, I went out. I came back and they'd just taken the door off and laid it down. It was still locked, just laid down. I'm living on *their* turf, you know. I mean it's my turf, too. Because this is America."

BIKER HEAVEN

"When I was offered Koopa, I was quite excited. I thought it was a great opportunity to play a giant human lizard."

Trapped in a dystopian nightmare, Hopper made the best of it in *Super Mario Bros.*, the big-screen version of the Nintendo game. With a wicked long tongue that looked like a pointed flank of raw strip steak, he was King Koopa, evil despot of Dinohattan, a bizarro New York City filmed in the early 1990s in a vacant cement plant in the beach town of Wilmington, North Carolina. Searching downtown Wilmington for a studio in which he could paint, Hopper stumbled on an enormous sandstone Masonic temple in total disarray, about to be torn down.

Standing on the roof of his five-story shrine overlooking Cape Fear River, Hopper said, "I agree it's a little weird, but I *like* it here."

A vision of the future in perfect Masonic order unfolded for fifty-five-year-old Hopper. Buying the property for peanuts and putting a million into restoration, he planned to open an acting school, unleashing veritable hordes of Hopper-trained actors into the universe.

"Daddy, I think you're probably a really good actor, but why did

you play King Koopa?" asked his son, young Henry. "He's such a bad guy, why did you want to play him?"

"So you can have shoes."

"I don't need shoes."

Yet Hopper found himself hawking for Nike as Stanley, a deranged referee. In a trench coat, wearing an intense gaze and black backpack, Dennis rode the bus while ranting on about the Dallas Cowboys quarterback. Sneaking into the Buffalo Bills locker room, he sniffed the potent aroma of an enormous shoe belonging to the defensive end. He unwrapped Neon Deion Sanders's shoe before a Christmas tree. "Can you imagine the career Jack Nicholson has had and he has never gone out on television to plug *anything*?" Hopper asked Charlie Rose in their continuing dialogue across several interviews throughout the years. "I'm not saying that I'm doing wonderful work, and I'm not saying—I think *Speed* is terrific, you know. But the great role? I don't feel I've ever really had."

Performing for Charlie in a yellow-and-brown houndstooth sport coat and green paisley tie, Hopper offered more about his addictions, and regret, anything to prove himself a good clean boy—sober and ready to work again. He wanted Hollywood to see he was the kind of upstanding actor who could be entrusted with the role of a megablockbuster maniac who holds a city bus hostage with a plan so sick, he'd created a bomb that would *blow up* if the bus went under fifty miles an hour!

Concluding his night of talk show magic, Hopper did much better on *Charlie Rose* than he had a few months earlier in 1994 on *The Tonight Show*, when he told Jay Leno an anecdote about how actor Rip Torn, who had once been considered for Jack Nicholson's part of the Southern lawyer in *Easy Rider*, went after *him* with a knife:

"Rip and I had a little, uh, problem—"

"What kind of a problem?"

"Well, at dinner he pulled a knife on me. It was one way for me to say we're not working together."

Actually, as the courts later ruled, it was Hopper who had gone for the steak or butter knife, according to various memories of the fateful night.

/ / /

"Well, that's supremely ironic, isn't it, that he should tell it exactly backwards?" remarked Terry Southern.

Terry had hung around trying to be a friend to Dennis even after he was given the cold shoulder. After *Easy Rider* hit like a winning lottery ticket, Hopper argued that he himself had written the script and denied Fonda and Terry's role in it. This was particularly difficult for Terry, seeing as he was the writer among the brain trust, the only one among them who knew what he was doing when he got behind the typewriter and plowed.

Hopper claimed Terry was just a flashy name to get the production financed as, backed by a high-powered legal team, he tried wrenching from Southern his deserved writing credit on *Easy Rider*.

"Terry never wrote one fucking word, not one line of dialogue," Hopper claimed.

So what about all those heated sessions in the Clark Cortez? And those in Terry's lawyer's office on West 55th Street that the brain trust appropriated as their story conference room, hashing out the tale of Billy and Captain America over cigarettes, joints, and martinis?

Hopper claimed it was all in his head. He embellished, saying that after dinner with Rip Torn, he stayed in New York and locked himself in for two weeks and emerged with a screenplay. This was the Hopper friends described as being unable to sit still for a moment. He couldn't get himself to pick up the pen and write his memoirs, despite the multiple high-figured book deals he collected over twenty-plus years, only to have to give back his advances because he hadn't written a single word. Meanwhile, Terry

had slaved over a letter he hated to write and sent it to Hopper in 1970, hoping the spirit of the sixties was still alive.

Dear Den:

I'm very sorry to bug you, Den, but I'm in a terrible bind— completely strapped, an inch, maybe less, from disasterville . . .

In view of such circumstance, and of our (yours and mine) solid ancient friendship, and of great success of <u>ER</u>, could you please put a single point of action my way?

I'm aware there may be a difference in our notions of who contributed what to the film (memory flash highly selective in these cases), but the other day I was looking through a copy of the original 55th Street script that we did together, and was amazed at the amount and strength of material which went from there intact to the silver-screen.

Please consider it, Den—I'm in very bad trouble. Thanks.

Hopper never responded. Terry stuck around anyway with Hopper, trying to make William Burroughs's beatnik classic *Junkie* into a film. Patti Smith was slated to star alongside Hopper. It was shelved, especially after Hopper dabbled with heroin as part of his research.

The idea for a sequel to *Easy Rider—Easy Ridin' in Biker Heaven—* came right around the time Terry accompanied Hopper to the Big H Motors Speedway, where he offered his friend moral support while he flirted with self-annihilation in the Dynamite Death Chair act. The sequel was also shelved, and Terry had no problem with Dennis trying to inch in on his credit on that one.

Set in a postapocalyptic America in the year 2068—a hundred years after that fateful day the duck hunters gunned down Billy and Wyatt—the Leader of Biker Heaven comes down to earth to

get the two back on their hogs for a ride through the wasteland to burned-out Washington, DC. They are delivering to the president the *real* American flag, the badass Revolutionary War–era DON'T TREAD ON ME Gadsden flag with a coiled rattlesnake ready to strike, later used by Nike.

Occasionally Hopper would summon Terry to cool happenings, where Terry was good to have around—"Man, you're going to dig this scene."

Dennis called him to come to *Hustler* publisher Larry Flynt's mansion, where Hopper was a guest photographer shooting a "Celebrity Porn" feature with hot lesbo action. Hopper was really excited because he thought there was going to be real sex—only to discover it was fake: he just had to get the shot.

In March 1992, Hopper's people faxed over a memo instructing Terry to relinquish any rights to *Easy Rider*.

"Vicious greed," Terry called it.

Following Hopper's appearance on *The Tonight Show*, Terry was to give a deposition on behalf of Rip Torn, who was suing Hopper for defamation because he was fed up with Hopper's recurring telling of the knife story. Torn felt it had done a hatchet job on his career. Speaking under oath, Terry said he had stopped considering Dennis a good friend after asking for his help on numerous occasions. Collapsing on the Columbia University steps, where he was teaching screenwriting, Terry died penniless, without his point, but with a piece of paper in his pocket scrawled with his thoughts about the significance of *Easy Rider*.

He mourned for America and bemoaned a culture so ravaged by hatred and paranoia that the movie's "grotesque inevitable resolution" was for the two free-spirited protagonists to be blown away— "for no better reason than a Newt Gingrich type objecting to their long hair."

In December 1995, Hopper sued Fonda for a greater share of *Easy Rider* profits, in a breach of contract suit that claimed he'd

only gotten 33 percent of the film's proceeds when he should have received 41 percent. Those eight extra points would've compensated for the screenplay Hopper claimed he had written all by himself, which he swore until the last day of his life.

Terry was dead by the time Hopper was called to testify, but when the matter had come up at the Rip Torn hearing, for which Torn was eventually awarded $475,000 in defamation, Hopper accused Terry of committing perjury when Terry said he was the author of *Easy Rider*.

"I did it myself," said Hopper.

"What about a copy of the screenplay?"

"I don't know that one exists," said Hopper, still creating nimbly in the moment like Cocteau.

A preshooting draft was produced in court. By the end of the hearing the judge decided that Hopper was an unreliable witness. All arrows pointed toward *Easy Rider* being a collaboration. It was the ultimate case of: Who wrote that story?

Perhaps the most revealing evidence open to anyone who has the time to spend an afternoon at the New York Public Library is not just an *Easy Rider* screenplay, found in Terry Southern's stack of embalmed papers, but also a thirty-eight-page partial screenplay that scripts the entire Mardi Gras trip, cemetery acid scene, and even includes the movie's iconic line, "We blew it."

Hopper appealed the Torn ruling and the result came back to bite. The judge fined him even more. It cost Hopper a pretty penny to tell what would be his million-dollar anecdote. How would he ever make up the bread?

HOPPER'S OWN

It was the role of a lifetime, reminiscent of *Patton*, the film opening with the great George C. Scott standing in front of a giant unfurled American flag in his uniform, delivering a speech to his troops—"Americans love a winner and will not tolerate a loser."

Fringed by an enormous Nike flag in his stripes, referee Hopper took in the powerful feeling of performing for the 1995 Super Bowl before the biggest audience he'd ever have. Well, why not? Paul Newman was hawking his own salad dressing and Fig Newmans.

Next up was *Waterworld*, a *Mad Max* rip-off originally to be a Roger Corman film.

"I play a golf fanatic called the Deacon," Hopper told his friend Jean Stein, Dr. Stein's daughter, for her literary magazine. "The movie is set in a water world after the ice caps have melted. But the Deacon knows there's land out there somewhere and he's got to find it because he wants to play golf. First he's going to drill for oil to fuel his jet skis and war machinery. Then he's going to start by building an eighteen-hole golf course. But he wants to have plenty of land for expansion, thirty-six holes, forty-eight holes, seventy-two holes."

The role was close to his heart. Hopper had picked up the game in Texas while filming *The Texas Chainsaw Massacre 2* in which he was Lefty, an ex–Texas Ranger who packs a pair of chainsaws in his holsters—

"Keep hitting the ball straight toward the hole until you hear the turkey gobble," Willie Nelson cryptically instructed at his nine-hole Pedernales Cut-N-Putt golf course in Spicewood, Texas.

Hopper tried joining the elite at Sherwood Country Club located among the glens in Thousand Oaks, California, where Errol Flynn once played the legendary outlaw Robin Hood. Jack Nicholson got in. Hopper didn't.

"He's *charming* in the locker room, so I hear," said Hopper. Not that he would know.

Unfit to frolic on Sherwood's greens, Hopper joined his band of merry men—Joe Pesci, Neil Young, Bob Dylan. The quartet retreated to a Japanese-owned public course tucked in a canyon above Malibu. Hopper didn't have much of a swing; he couldn't hit the ball very far. But he really liked golf. And Joe Pesci was *incredible*.

One day, on the links with a golfing buddy, Hopper was feeling lousy with an upset stomach. After three or four holes he finally said something.

"Aw man, I feel like shit."

"Quit!"

"No man, I'm gonna go on. I'm gonna go on."

He made it to the ninth hole. Then he puked all over the side of the green.

"Will you *go home*, man?"

It turned out Hopper had passed a gallstone. He'd been in unbelievable agony and still wouldn't leave the course. He was very passionate about golf.

Shooting off a Hawaiian island, decked out in a postapocalyptic eye patch, codpiece, and long Western-style duster, Hopper

swung his rusty golf putter. He had shaved his head himself for the role and, letting his hands travel across his skull, felt the texture and uneven shape of his head. Squiggly little veins raised like rivers on a melon. It irked him. He didn't like it.

60 MINUTES TAKE TWO
STARRING DENNIS HOPPER

CHARLIE ROSE
The biggest mistake of your life was making *The Last Movie*.

DENNIS HOPPER
The Last Movie and moving to Taos, New Mexico.

CHARLIE ROSE
Do you assess this career as a . . . ?

DENNIS HOPPER
As a failure? I mean, I think I would. There are moments that I have had some real brilliance, you know? I think there were moments. Sometimes in a career, moments are enough.

There was a moment in 1987's *Straight to Hell*, a punk spaghetti Western. Dennis played a bad guy who sells an arsenal of guns to more bad guys. Handing over the goods, a whole bunch of gangsters charge in through the door, guns drawn, looking blank. Hopper looks at them and laughs, "Ha! Ha! Ha!" It wasn't in the script. It was just his reaction when they came through the door. It set everyone on edge for the scene. *Now* what's gonna happen?

There was also the time he played a drug smuggler for the

Medellín cartel on *Doublecrossed*, a low-budget cable production filmed in the middle of nowhere. Hopper hit a note, late one night, that moved the dog-tired crew to stop what they were doing and *applaud*.

Another cheap film was with Peter Coyote. Hopper's old actor friend from the San Francisco Mime Troupe mentioned how Sweet Willie Tumbleweed had been shot in the head, leaving one arm and one leg paralyzed, and the old Diggers wanted to buy him a three-wheel motorcycle so he could continue to ride with the Angels. Dennis whipped out his checkbook and wrote a ten-thousand-dollar check without blinking—"a very classy way of acknowledging the debt," said Coyote, adding, "I know he had a little mournfulness that he never had the career of Anthony Hopkins, and he didn't take care of his life in a way to do that. But by God, everything he did, even if it was a cheesy piece of crap, he made it more interesting."

Hopper's unique genius made a big hit at the video store, haunted by troubled souls who dug Christopher Walken. They flocked to watch *River's Edge* on VHS, with Hopper playing Feck, a hermit who dances the night away with a rubber sex doll. Finely attuned to giving people what they wanted, former video store clerk Quentin Tarantino at last paired the two together for *True Romance*, his movie about a boy and girl who hit the road after a cocaine score. Hopper played the easygoing cop who in his last moments on earth educates Walken, an icy Sicilian gangster, about the peculiar genetic makeup of his heritage.

HOPPER
You're part eggplant.

WALKEN
You're a cantaloupe.

"As far as I'm concerned," Tarantino raved to Hopper, "you and Chris together in that scene in *True Romance*? That should go into a time capsule."

He'd be perfectly preserved then in the year 2068, when the Leader of Biker Heaven descends on an American wasteland and barks the order.

LEADER OF BIKER HEAVEN
Billy, don't you understand? You guys really believed in the American Dream! The dreamer may die, but the dream is *immortal*. Give them back that dream, bikers—give them their new *flag*. Will you do it?

Hopper needed to think. Idealism could sure make you broke. He had four ex-wives and alimonies to pay.

THE GUGGENHEIM GANG

Thousands gazed on the genuine—but *fake*—star-spangled Captain America chopper for the Guggenheim's *The Art of the Motorcycle* exhibit displayed up the museum's spiral ramp in New York City. All the *real* choppers from *Easy Rider* had been stolen during the filming or blown up for the final scene, so Captain America's was a stand-in, reflected in Frank Gehry–designed stainless steel mirror panels specially installed for the show. Sponsored by BMW, the 1998 summer blockbuster drew the largest crowd in Guggenheim history, filling the museum's coffers and fueling its ever-expanding global ambitions.

Around the same time, Hopper was recruited to join the so-called Guggenheim Motorcycle Club, a celebrity gang of bikers who toured far-flung corners of the earth pimping for the museum. Star power on BMW-sponsored crotch rockets, wherever the Guggenheim staked ground in the name of art, Hopper and his gang would go.

Straddling his sleek Beamer, Hopper took off on a hundred-mile ride through southern Nevada to herald the arrival of the fabulous new Guggenheim Las Vegas, which was planned to open the following year. When his friend and fellow biker supermodel Lauren

Hutton crashed her objet d'art along Nevada State Route 167, some twenty-five miles east of their final destination, the trip was cut tragically short. Miraculously surviving the crash with a punctured lung and broken bones, Hutton was ready to jump on the back of Hopper's bike for the pilgrimage back to Vegas the following year.

After a three-day ride, they rolled in across Death Valley to celebrate the grand opening of the Guggenheim Las Vegas, kicking off with an encore show of *The Art of the Motorcycle*. This time, a genuine *fake* orange-and-yellow Harley-Davidson "Billy Bike," with a Panhead engine and flames painted on the gas tank, gleamed next to Captain America's fake chopper.

Next stop for Hopper? The Arabian desert to hype for the Guggenheim Abu Dhabi. Then Saint Petersburg!

Cruising past Russian peasants lining the route, Hopper skirted critics who damned the BMW-sponsored Guggenheim road show as a harbinger of a fast track to a global cultural wasteland wrought by corporate America. If only Jack Nicholson in a gold football helmet was riding on the back, reminding, "It's real hard to be free when you are bought and sold on the marketplace."

/ / /

Sprouting a goatee, Hopper played his Artist role to the hilt at Hugo Boss's fabulous Fifth Avenue flagship store in Manhattan.

"Marcel Duchamp and Andy Warhol were all in the tradition of artists who finger-pointed," he said to a reporter on the store's red carpet with no hint of irony. "They exposed the ills of a too-commercial culture."

His Hugo Boss exhibition featured enormous billboard-sized paintings created from his old sixties photographs, which he'd transformed into large-scale works like those once showcased on the Strip.

"I've got this *amazing* show here," raved the Guggenheim Foundation director Thomas Krens on seeing Hopper's exhibit, picking up the phone and calling the head of the State Hermitage Museum in Saint Petersburg.

A shrewd commercial player, Krens had recently hooked up with the Hermitage for yet another Guggenheim museum in Vegas—this time the Guggenheim Hermitage, located in the Venetian Hotel's fake Venice with its fake Grand Canal, fake Doge's Palace, and real Japanese tourists taking photos on the fake Bridge of Sighs.

Hopper returned to Russia for his art exhibition at the Hermitage, proud to be the first living American artist ever shown there. He rode his sleek Euro crotch rocket in his black-and-white leather BMW biker getup from Saint Petersburg to the Pushkin Museum in Moscow, ready to schlock for a Solomon Guggenheim Fund–organized exhibition, *Art in America*, serving up three hundred years of American art.

"*Fuck* Heineken," screamed Frank Booth from somewhere inside him. "*Pabst Blue Ribbon!*"

Trailing in his wake was a pack of filthy-rich Russian oligarchs who'd joined his three-day motorcycle ride through the Russian countryside.

"*Putin* wanted to meet me!" said Hopper of the former KGB agent. "I guess he's seen a lot of bad guys. He shook my hand and said, 'I love your work.'"

/ / /

Back in Venice Beach, he'd been filling his compound with art with an urgency to replace what he'd lost—first with the divorce from Brooke, then when the IRS cleaned out his place in Taos. Some art dealer friend wanted to sell him back a painting he'd lost, whose value had skyrocketed.

"Man, fuck that guy. You know how much I bought that fuckin' painting for? Fuck that guy!"

Hopper felt completely comfortable ranting to his assistant, Gary Ebbins, who didn't know much about modern art when he began working for Hopper. Dennis took time to explain how art evolved to a point where Robert Rauschenberg finding a piece of twisted metal on the freeway was art and not just a schmuck picking up junk.

"Dennis, there's a crate."

"It's gotta be the Rauschenberg piece!"

"You bought a Rauschenberg?"

"No, no, no, no! Let's open it up!"

"What the fuck is this?"

"It's *Lemon Junction*!"

"Lemon junction?"

"This is a very fuckin' valuable piece of art, Gary! We're gonna hang it!"

"You and me?"

"Yeah! We're gonna put it up on the wall and we're gonna hang it. Do you realize all the evolutions that art had to go through to get to *Lemon Junction*, Gary?"

"I get it. I get it, man! So, Dennis? If I see a piece of metal on the freeway—"

"No! You can't even *go* there. If Gary Ebbins sees a piece of metal on the freeway, it's still a fuckin' piece of worthless metal!"

/ / /

To one of his Guggenheim biker buddies, Laurence Fishburne, whom he'd been in the shit with back in the fake Nam, Hopper explained how one should look at works of art as friends. And if you don't like a work? You two simply don't have to be friends. Walk away.

Adding to the charm of his picket-fenced Gehry compound was that Hopper was actually friends with the outlaws whose canvases hung on his walls. He knew Keith Haring back when he was tagging New York streets and spoke at Haring's memorial at Saint John the Divine after he died of AIDS, describing how he "attacked the subway walls with the fierceness of a gunfighter." Keith's sexually graphic *Moses and the Burning Bush* loomed above Hopper from his second-floor home-viewing gallery. It pictured Moses getting the oracle from the burning bush, who's female.

"See, here's the vagina, the breasts—and Moses has a hard-on," said Hopper. "So he's getting it off with the burning bush!"

Hanging nearby was the broken-plate portrait of Hopper, which Julian Schnabel made to cheer up Dennis after he got flayed by Rip Torn's lawyers. Hopper acted the part of the art dealer in Schnabel's *Basquiat* film, about Warhol's protégé. One of Jean-Michel Basquiat's sprawling canvases hung in the Hopper compound, not far from *Angel in Hell*, a portrait of lilac-skinned Cindy Sherman framed in an antique gilded mirror. The work was painted by artist Kenny Scharf, another regular at the Hopper compound Christmas parties.

"From the time I met him up until Bush number two, I had constant contact with him," said Scharf. "Up until the Bush thing I just thought he was the coolest guy ever."

The Bush thing being that Hopper was pro-Bush. Hopper didn't hide from friends that he had proudly voted for George W. *This* was the same counterculture hero who roared through the conservative swaths of America in *Easy Rider*?

When Bush was getting ready to run for reelection, Hopper hosted a holiday dinner party, where he gave all his friends a miniature abstract painting with a number on the back. Everyone was to unwrap it and put it on numbers on the ground, like a grid puzzle. When they turned the paintings around, it was Bush's face with the slogan AXIS OF EVIL. Hopper got it. He chuckled. He voted for

Bush anyway. It worked with the repentant role of "How the Mad, Bad & Dangerous Movie Star" came off the bench and back in the game.

/ / /

All the while Hopper was searching for a movie to direct. He still hoped to do a great one—"You wanna be in my *movie*?"

Hopper went around asking friends to be in *Backtrack*, which he would direct and play a hit man who stalks a conceptual artist. He recruited his tireless assistant, Gary.

"Put a suit on. You're gonna be a *gangster*. We're gonna give you a forty-five and you're gonna *shoot* at the helicopter."

Hopper cast his old mentor, Vincent Price, as the mob boss. Long ago, Price had told Hopper that he'd one day be a voracious art collector. He even gave Dennis his first painting, something green and hideous. Now in his late seventies, Price had been traveling America *Easy Rider*–style, cruising the country in his very own Clark Cortez RV to see the sights and vistas at the national parks. Though he'd hoped to take a stab at the great leads, Hamlet or Richard III, after that *House of Wax* role that forever launched him as a master of horror, he had to make do mostly with Z-movie thrillers like *Theatre of Blood*, playing a vengeful Shakespearean actor who murders his critics.

Dean Stockwell would play another mob boss in *Backtrack*. So would Joe Pesci, Hopper's golf bud.

Coming over to the compound to talk about his role as a Venice artist who *paints* with a chainsaw, Bob Dylan wandered around Hopper's digs—"Wow, man, look at all these *books*. Have you *read* all these *books*?"

To play D. H. Lawrence in the same arty gangster film Hopper had cast his own in-house writer, Alex Cox, a filmmaker living in one of the Gehry shacks connected to the main house via

a second-story industrial catwalk. Cox doctored the script to fit Hopper's every whim and personal arcana. Hopper wanted very specific things. He wanted this church outside Taos in the script because, Hopper explained, it had a hole in the ground where natural lithium came out, which made him very happy. That *had* to go in his movie. Also, he wanted a scene shot on a miniature golf course with one of those Mother Hubbard's shoe holes.

"Now, why these things mean so much to him, I have no idea. Where does a miniature golf course fit into that guy's life?" Cox wondered. "Yet it did."

Alas, the inspirations were again more inspired than the film, the journey better than the destination. Hopper had grandiose aspirations for his *Backtrack* film, but he disavowed it completely after the studio took final cut away from him, cutting his fucking movie to shreds and renaming it *Catchfire*.

/ / /

Hopper went to Phil Spector to try to put together another film since they never got to do their early incarnation of *The Last Movie*. Having gone the way of a neon Charles Foster Kane, Spector's lush gothic Pyrenees Castle in Alhambra was his own LA Xanadu, featuring velvet curtains in the mysterious windows of thirty-five bedrooms, black-and-white-checkered floors, and creepy suits of armor. At the end of the long driveway was a large cage Phil had custom-built to house his ferocious dogs; it seemed his study of those sweet Saint Bernards had turned dark.

Hopper returned from his visit completely bewildered, never wanting to go back there again. The guy was a ghost, sleeping all day, haunting the place by night.

"Well, it's *Phil*, you know?" said Hopper. "He just hasn't changed."

The remaining scripts lay in the compound, littered across

Mabel Dodge Luhan's wooden Florentine table, which Hopper had spirited from the Mud Palace when he left behind the seventies for Venice. Hanging above the table was a tastefully sleek avant-garde chandelier made entirely from crushed glass. It was expertly hung, like his other art.

Happy at home, he was left to contemplate his directorial career.

Would he push on with the meta-Western in which Pancho Villa, the Mexican revolutionary, meets Victorian adventurer Ambrose Bierce? Or how about taking a crack at the adaptation of the book *The Monkey Wrench Gang*, about a pack of ecoterrorists? Or there was *Hellfire*, about wild-man Jerry Lee Lewis, whom Hopper wanted Mickey Rourke to play?

Floating somewhere in the compound was the *Fear and Loathing in Las Vegas* script, sent over by an inspired someone who knew how groovy matching Hopper with Hunter S. Thompson's drug-fueled journey into the American Dream would be. *Easy Rider 2*? Not so much, but Hopper planned to break through with an "*Easy Rider* for the nineties," which was not some half-baked sequel, but more along the lines of Dante's *Inferno*.

"Very calm," explained Hopper. "But underneath that calm there's really tortured things happening."

Instead he was slated to direct *The Hot Spot*, a sex-soaked noir starring *Miami Vice*'s Don Johnson as a car salesman. Hopper referred to it as "The Last Tango in Texas." At home in his spare time, he assembled newspaper clippings to fill a voluminous scrapbook about Mexico's serial killings. He was back from traveling to Romania, trying to secure funding the way Orson Welles scoured Europe.

Should he just give up and do the Charles Manson biopic, written by the madman himself?

KAAAAKRRRRRRRRRHHHHHHHHH!!!!!!!!!!!!

"Man," said Hopper, stunned. "A few feet, either way, it could've been all over!"

A wire snapped, sending fourteen pounds of his loose, tastefully crushed chandelier glass plummeting down on the Florentine dining room table, ingraining yet another cosmic memory in its wood.

Hopper didn't sink so low as to do *Charles Manson in His Own Words*. Instead his last film would be a fashion label–inspired movie titled *Tod's Pashmy Dream*, starring Gwyneth Paltrow, shot in *La Dolce Vita*–style in Rome. Sponsored by the luxury bag company Tod's, the promotional short was billed as "A Dennis Hopper Film," starring Gwynnie and a rather boring Tod's Pashmy bag. It was totally fabulous like Warhol on pink champagne! Enough to make any real artist puke.

/ / /

"What's it called, *The Last Movie*?" asked hipster director John Lurie.

Hopper was adrift in Thailand, filming an episode of John Lurie's *Fishing with John*. Hopper survived the trip on his post-rehab diet of Snickers and Diet Coke.

"You know," said Lurie, "you should really get that movie back and edit it."

"Yeah," Hopper deadpanned. "Why didn't I think of that?"

/ / /

Hopper was instead busy assembling the movie of his life, the one he'd shot frame by frame on his Nikon. A German art book publisher, famous for high-end smut like its *Big Butt Book*, commissioned him to do a giant photo book. In keeping with the scope of Hopper, his coffee-table book was going to be practically the size of a coffee table.

Hopper needed a few pictures to fill in the gaps, so he gathered friends to the cause.

Stewart Stern had taken a terrific shot of him as a young man at the hospital, waiting for his and Brooke's daughter to be born. Stern hadn't seen Hopper for years after *The Last Movie*. He lived in Seattle now and was absent from the audience when Hopper flew in for a film festival. Hopper called out for him from the stage. Someone told Stern, and they arranged to have dinner that night. To Stern's surprise, Hopper was not only incredibly sweet but sober.

"Dennis. How did you get straight?"

"I just got to where I couldn't do it anymore."

"Well, are you open to an idea? I believe that *The Last Movie* could be the most important document that any future artist could possibly have. That is, if you go back and shoot it again without yourself in the lead. Get the best actor you can find. Shoot the picture again. Then we'll issue it. Both pictures and the script. Let people see what happened. Not just to the film, but to *you* as an artist. What the difference is with you, as an artist, and the choices you would make now, against what you made before when you went nuts in Peru. It would do a lot of good for people to see how art can be demolished by what you think is inspiration and is only coke. It'll give you a chance to vindicate yourself and to have a film that people will look at instead of a fancy failure."

"Yeah, that's, you know . . ." laughed Hopper, then he shrugged it off.

"From then on we were friends," said Stern. "But he never did the movie, and he never made the film that I always wanted to make most, which was about his boyhood on the farm in Kansas with his grandma. Oh, what he could have done with his grandma! Because at the bottom of all that was this motherless child."

/ / /

Hopper called his old friend, Bobby Walker, who had a terrific shot of Hopper on the beach teaching his daughter how to shoot a camera. There was another great one of Hopper in front of a big Dr Pepper soda pop sign.

When Bobby came over to give him the photos, Hopper was swarmed with assistants, busy having his appearances arranged and possibly filming this commercial. Phones were ringing off the hook dealing with his art and buying and selling and showing himself. Hopper was part of a world that Bobby didn't want any part of.

Bobby didn't want to take up too much of Hopper's time, but later thought at length about seeing Dennis. Tucked away at his home in Malibu, packs of choppers roared past in the distance, all living out *Easy Rider* fantasies. In retrospect, Bobby was glad he'd decided not to set himself and his family adrift like Kon-Tiki at sea in that escape pod. In the sixties, he was planning to get all his teeth pulled, so he "didn't have to worry about dentists, 'cause that's the worst thing when you're living in remote areas."

Bobby's dad, actor Robert Walker, who was admired by James Dean, had died at thirty-two from a drug overdose. Bobby's thoughts turned toward Hopper and whether he squandered his talent, or whether something from his searching would survive like all great art.

I think so much got in his way in the old days of wanting to open the doors of perception and soothe the pains of everyday three-dimensional living. Obliterate any discomforts of the past, obliterate with booze and drugs of one kind or another. His pursuit of oblivion did him in, just as I think it did in all the great talents."

Bobby's mother, Jennifer Jones, had recently died, leaving Bobby to catalog his stepfather David O.'s memos to her, and they were strewn about his house. Unattached to material things, at his mother's suggestion Bobby was trying to pawn her Oscar, only

to be informed by the Academy that he'd only be allowed to sell it back to them for a dollar. Seemed like valueless junk—though Hopper would've killed for one, something to hold aloft for that singular great role that never came down the pipeline, the conventional one at least.

THE COWBOYS

You had a birthday there in France at the film festival," said Jimmy Kimmel on *Jimmy Kimmel Live!*

"On a yacht, yeah," said Hopper, describing his seventy-third birthday party celebrated in May 2009. "Everybody from Harrison Ford to Bono to Mick Jagger, it was incredible."

"Elton John was on the ship?"

Sporting a suit and tie, Hopper, playing the elder goateed artist statesman, told another story, honed over the years. It was the one about the time he went to see Orson Welles perform his hocus-pocus at the Riviera Hotel.

"You went to see Orson Welles in Las Vegas?"

"Yeah, Orson had come back from Europe and did a show in Vegas. It was terrific."

More magic tricks. Welles was magnificently pathetic.

Like his muse, Hopper had played the manic sellout, the repentant former wild child, the crazy villain, the comeback kid. Not to mention the homeboy. What were all these roles leading to? What were *they* going to say about him when he was gone? Would anybody even pay attention?

Would they love Hopper in his final role? Of course they would.

"Dennis," shouted a paparazzo on the streets of Venice.

Hopper turned around abruptly and, in his weakened state, fell and hit his head. He had to put on a huge white bandage and cover it with his street urchin cap.

The tabloids were all clamoring to get the inside scoop after his latest battle, this time with terminal prostate cancer. A dying Hopper was hot stuff to begin with, but on top of it America's eyes were glued to him, given the sensational Shakespearean feud raging in Hopperdom. Who would win his valuable art inheritance? The warring parties were his children from different marriages pitted against the estranged ex-wives, spitting at each other like wildcats. And the really sick thing? They were all trapped in Hopper's world—all living in his sprawling compound.

Hopper's daughter Marin lurked in the main house. Living in one of the "three little pigs," as the Frank Gehry shacks were called, was wife number four, Katherine LaNasa. Hopper met her in the late eighties when she was a ballet dancer. After watching her perform at the John Anson Ford Amphitheatre in LA, he sat beside her at the dinner afterward at trendy Spago. He was on a date with this really trippy chick who insisted on ordering him fish when he went to the bathroom—"I thought you might want more *fish* in your diet."

Katherine thought it was a weird sexual reference. In truth a mouthwatering carnivore, Hopper had already asked the publicist seat Katherine next to him because of her great ass. She was dressed in a crazy outfit she'd found in Paris like a little Indian boy. Watching her onstage earlier, he had liked the red bottoms under her tutu, how the red elastic went up her crack. The truth was she was a little overweight because she was recovering from an injury, but he didn't care.

Seeing Hopper three consecutive nights in the audience, someone said, "I didn't know you loved the ballet so much!"

Hopper and Katherine married in 1989 and divorced three

years later. They'd recently had a reconciliation on the steps of the Metropolitan Museum of Art. They hadn't been close since their divorce, but decided to quit bickering and be friends again. Supporting his final dying role, she came back into the fold. Their actor son, Henry, dribbled out abstracts, like the ones by his father run over in Vincent Price's driveway.

No, Katherine wasn't the estranged wife. The estranged wife, wife number five, was sequestered in another of the pigs.

Hopper had met her at Rebecca's Restaurant in Venice. She was the hostess—"I don't want to bother you now, but when you're finished," asked paper-thin Victoria Duffy, big eyes framed by her fiery hair, "would you mind if I asked you about your art?" Not to discuss his acting, oh no, but his *photos*. Very good.

Dutifully playing the role of Hopper's wife, Victoria smiled on his arm on the velvet carpet at all the events and played hostess for lavish parties they threw at the Venice compound, expensively hip after all these years. She was with Dennis for fourteen years, longer than any of the other wives, but Hopper just couldn't seem to get divorced from her fast enough.

As long as Victoria was on the premises, she'd be legally fulfilling the obligations of the prenup that they were both married and living together. Suddenly, the sprawling compound seemed too sprawling for Hopper's own good. From his bedroom window, bunkered in like John Wayne at the Alamo, he could practically see her over the little stretch of yard. All the while, they were, technically, still living together.

A white picket fence wrapped up his messy world like an all-too-simplistic bow. A frail Hopper surrounded himself with his loved ones—Andy Warhol, Bruce Conner, and Marcel Duchamp hanging on the walls. Soon all of his friends would be taken away from him.

The *Hotel Green* Duchamp/Hopper collaboration would go for $362,500 at the Dennis Hopper estate sale at Christie's, a

star-studded affair. Hitting $410,500 was Bruce Conner's religious-themed lithographs *Dennis Hopper One Man Show*. Warhol's *Mao* had been critically wounded when Hopper shot two bullets into him during his wild days, but Warhol resurrected the work by drawing two circles around the bullet holes and signing the hole over Mao's right shoulder, labeling it "warning shot." The Warhol/Hopper collaboration went for $302,500.

Then there was the Dennis Hopper Warhol, somehow *greater* than his Marilyns or his Elvises. It was a still from *The Last Movie*, canonizing Hopper as a rebel dreamer in his cowboy hat. *Dennis Hopper, 1971*, would go for just under a million. The large Basquiat would sell for a whopping $5,794,500, capping off this splendid affair bringing in a grand total of $14,741,657.

/ / /

IN THE EVENT OF A DIVORCE CUT HERE directed Hopper's painting by the enigmatic graffiti artist Banksy.

/ / /

"I love you all," Hopper told the cheering crowd gathered for his star ceremony at the Hollywood Walk of Fame.

Jack Nicholson wore a star-spangled *Easy Rider* shirt featuring Billy and Captain America. Desiree showed up; she was now an herbalist. Hopper's Helix High pal, Bill Dyer, was there, too.

"He told me he had cancer eight years ago," said Bill. "And the doctor told him he had gotten it all. Then Dennis called and told me they hadn't."

"Dennis!" the paparazzi shouted as he received the plaque given to him by the Hollywood Chamber of Commerce for its 2,403rd star. Dennis's star would bring in $3,750, a little more than the

certificate of nomination by the Academy of Motion Picture Arts and Sciences for Peter Fonda, Dennis Hopper, and Terry Southern for Original Story and Original Screenplay for the film *Easy Rider*. At Christie's, it would outbid a *Waterworld* pinball machine, not to mention the two lacquer end tables featuring Hopper smoking a big fat cigar, and a framed photograph of silent film star Tom Mix, the god of old movie cowboys in his white hat.

A pack rat, Hopper kept it all, the art and the junk. Somewhere in it was an *Easy Rider* poster featuring the chiseled motorcycle god Captain America in his black leather jacket, with the tagline: A MAN WENT LOOKING FOR AMERICA, BUT COULDN'T FIND IT ANYWHERE.

So where was the script for *Easy Rider* Hopper had sworn didn't exist?

Among the heaps was a script for *The Last Movie* with a note from Raybert's Bert Schneider, who was rumored to be an addict, living *somewhere* in the wilds having blown his share of *Easy Rider* profits. A few people had seen Bert over the years and said he was sickly but still had his brilliant blue eyes blazing for a little longer.

In the compound garage, parked along with a pair of motorcycles with flat tires, were stacks of paintings and found objects and boxes of photographs for Hopper's upcoming retrospective at the Museum of Contemporary Art in LA. It was just like the time a Universal exec told him, about *The Last Movie*, "Art is only worth something if you're dead. We'll only make money on this picture if you die."

"Don't talk to me like that," said Hopper. "You're talking to a paranoiac."

The exhibition going up in 2010 would look like a studio prop shop with freestanding backdrop "sets," like the graffiti-strewn wall and chain-link fence in Venice. Hopper once pointed to it like Duchamp, calling it art and ordering it cut down. Hopper hoped to

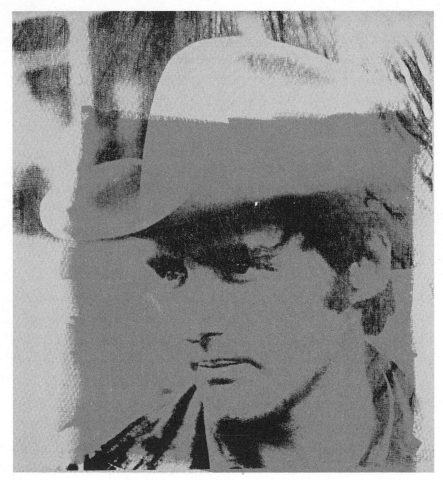

Dennis Hopper, 1971, *Andy Warhol*

live long enough to make a grand entrance. Just in case he didn't, a life-size Hopper statue stood ready in his cowboy getup, reproduced from a poster of *The Last Movie*.

/ / /

The light hit the movie screen. Going up in flames was Rosebud, the cheap little sled Charles Foster Kane had been playing on the day they ripped him away from his mother.

"It stood for his mother's love, which Kane never lost," said Orson Welles, about the grandiose recluse trapped in his private Xanadu till the end of his days, a man who clamored for the love of the world—on *his* terms.

/ / /

As the steel-blue Warner Bros. Special chugged in the distance ready to pick up Hopper and take him to the land of the movies, a constant stream of CNN rapidly fired images à la artist Bruce Conner. Flashing before Hopper were also early cowboy films, sent to him by an old friend.

The films were older than the ones in which Gene Autry once shot it out at the Dodge Theater. They'd been made back when Hathaway was a young son of a bitch whippersnapper working on *Ben-Hur*, and John Ford was an assistant director listening to a real cowboy, Wyatt Earp, jabber away. Stuck in Pasadena with a nagging wife and nowhere on the frontier left to roam, Earp moseyed over to the backlot to tell those damn fools in Hollywood what was what. He regaled Ford with the one about the time he'd shot it out at the O.K. Corral with Billy, leaving Billy dead as a doornail, silent as the tintypes hanging at Fly's Photographic Studio.

"I didn't know anything about the O.K. Corral at the time," Ford once said. "Wyatt described it fully. As a matter of fact, he drew it out on paper, a sketch of the entire thing."

In years to come, the gunfight at the O.K. Corral became the most famous gunfight in the Old West, courtesy of the movies, with Henry Fonda starring as Wyatt Earp in Ford's classic, *My Darling Clementine*.

The films that flickered before Hopper were earlier than that one still, going all the way back to *The Great Train Robbery*, hand-colored and starring that traveling salesman–actor G. M. Anderson. Staring at the audience in his ten-gallon, he pointed his

six-gun at them and *blam!* He sent crowds screaming and fainting and wanting more!

/ / /

His pupils opened. Blue around black of those eyes that *talked*. The light was fading. Everybody was saying he wouldn't catch the light, but Hopper hopped on his Harley-Davidson with the Panhead engine and flames blazing on the gas tank and gunned it.

Trailing behind him was a procession including a curtained Clark Cortez production vehicle, a truck driven by Hungarian émigré László Kovács, his cinematographer with the 35mm camera stocked with Kodak film, and Captain America's red, white, and blue chopper. The star-spangled gas tank Peter Fonda held between his legs, seeing as how it had come loose on the bumpy dirt washboard road.

Hopper took his show deeper into the heart of John Ford country, to the sacred Indian ground where Big Duke, that all-American kid born in the heartland as one Marion Mitchell Morrison, sprang forth as the Ringo Kid, appearing in *Stagecoach*, smiling amid gauzy clouds like the birth of Venus.

"There's no light," called László.

"Shoot it anyway!" said Hopper.

Standing at the overlook in the setting sun, Hopper searched for America, down there in Monument Valley. He couldn't find her anywhere.

It was the greatest moment of his life. The road beckoned. The journey continued.

CAPTAIN AMERICA

The brilliant thing," said Peter Fonda, "the beautiful moment, the exceptional thing about it is, we had wrapped the film, we had a big wrap party, and we forgot to shoot the last fuckin' campfire. It was what it was. It was 1968. We argued about that scene. We screamed at each other for forty-five minutes. He wanted me to say all this shit. I didn't wanna say it. Mind you, this goes back to September 27, 1967, in Toronto at the Lakeshore Motel."

"All I wanna say is, 'We blew it,'" said Fonda to Hopper.

"What? Whaddya mean we blew it? What? *Fuck*, it looks so cool. Whaddya mean we blew it?"

"He wanted me to explain why we blew it," recalled Fonda. "I refused. He was yelling and yelling at me and it was this terrible."

"Well, tell me what you wanna do, man."

"I wanna do it like Warren Beatty."

"Warren Beatty? What the fuck do you mean, man?"

"You know, Beatty cuts all his lines in half and mumbles what he does speak."

"Can you hear yourself, man? I mean, man, I mean, man, man, can you dig it, man? You sound like a fuckin' child, man. They've

been waiting forty-five minutes for us. So let's just step out of this motor home and give each other a hug. They'll just think we're a couple of actors that have been, you know, working our Method up to do the scene and then we'll go down and do it. We'll do it two ways. First we'll do it your way, then we'll do it mine."

Hopper stepped out of the Winnie and threw his arms around Fonda.

"I love ya, Fonda!"

"I doubt it," thought Fonda, throwing his arms around Hoppy. "I love you, Dennis."

BILLY
We're rich, man. We're retired in Florida now, mister.

WYATT
We blew it.

BILLY
Whaddya mean we blew it?

WYATT
No, we blew it.

"I'm lookin' at him with my upstage eye," recalled Fonda. "He had a furrow that maybe Botox removed from him in later life, I dunno, but he furrowed his brow. That Napoleonic furrow was going Grand Canyon, dude! He's gonna hit me!"

"Cut! Okay, man. Stay right where you are, man, you know, man, I, man, just, man, just. Man, just stay where you are."

"I'm stuttering now," said Fonda, taking himself back to the moment. "It's not for effect. If I could pull this tape through, you

would hear exactly as it was said. My unfortunate memory is that I got saddled with all this fuckin' *junk*. No, it's not junk. In this moment, it's not junk. 'Cause it's about a brilliant man in my life. Hopper was always calling me saying—"

"You gotta come, Fonda. You gotta see this!"

"Whether it's paintings, whether it's films, you've gotta be a part. Irreplaceable. More instructive to me than anybody else in the business. Certainly anybody in my family. Dennis was right in there, delivered me out of the grasp of Hollywood and into the possibility of filmmaking.

"I never would have seen *Duck Soup* had it not been for Hoppy. Never would have seen *Viridiana*. Never would have seen *The Exterminating Angel*. I never would have seen *The Magnificent Ambersons*. Never would have done the most incredible fuckin' shit. It was Dennis who codified me in all those moments in that period of my life, who anointed me, and knighted me, and bouqueted me, and graduated me, and did all that. I don't think on purpose. It was just—he was so *bright*—and he had such perception of art and form and substance that it infused my entire life as an actor, as a director, and it continually does that. 'Cause I always use that Cocteau reference. Ninety-eight percent of art is accident. You *want* that accident. We can't make it happen. It's contrived, but if it happens, you realize it and play with it."

"Stay right there, man. Don't leave it. Don't leave it, man. Don't leave it."

"I'm in the moment. Okay, I'm not leaving."

"Okay, László, put the hundred millimeter."

"'Cause Hoppy would say, 'I'll shoot you with a hundred millimeter. Having photographed me a lot, he knew that my best lens was a hundred millimeter lens. That was the best close-up lens for me. That was the most flattering fuckin' lens."

"Stay right there, man. I may ask you to say it like sixteen times, but can you do it?"

"Yeah, man, yeah, no problem. Yeah. I can do this, no problem."

"Okay, and cut!"

"All right and action!"

"We blew it, Billy."

"I think we probably blew it in sixty-seven, but I allow my-self the opening gate because I wrote it in sixty-seven, so maybe I wrote it before we blew it. There's no *g*, Dennis! In *Yin/Yang*. Doesn't matter—this close to genius. Thinking we missed it, and suddenly—oh no, we didn't miss anything. We did fuckin' genius. We didn't do it thinking we're geniuses. At least, I didn't. I know Jack didn't. Just fuckin' did it."

/ / /

Peter wasn't invited to the funeral, but he just thought it was the right thing to go. He landed in the small Taos airport and took the stretch of highway to the adobe church across the street from Hop-per's old El Cortez movie theater. The leathery men and women employed by High Desert Protection Service stood guard, expect-ing to be overrun by a pack of Glory Stompers.

Guarding the "no" list by the church doors—with Victoria Duffy Hopper getting top billing, was the chunky publicist-type gatekeeper of fabulous velvet-rope events. She barred Fonda from entering the church. Fonda got back on the plane.

"Dennis went to his grave thinking I cheated him," said Fonda. "I never cheated him. And he never cheated me. Even though he did some stuff that was unhappy for me, he never cheated me. That he would carry that so far into his life, that he would die with that in his heart, upsets me because I would prefer he would die thinking—"

"We did it, man. We're retirin' in Florida, mister. We're rich, Wyatt!"

"Aw no, Billy, we blew it."

"Whaddya mean, man? We got the money, we're rich! That's what it's all about. You get the money, you're free."

"No, Billy, we blew it."

"On the trip back I didn't say goddamn because I had flown in. I made that ride. We did this film together. Regardless of what happened afterward and how we viewed it, doesn't make a difference. We did this film together. And I am so happy and proud of that. Regardless of everything else that happened on the negative side, what happened on the positive side is much more important. Yin Yang. Or *The Yin(g) and the Yang.*"

THE FUNERAL

On a hot and dusty afternoon in Taos, Dennis Hopper led a procession of outlaws of one breed or another on a ride to the cemetery. They wore black suits, bolo ties, and paraded a variety of facial hair that would've made them clear picks for that two-hundred-dollar best beard contest back in Dodge City. There were plenty of arty goatees, but the two real contenders were a guy with a woolly white beard à la Rip Van Winkle—outlaw historian Peter Mackiness, whom Hopper had cast as Jesus Christ in *Backtrack*, and a real dude, Kansas-born Doug Coffin, whose pointy mustache stuck out two inches straight on each side like feelers for trouble. He looked like a sheriff out of Tombstone. Somewhere in the mix was movie star Val Kilmer, well baked by the New Mexico sun, looking like a professional wrestler in a cowboy hat. There was the mayor of Taos, who'd finally given Hopper the key to the city. Back when Hopper was locked up in the local jail, the joke was they were going to throw away the key. There were veterans from those wild and woolly days, including Hopper's personal belly dancer, swathed in blue leopard print. The international press mistook her stone-faced spiritual-healer boyfriend for Peter Fonda. After the real Fonda was turned away.

Fans came to Taos from far and wide. An old jazz cat was dressed in his Harlem best—pinstripes and white-and-black spats. A few LA guys wore *Crash* hats, having worked on the TV series in which Hopper played a deranged music producer. Stoic Tiwa Indians represented the Taos Pueblo. Billy and Captain America once rode through on their way to the movie commune. Coming back full circle after a thousand years, ready to join the riders, were bikers clad in leather and cutoff jean vests, veterans of the bike events "Red River 2010" and "Los Compadres 13th Annual 1991 Bike Run."

Blasts farted from their American hogs. Real hogs to be ridden flat out onto the open road, not stuck in some graveyard museum. No Euro crotch rockets here.

Trailing was the scraggly Dutchman of Taos, the grandson of a Hudson River Valley artist. Hopper once admired his orange Indian chopper now navigating the narrow dirt trail. It was said the man over there with coyote-blue eyes and a silver-tipped cane could get you a buffalo skull if the price was right; he had arranged for Hopper's burial in this Penitente graveyard, rangy with old crosses and plastic rainbow-colored flowers atop the rock mounds piled on the graves.

"Wow, this is the *hippest* place to be buried," remarked one of Hopper's art pals to a writer.

A rock-and-roller concluded this was Hopper's final blow in the Chicano-hippie war: he'd not only set foot on their turf and taken their women, but he'd also be buried on their land.

In the shadow of mystical, smiling Taos Mountain, the white pine box was lowered into the earth. Hopper got his send-off, kicked off by that orange Indian chopper.

VAROOOOOOOMMMM!!!!!!!!!!!!!
VAROOOOOOOMMMM!!!!!!!!!!!!!
VAROOOOOOOMMMM!!!!!!!!!!!!!

VAROOOOOOOMMMM!!!!!!!!!!!!!
VAROOOOOOOMMMM!!!!!!!!!!!!!
VAROOOOOOOMMMM!!!!!!!!!!!!!
VAROOOOOOOMMMM!!!!!!!!!!!!!!

The roar was deafening.

Jack Nicholson burst into tears.

Suddenly, a Tiwa Indian woman, who was known to have visions, saw Hopper shooting out from his grave on his customized orange-and-yellow Harley-Davidson with the Panhead engine and flames on the gas tank. He was heading higher and higher to a more monumental valley.

Photographs

Index

Note: Page numbers in *italics* refer to illustrations.